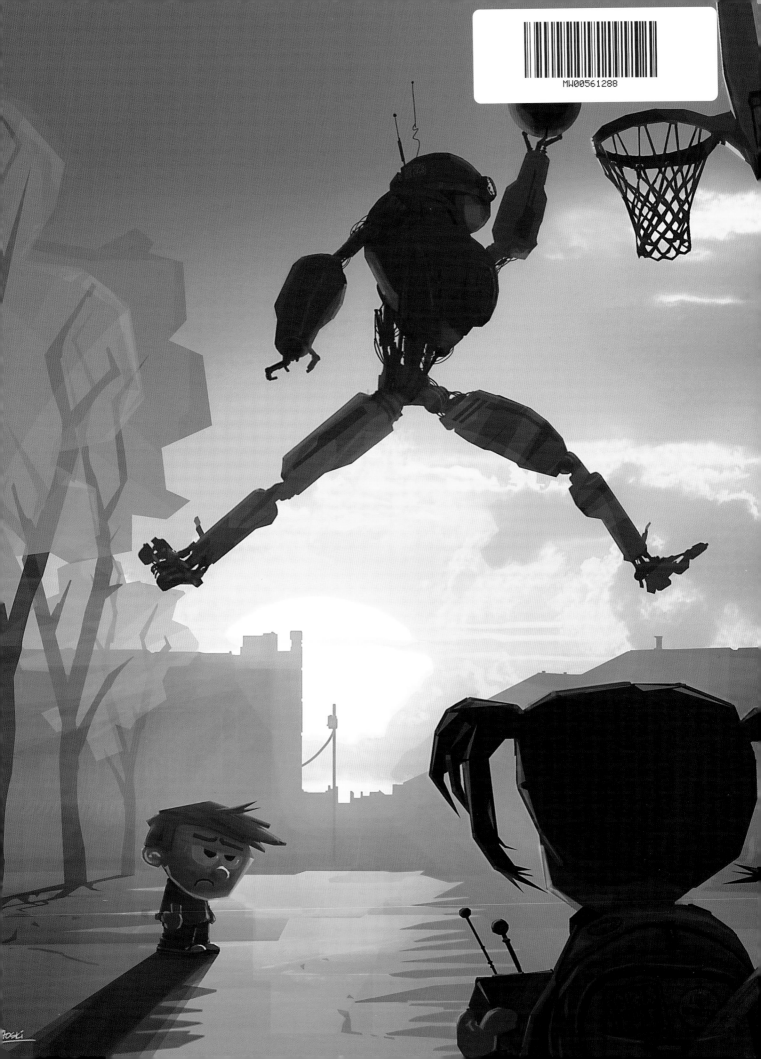

Above
Kevin Conran
Pencil, Photoshop

Previous
Chris Stoski
3ds Max, V-Ray, Photoshop

NUTHIN' BUT MECH 3

sketches and renderings

designstudio|PRESS

NUTHIN' BUT MECH 3

Graphic Design: Christopher J. De La Rosa
Art Direction: Scott Robertson
Copyediting: Teena Apeles

Published by
Design Studio Press
8577 Higuera Street
Culver City, CA 90232

www.designstudiopress.com
info@designstudiopress.com

10 9 8 7 6 5 4 3 2 1
Printed in China
First edition, October 2015

Paperback ISBN:
978-162465027-7

Library of Congress Control Number:
2015948746

Front Cover Image: (left to right)
Colie Wertz, Chris Stoski, Francis Tsai, and
Eric Joyner

Back Cover Image: James Paick

Facing Image: Ben Mauro

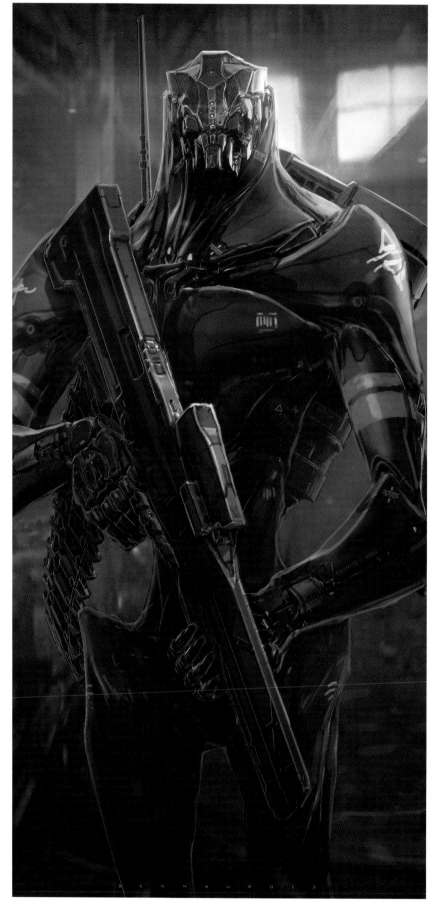

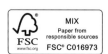

Contents

Francis Tsai
SketchUp, Photoshop

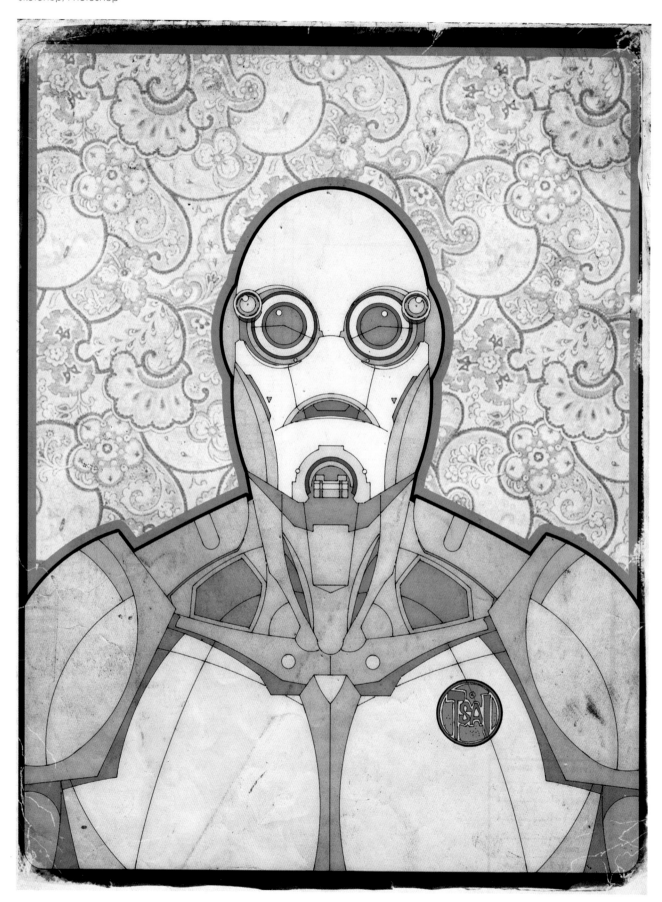

Introduction

Welcome!

Book three and we are still going strong! Once more I have had the good fortune to gather a stellar group of visionary artists, and many are having their debut in these pages. Over the course of three books I find myself continually stunned by the range and diversity they bring to these volumes—each with his own unique aesthetic signature. I hope that you are again inspired by what these incredible artists have contributed to volume three of *Nuthin' But Mech!*

On a more somber note, I want to take a moment to acknowledge and celebrate one of the contributors of this book who has passed away: Francis Tsai. Early in the production of book one, Francis informed Scott Robertson and me that he was diagnosed with amyotrophic lateral sclerosis (ALS), or Lou Gehrig's Disease, and would have to decline involvement. It was a sad moment to receive this news, as Francis was a pinnacle in the early days of the concept art community. As the disease advanced and he lost more of his motor functions, he was literally drawing with a toe on his phone! When that ability was lost, his personal drive could not be hindered. Some of his close friends put together a means by which his eye movements were tracked and translated to software from his wheelchair. Francis would not permit his failing body to curb his passion. He had the full support of his friends and family, especially his amazing wife, Linda, who remained supportive until the very end. I can only describe both of these people as astonishing and inspirational in the face of such adversity and challenge.

I had only a few email exchanges with Francis over the years, but each one was certainly a treat that motivated me personally. Like so many other artists working today, he was an influence on my professional pursuits in entertainment design. He provided the community opportunities to communicate with him, which he did so generously. He excitedly contributed in the very beginning of *Nuthin' But Mech* with the same unmatched zeal with which he approached all his creative pursuits. That passion will be missed, but Francis set a standard in both his art and life that we should all aspire to. As with book two, we have decided it best to donate the proceeds of this book to Linda Tsai in memory of her late husband. She is an example of patience, loyalty, and love that should be recognized and admired.

Francis, thank you for your excitement and drive to create at your very best with passion that can withstand any obstacle. You will be missed. This one is for you.

Lorin Wood
Dallas, Texas
Summer 2015

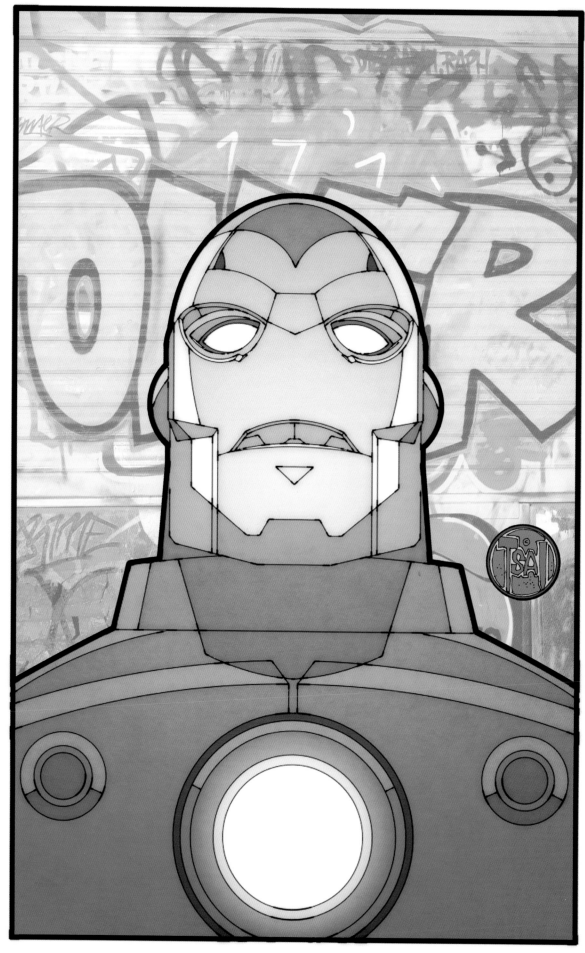

In Memoriam

How do you start one of these?

I could not hold back the tears when I found out Francis Tsai had ALS, and I could not cry more effortlessly when I found out he had passed away because of it.

He battled ALS and, in my opinion, he beat it.

He beat it because no matter what the disease took away from him, inch by inch, Francis cunningly found a way of doing what he passionately loved to do. When his hands stopped working, he used his toe to paint on an iPad. When his toe stopped working, he used eye-tracking software to create art the rest of us only wish we could imagine. This disease finally had to take his life, because it was the only way to keep Francis from being a productive, creative artist.

I can only give you a superficial glimpse into the man I knew. Francis was a man of few measured words, but when he spoke, we all listened intently. He was comfortably humble; one of those rare artists who possessed true self-confidence, borne of incredibly honed artistic skill and experience. His work did all the talking for him.

Not to say Francis did not have a sense of humor. On the contrary, he had a great funny bone, and it came out in the form of little sketches and groan-inducing puns. He was one of those rare problem solvers who never complained and was always ready with solutions and options.

He had studied architecture and, contrary to sketching norms, he used to sketch with a finely sharpened mechanical pencil. He had the unique skill of sketching loosely but also incredibly accurately, with a dead-on perspective. He was fast, very fast, and yet his hand movements were calm and seemingly slow.

Francis had such an incredibly large body of work. What you see online or in his books is only the tip of the iceberg. I used to joke with him that he'd not even reached middle age yet, and he'd created three lifetimes' worth of work. In a cruel twist of irony, he did not have the benefit of even half the lifetime he deserved to have.

He was the best of us, because he used the time he was given so beautifully. Francis taught me how to cherish the time I have been blessed with. He showed me how to take on life's worst tests with courage, dignity, and resolve. His humanity, his dignity, his honesty, and his morality were his true gifts. And Francis lives on through his soul mate and loving wife, Linda; his sister, Marice; both his parents; and his legions of friends and fans.

Francis was very special to me. We never had a traditional friendship where we'd hang out or call each other regularly. But if immeasurable respect for a peer could equate to affection, or even love, then I can honestly say I loved Francis, and I miss him deeply.

FARZAD

Farzad Varahramyan
Carlsbad, California
Summer 2015

Artists

Darren Bacon
Modo, Photoshop

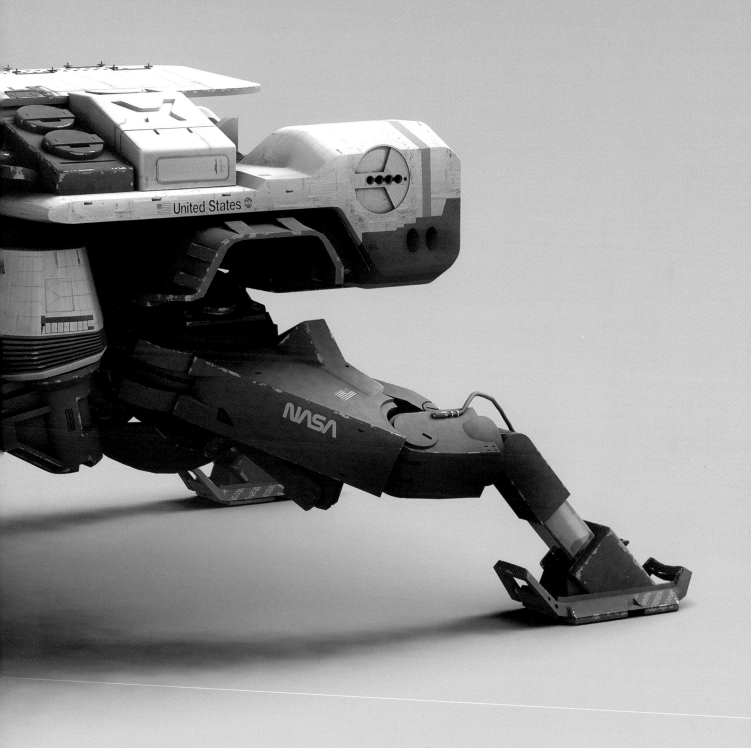

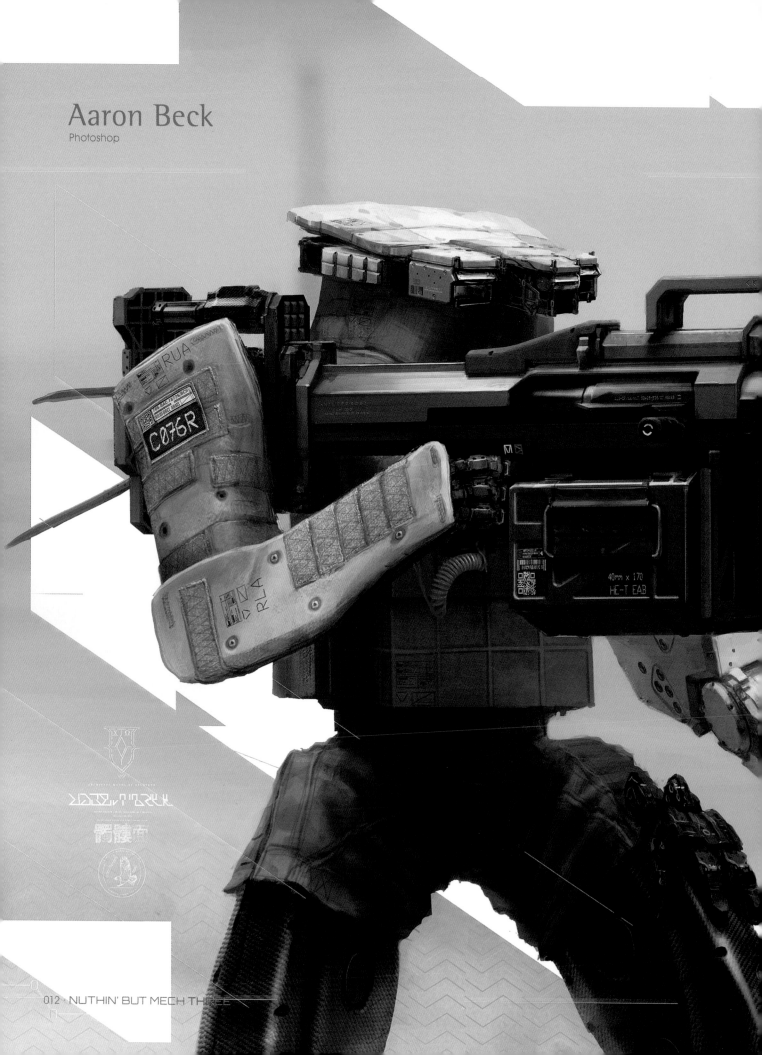

Aaron Beck

Photoshop

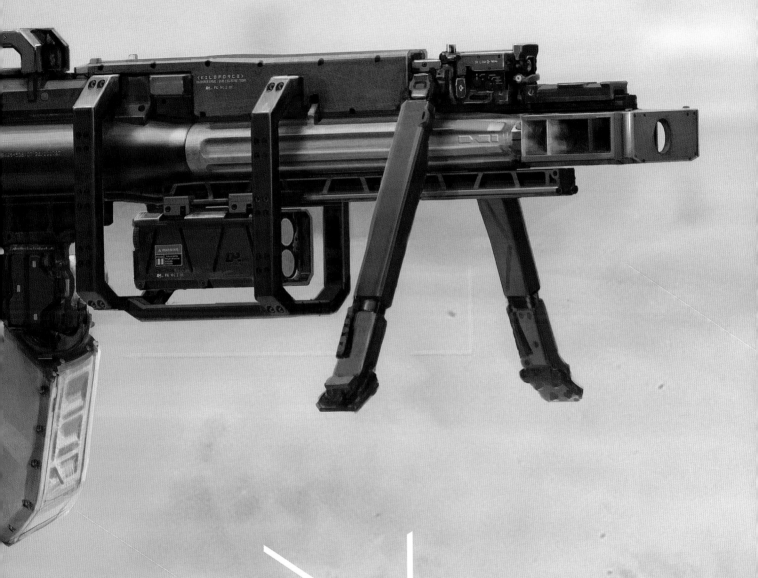

KILØFORCE

KILOFORCE ARMS

carbon

013

< K I L 0 F O R C E >

KILOFORCE ARMS AUG-DF

Kiloforce Arms Co. AUG-DF 40 mm cannon, 40 x 170 mm high-explosive, telescoped case, electronic air-burst ammunition is designed for either robotic-assault chassis usage or vehicle pintle mount. Underslung and exo-frame protected multi-spectrum optics array is linked to user by secure, wireless data link.

Weapon can be fed by direct, connected box magazine with linked belt ammunition or flexible exterior belt linked to a variety of large storage devices. Barrel designed to accept modular cooling jacket for sustained high-velocity fire.

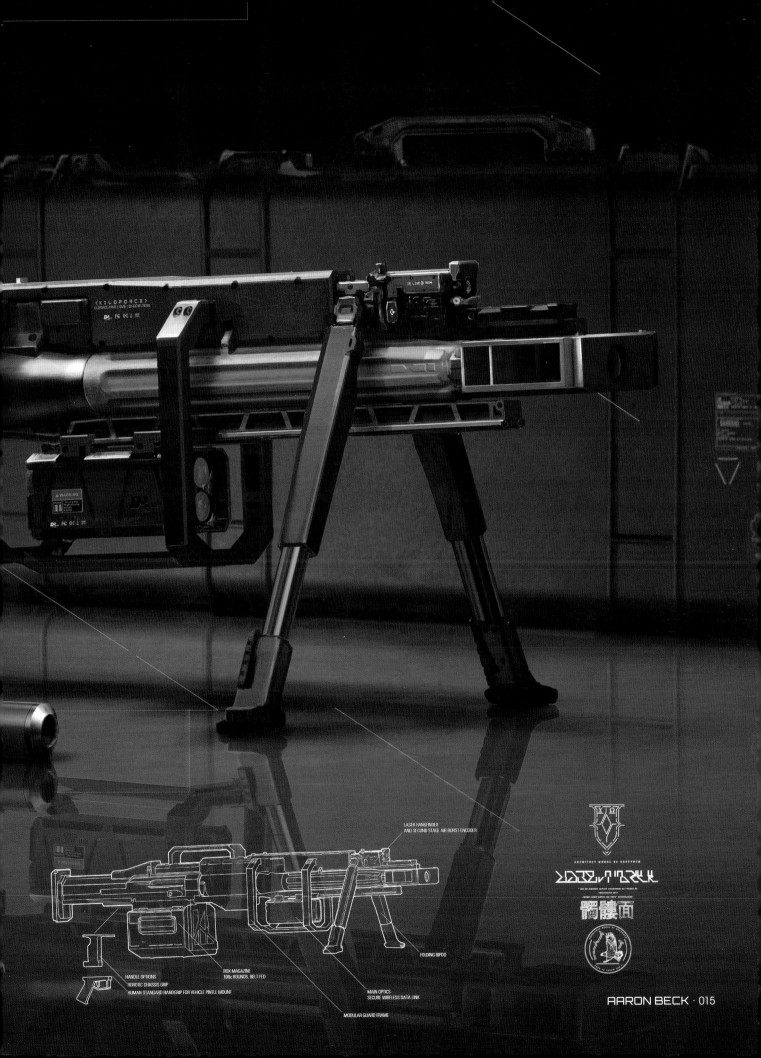

< KILOFORCE >
KILOFORCE ARMD ⏐ GUN ⏐ 03-43707 79265

IR LINK

LASER RANGEFINDER
AND SECOND STAGE AIR BURST ENCODER

ARCHITECT MODEL 04-4G42YNT8

霜霞面

HANDLE OPTIONS
ROBOTIC CHASSIS GRIP
HUMAN STANDARD HANDGRIP FOR VEHICLE PINTLE MOUNT

BOX MAGAZINE
100x ROUNDS, BELT FED

FOLDING BIPOD

MAIN OPTICS
SECURE WIRELESS DATA LINK

MODULAR GUARD FRAME

Søren Bendt
Maya, Photoshop

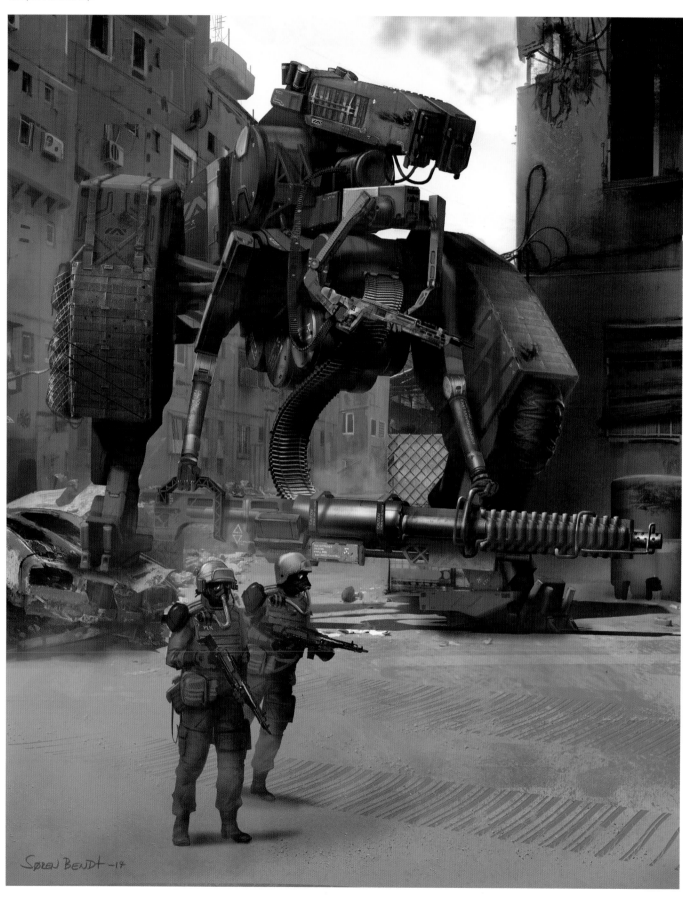

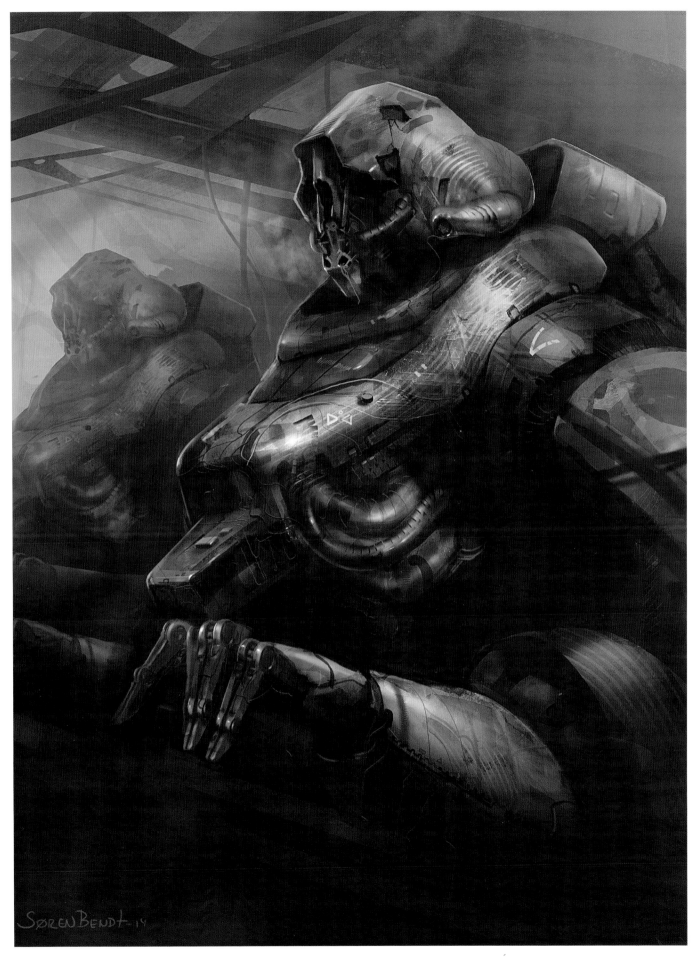

SØREN BENDT '14

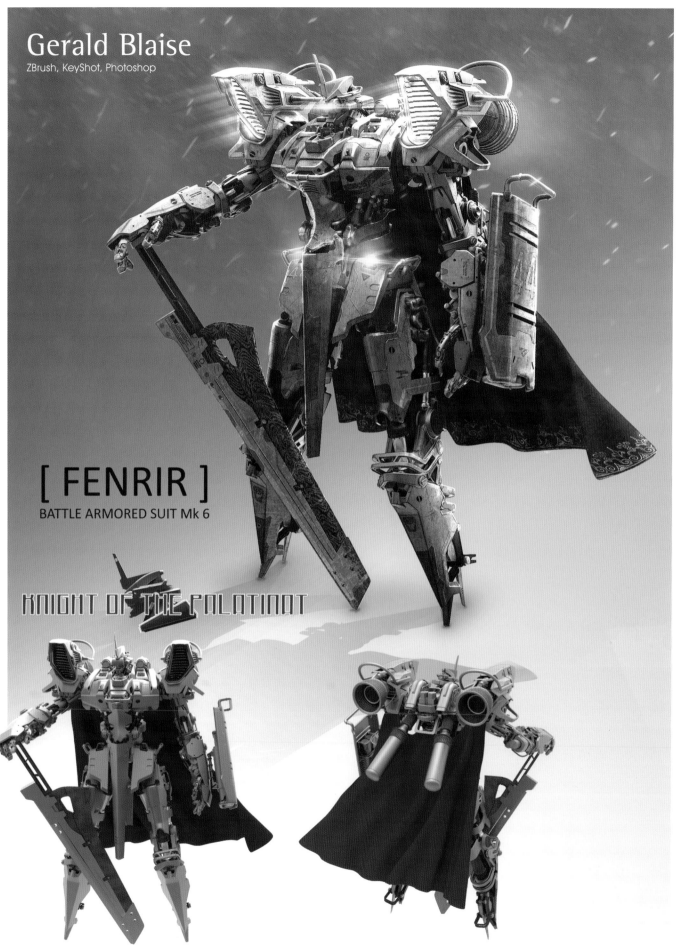

Gerald Blaise
ZBrush, KeyShot, Photoshop

[FENRIR]
BATTLE ARMORED SUIT Mk 6

KNIGHT OF THE PALATINAT

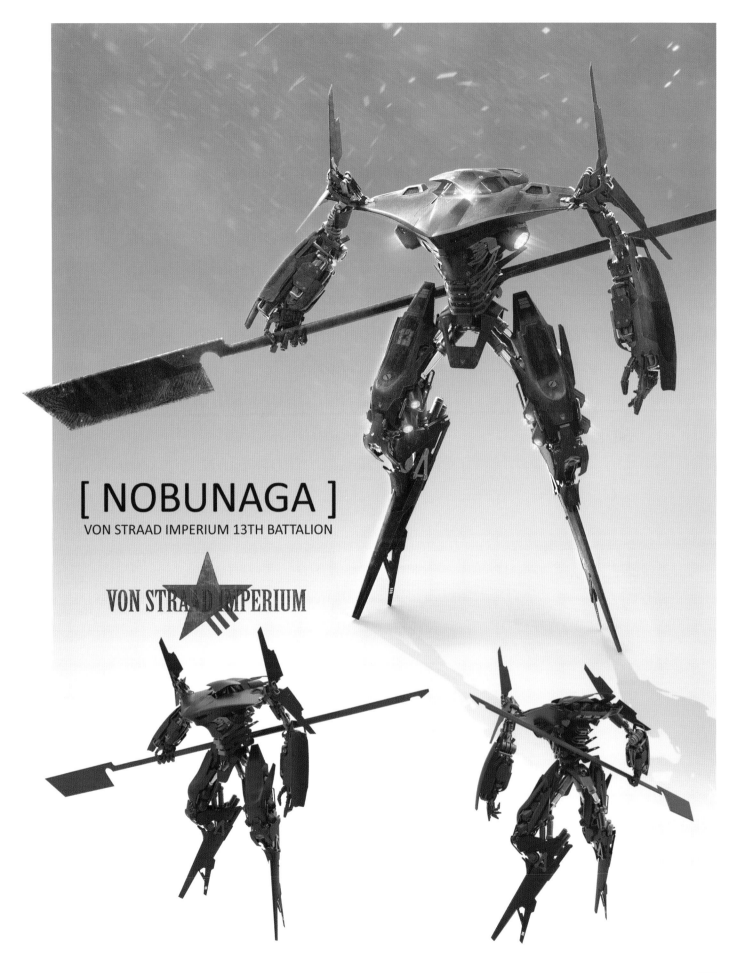

[NOBUNAGA]
VON STRAAD IMPERIUM 13TH BATTALION

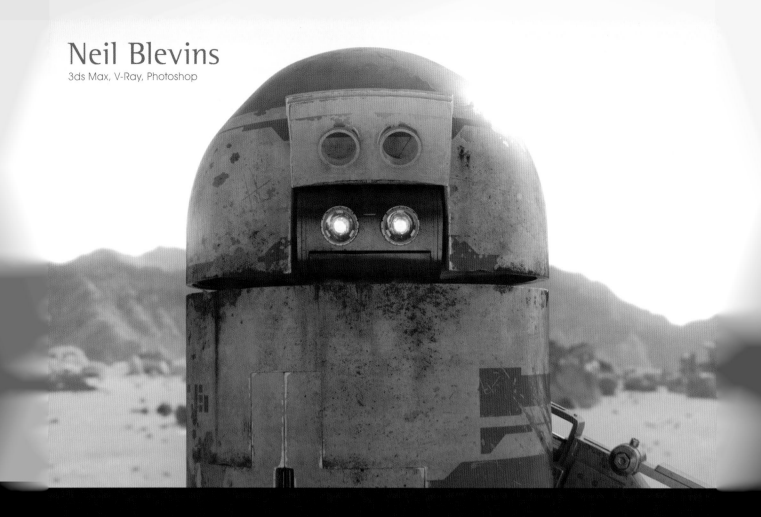

Neil Blevins
3ds Max, V-Ray, Photoshop

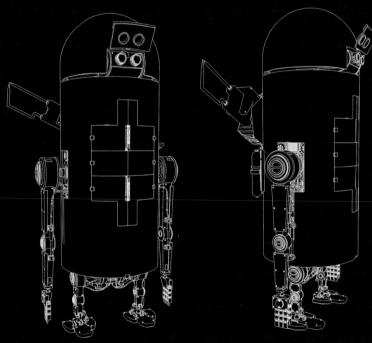

△ I N C △

This robot is from a visual development book project I'm working on called Inc.

In the story, Inc robots were designed as all-purpose construction robots. Different variations were made to handle such tasks as heavy lifting, welding, excavations, demolitions, etc.

With the collapse of the original colony millennia ago, a few Inc units remain wandering the desert. This particular Inc unit was later retrofitted by its human partner, Landis, to handle a very unique task, a task no robot had been asked to perform before.

And that is where our story begins . . .

Neil

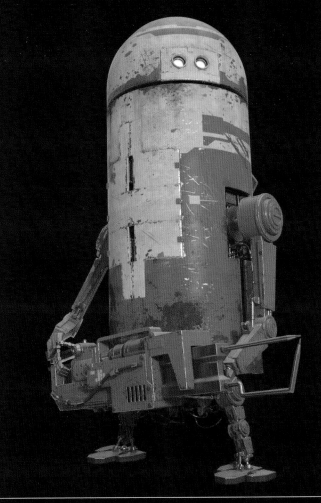
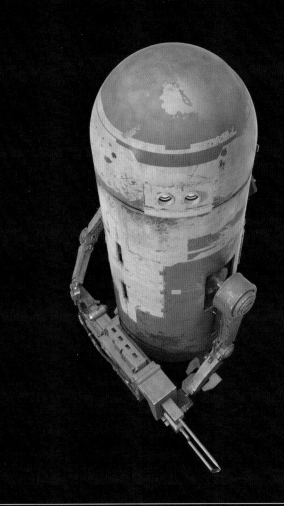
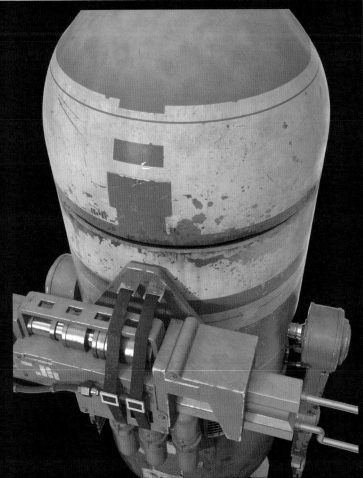
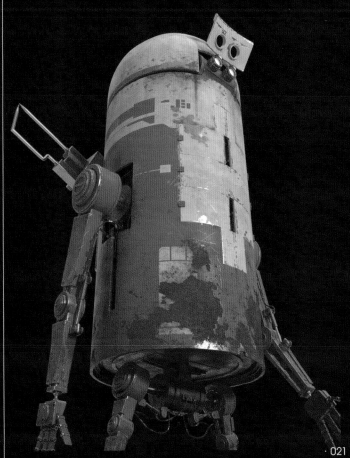

Chris Bonura
Maya, Modo, Photoshop

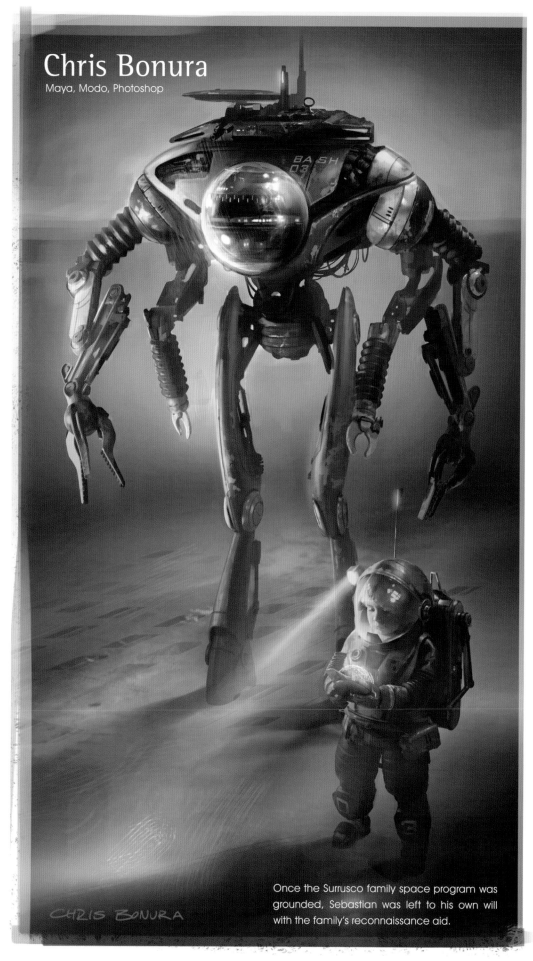

Once the Surrusco family space program was grounded, Sebastian was left to his own will with the family's reconnaissance aid.

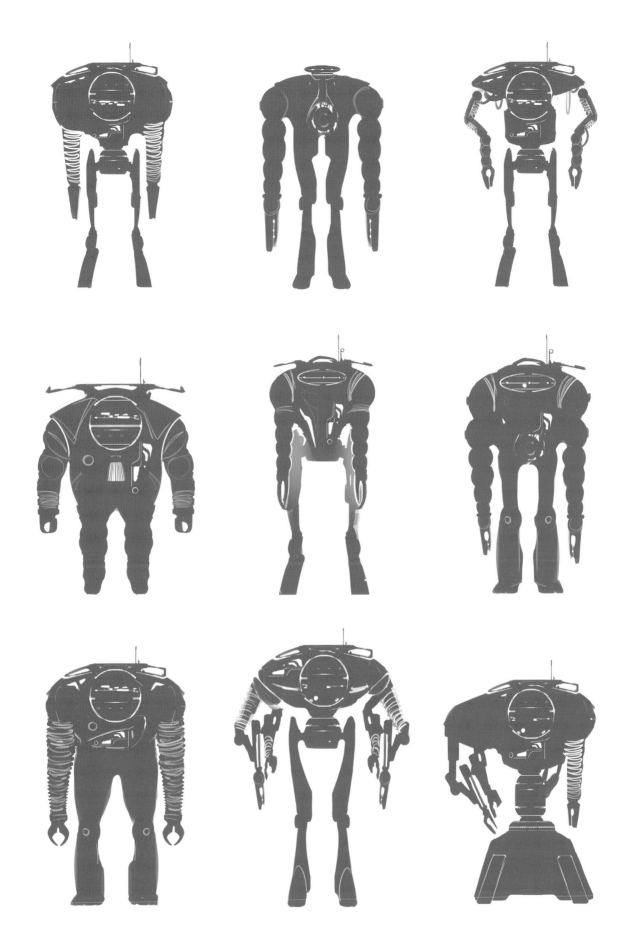

BOT THUMBNAILS

CHRIS BONURA

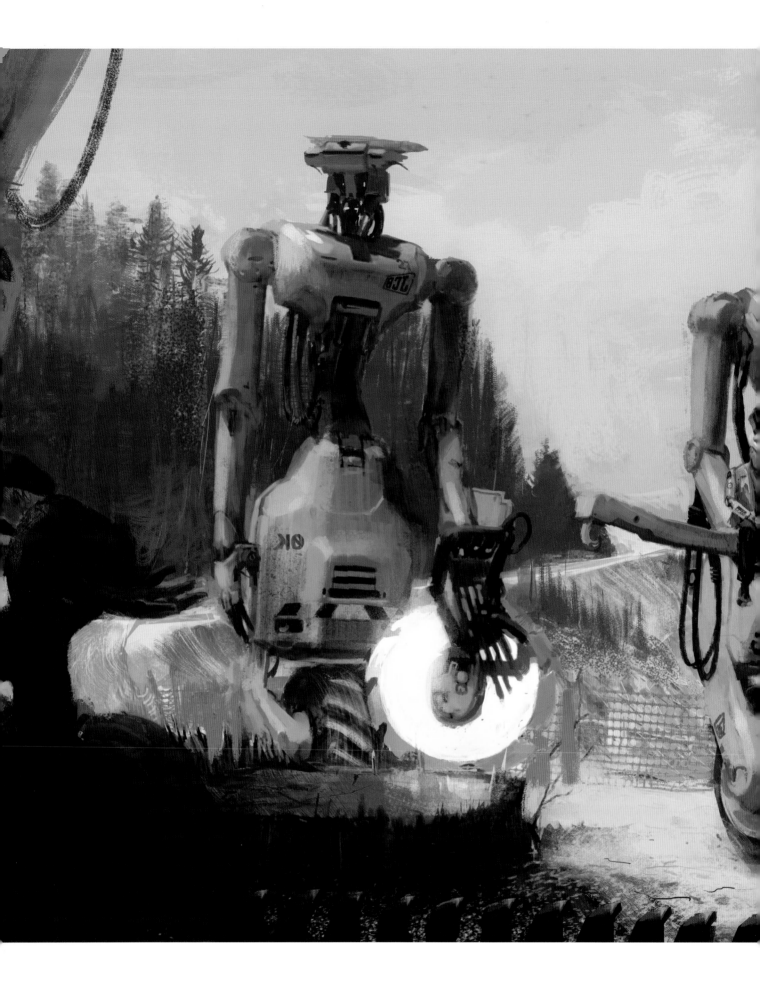

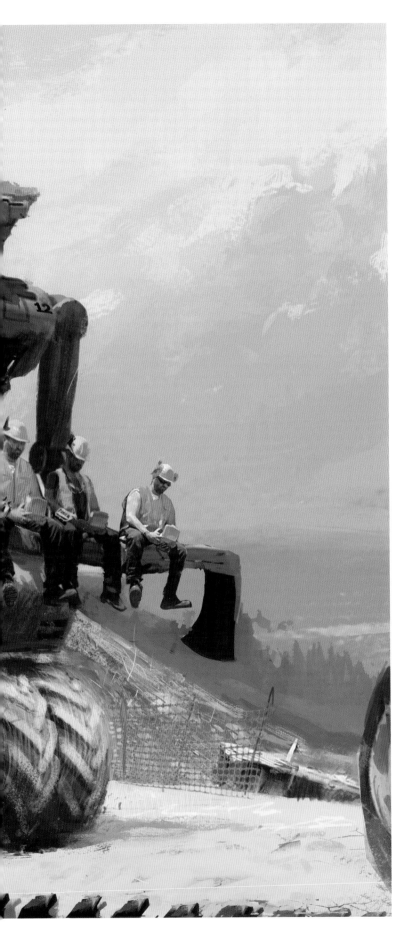

Al Brady

3ds Max, Photoshop

Forestry workers and their human overseers travel from one plantation to another.

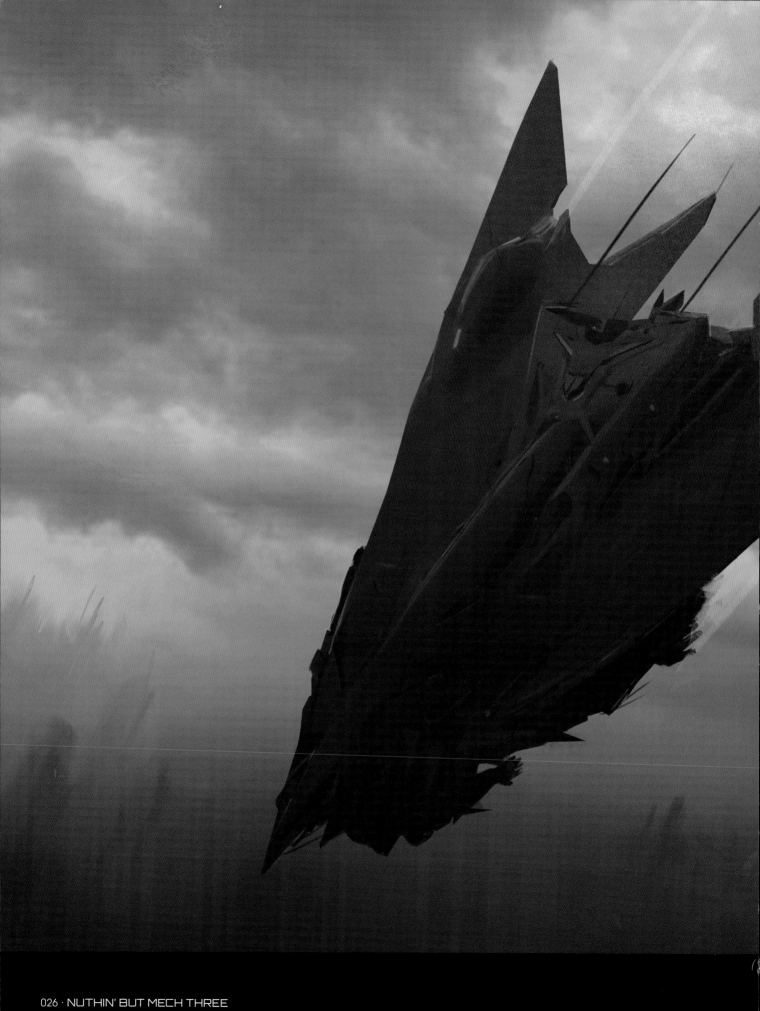

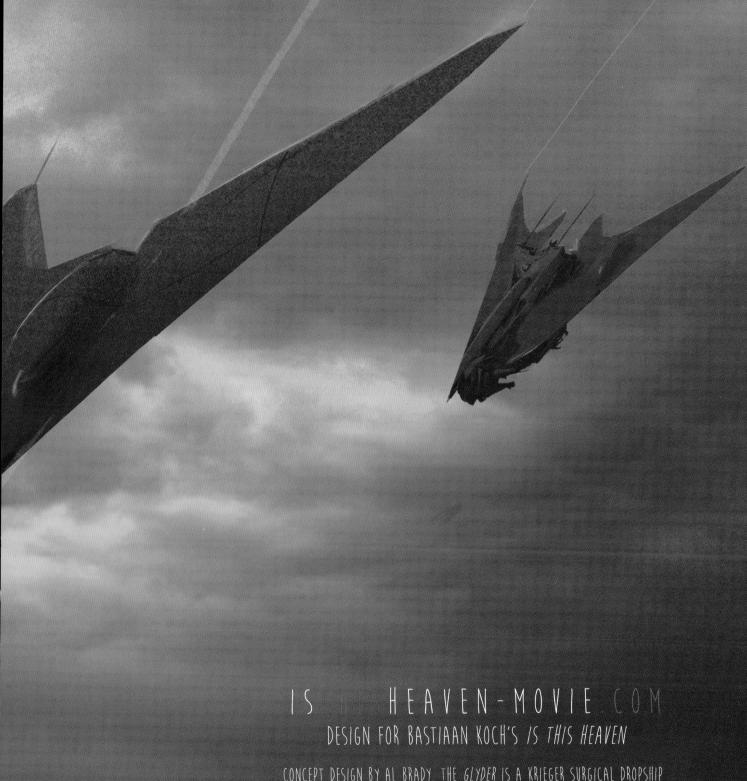

IS HEAVEN-MOVIE.COM
DESIGN FOR BASTIAAN KOCH'S *IS THIS HEAVEN*

CONCEPT DESIGN BY AL BRADY, THE *GLYDER* IS A KRIEGER SURGICAL DROPSHIP
PROPERTY OF MARAUDER FILM LLC 2014

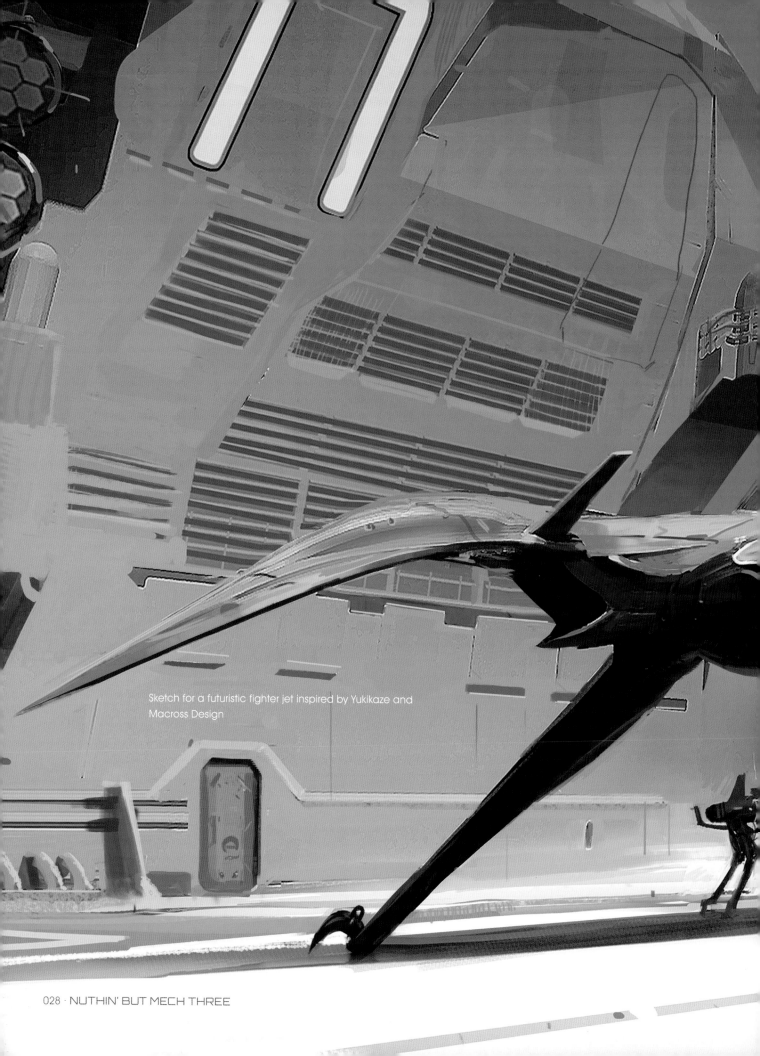

Sketch for a futuristic fighter jet inspired by Yukikaze and
Macross Design

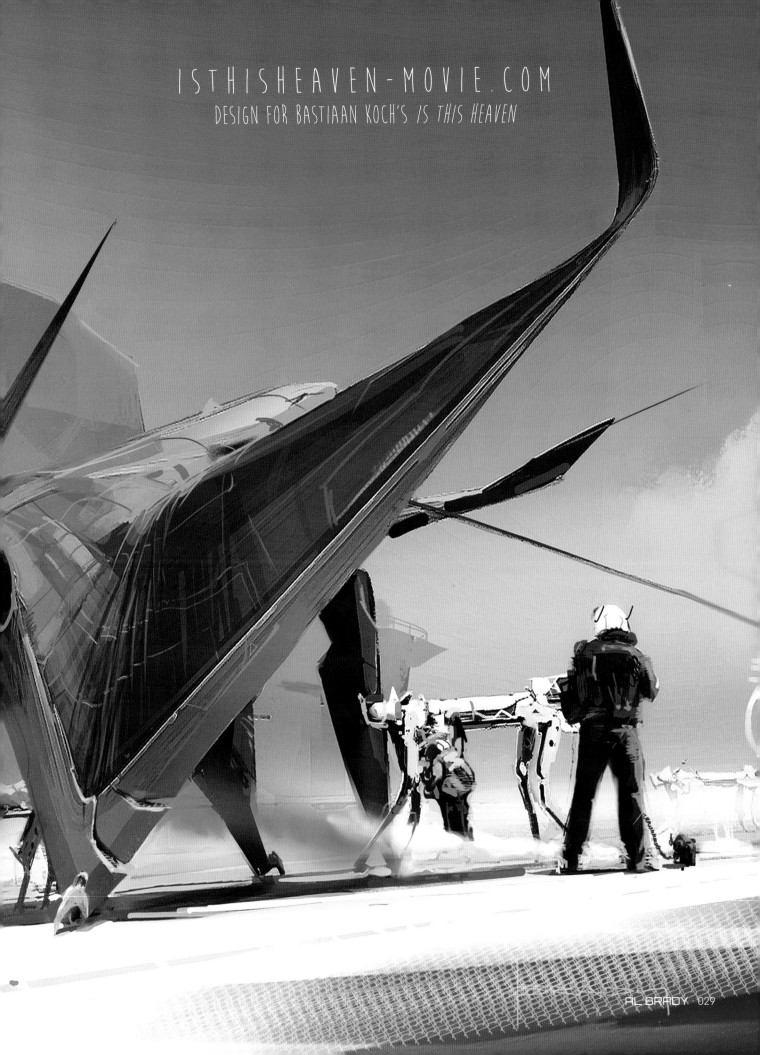

AL BRADY · 029

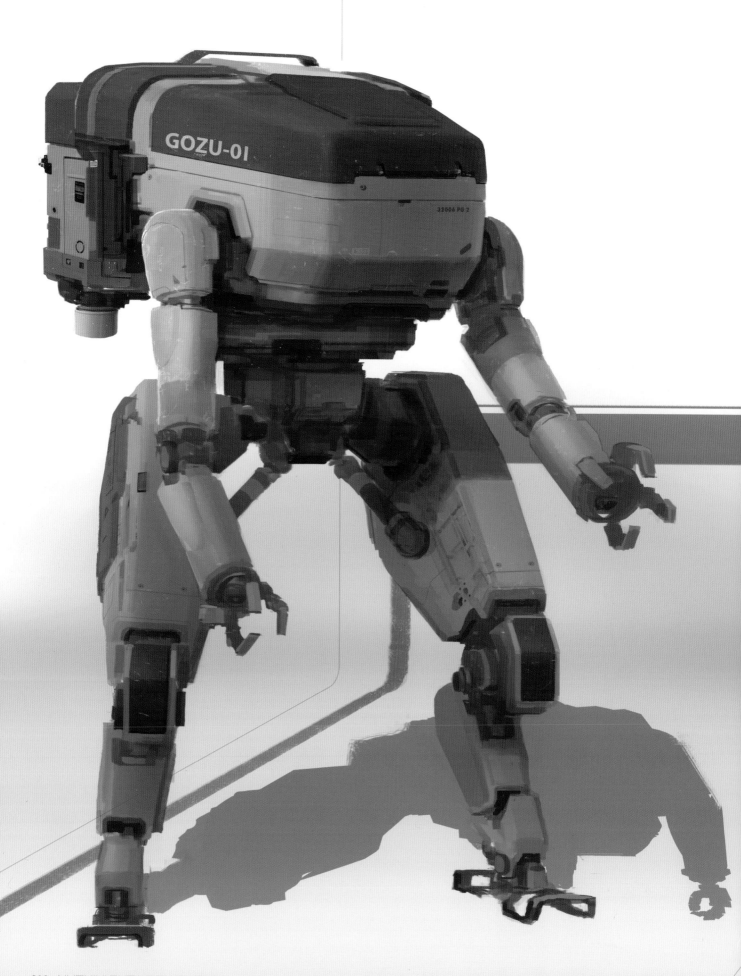

GOZU-01

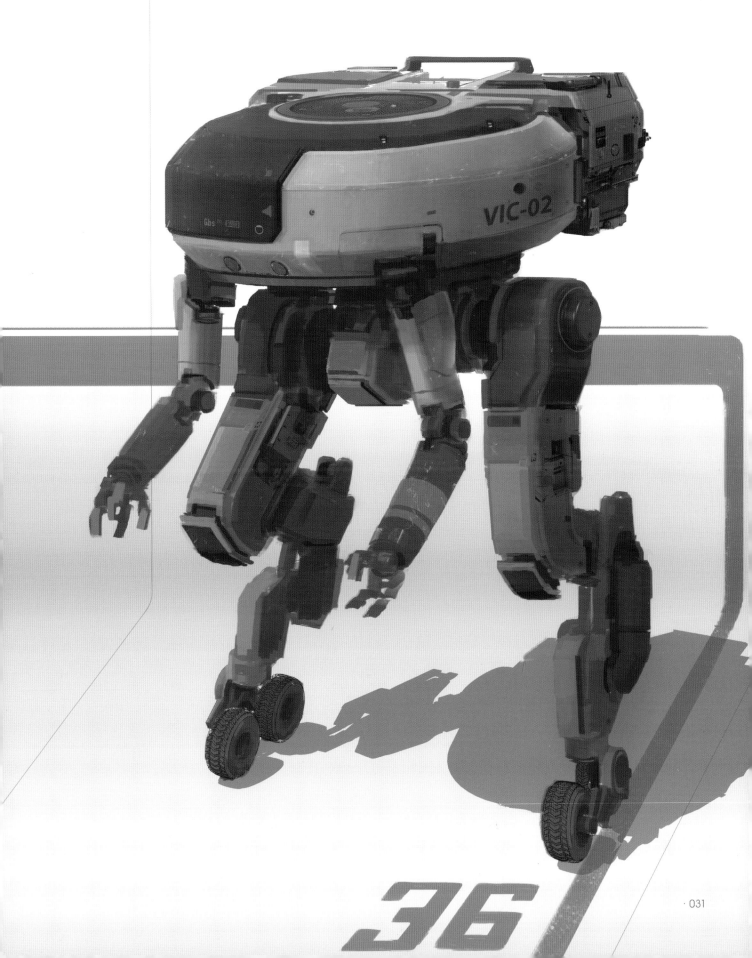

VIC-02

36

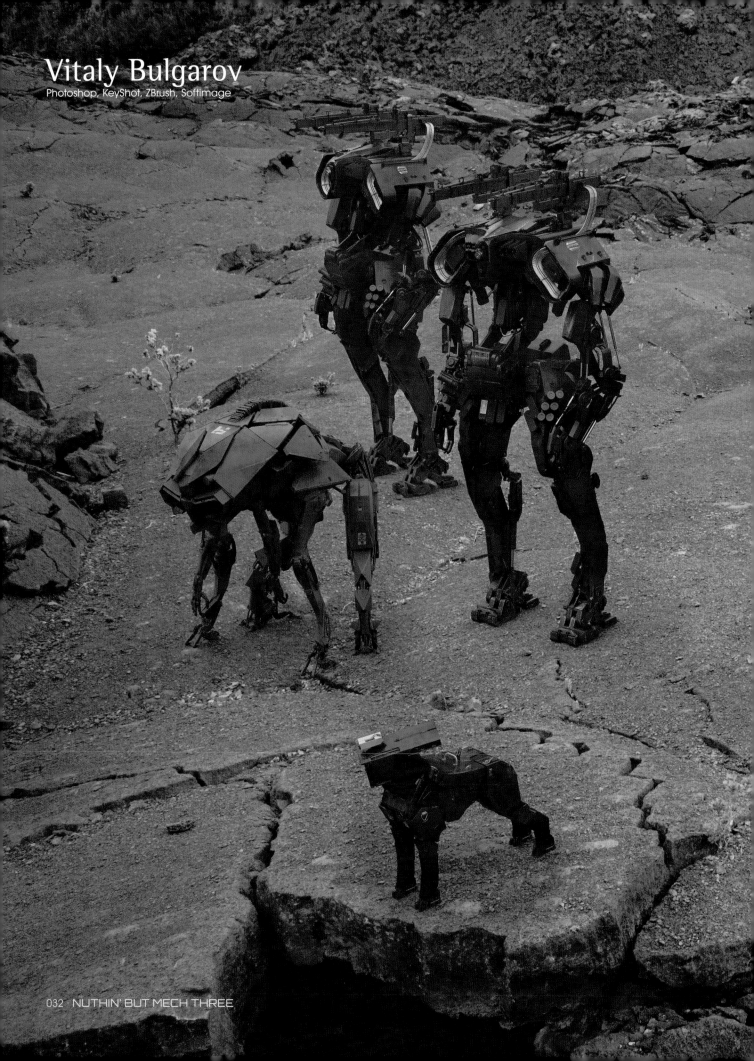

Vitaly Bulgarov
Photoshop, KeyShot, ZBrush, Softimage

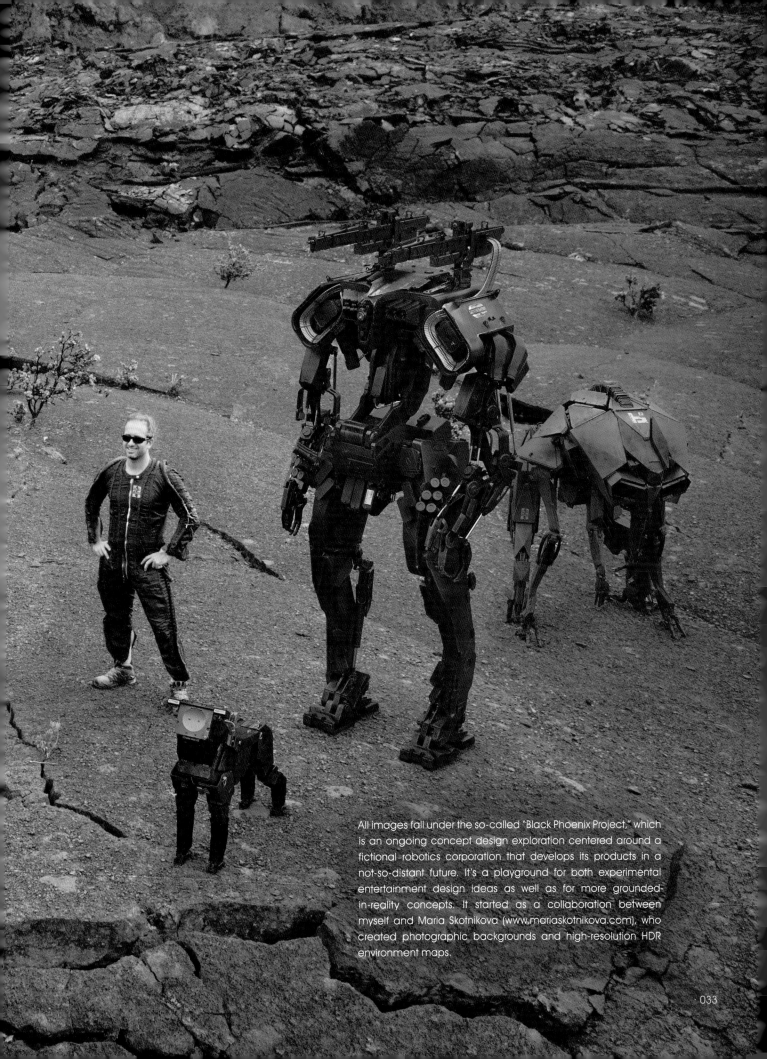

All images fall under the so-called "Black Phoenix Project," which is an ongoing concept design exploration centered around a fictional robotics corporation that develops its products in a not-so-distant future. It's a playground for both experimental entertainment design ideas as well as for more grounded-in-reality concepts. It started as a collaboration between myself and Maria Skotnikova (www.mariaskotnikova.com), who created photographic backgrounds and high-resolution HDR environment maps.

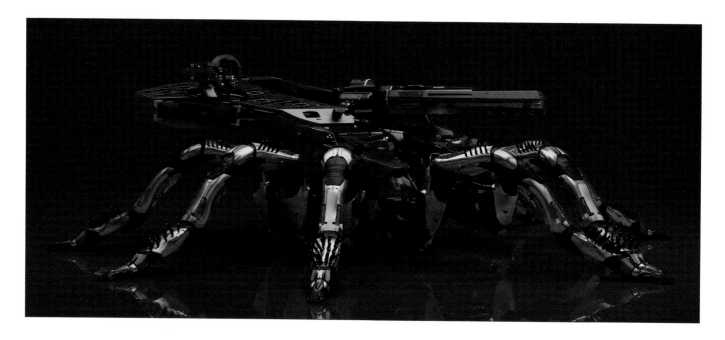

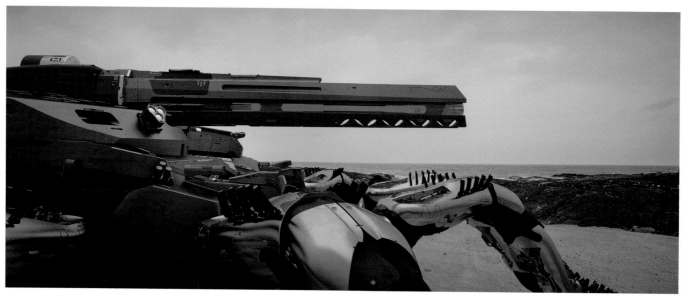

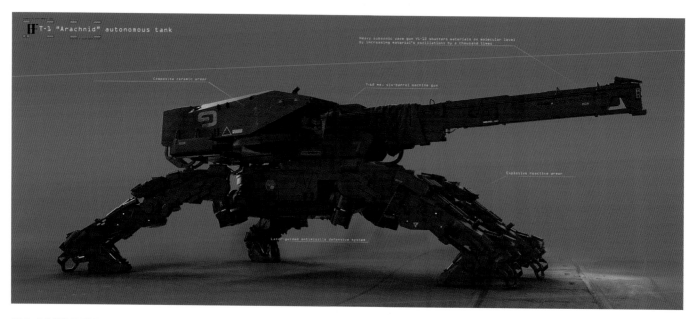

HT-1 "Arachnid" autonomous tank

Heavy subsonic wave gun VL-12 shatters materials on molecular level
by increasing material's oscillations by a thousand times

Composite ceramic armor

7-62 mm. six-barrel machine gun

Explosive reactive armor

Laser-guided antimissile defensive system

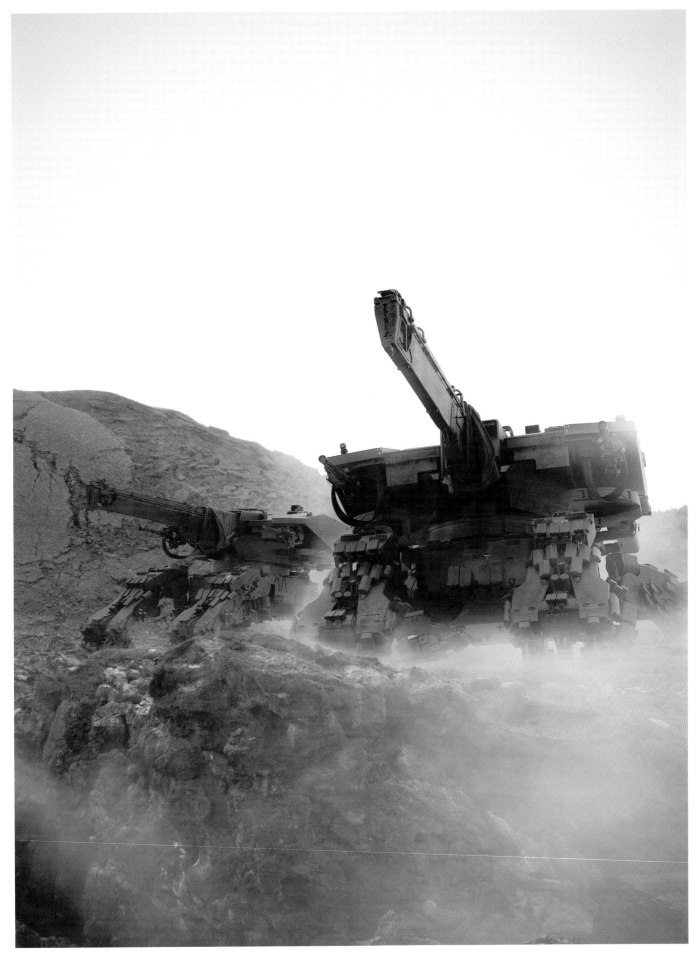

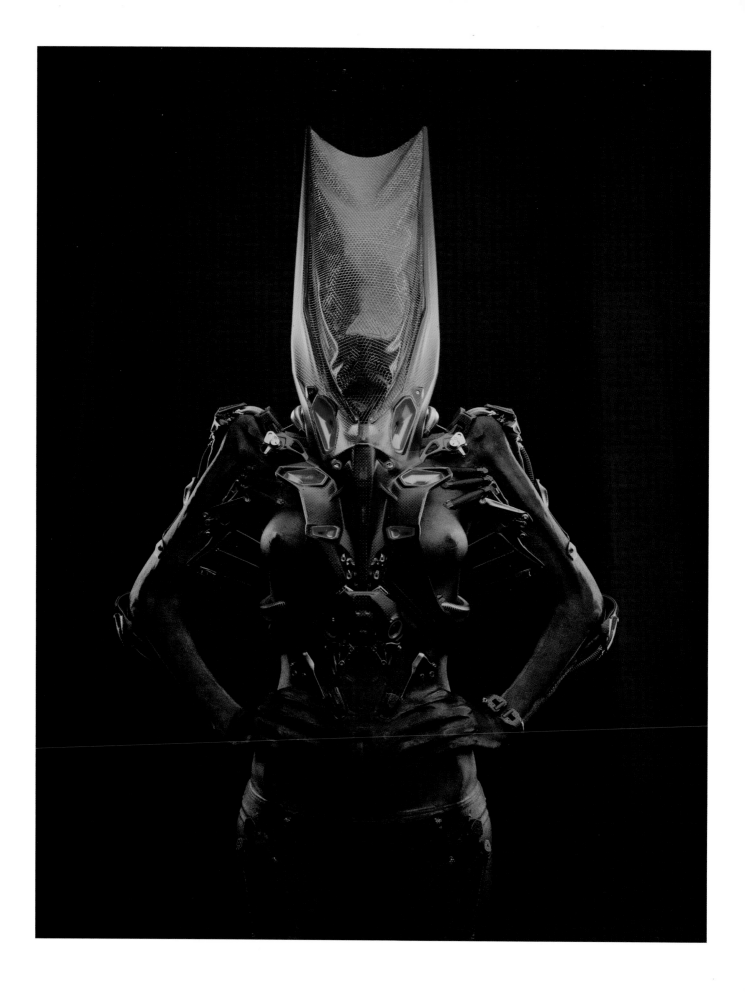

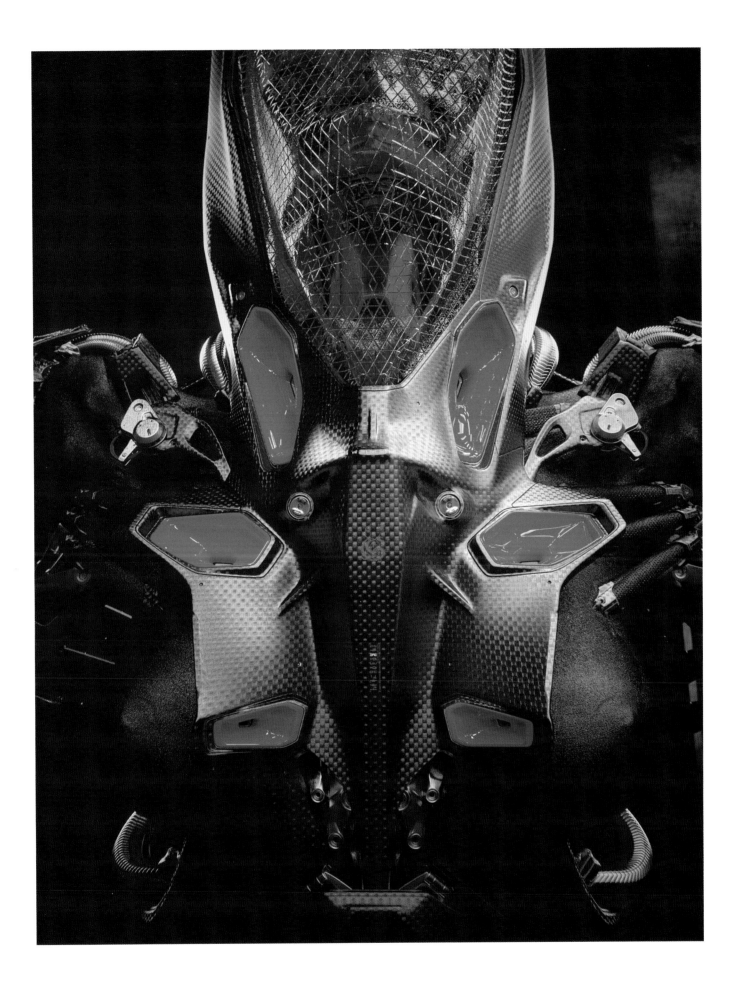

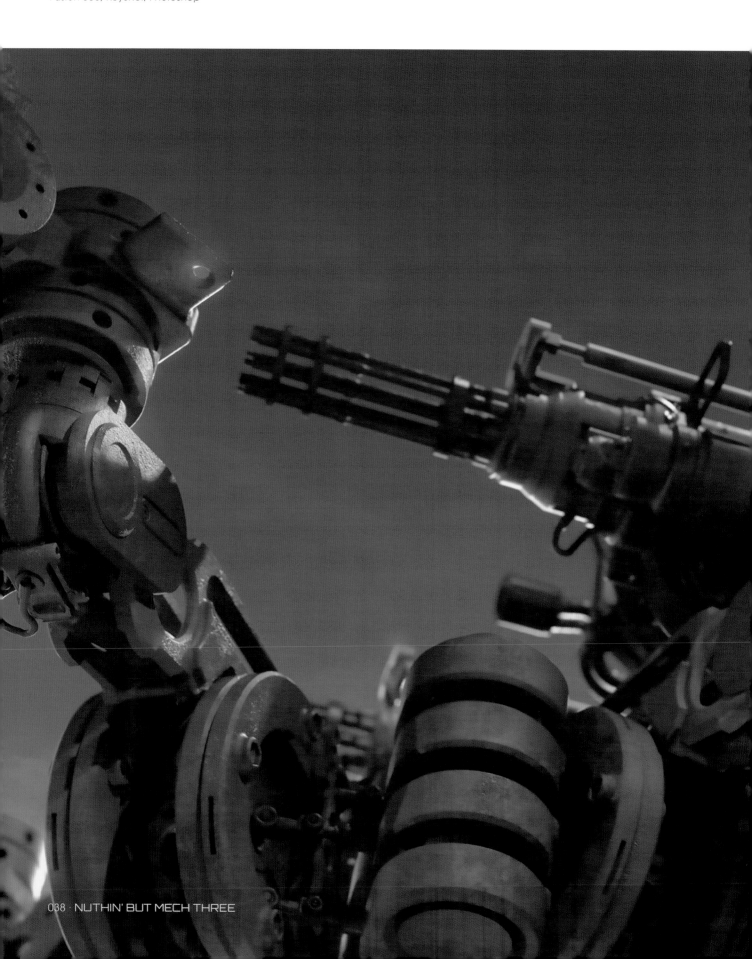

Kirill Chepizhko
Fusion 360, KeyShot, Photoshop

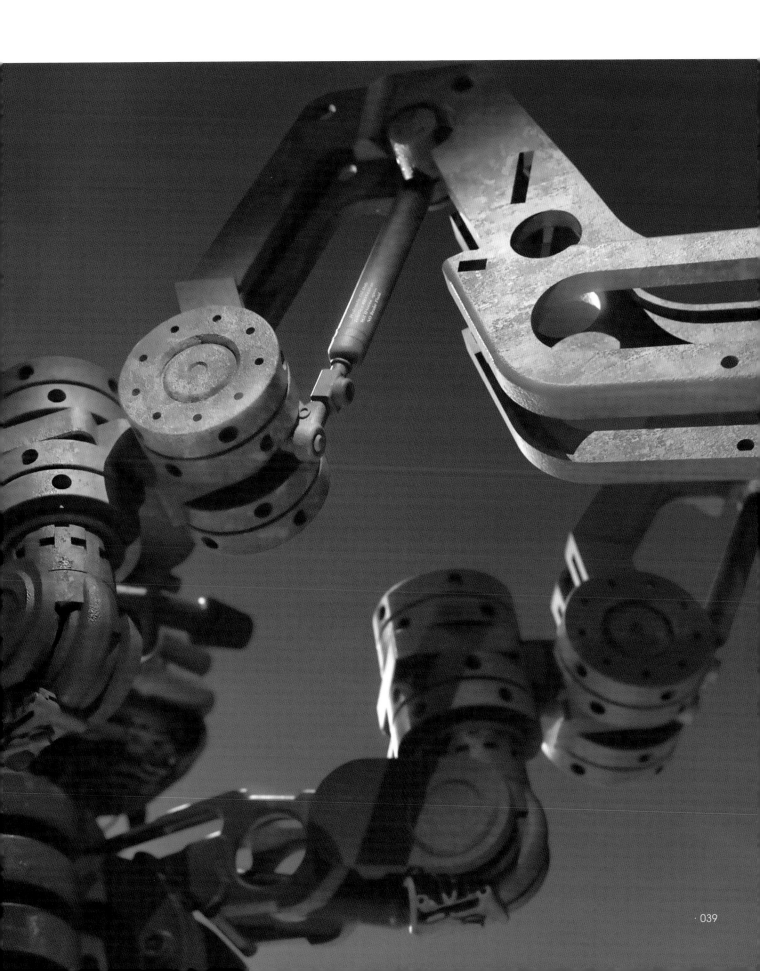

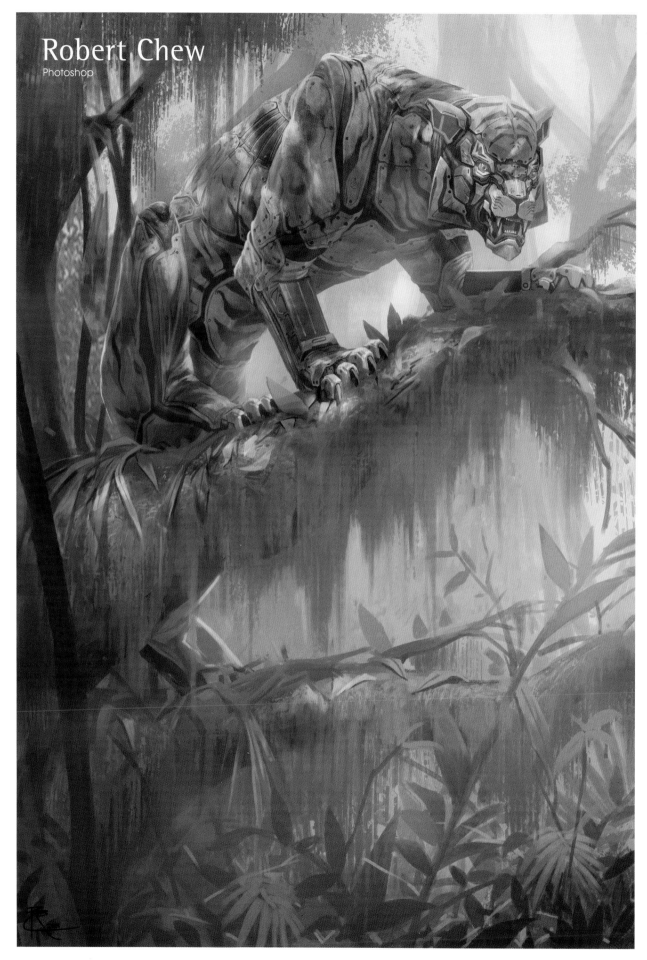

Robert Chew
Photoshop

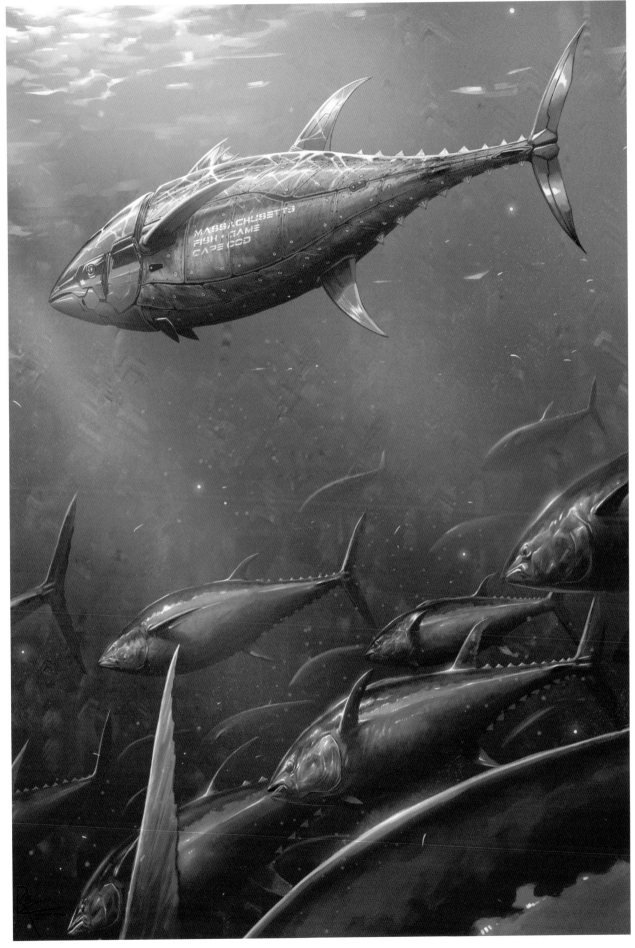

Thierry Doizon
Modo, Photoshop

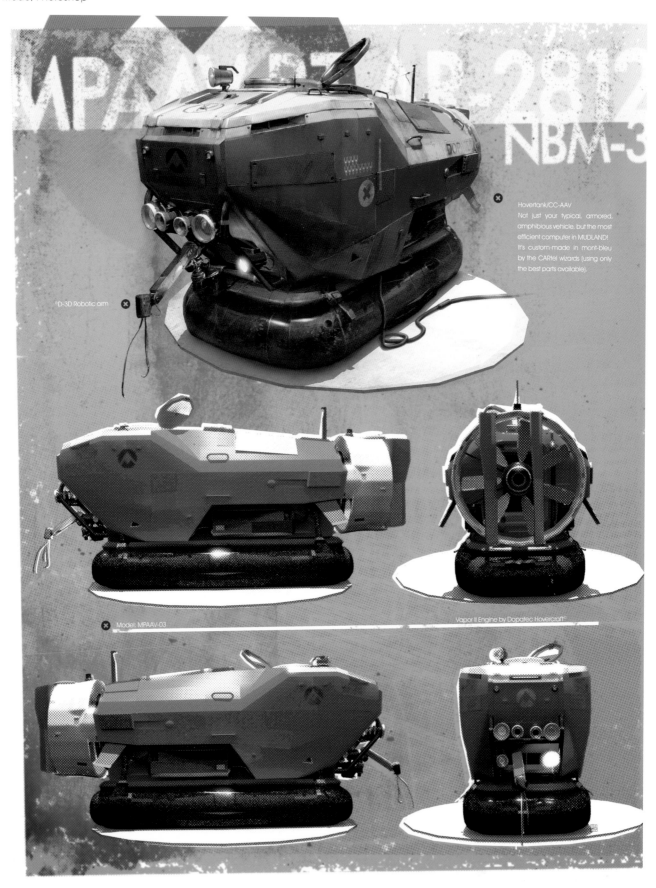

MPAAV-BZ-AR-2812

NBM-3

Hovertank/CC-AAV
Not just your typical, armored, amphibious vehicle, but the most efficient computer in MUDLAND! It's custom-made in mont-bleu by the CARtel wizards (using only the best parts available).

"D-3D Robotic arm

Model: MPAAV-03

Vapor II Engine by Dopatec Hovercraft®

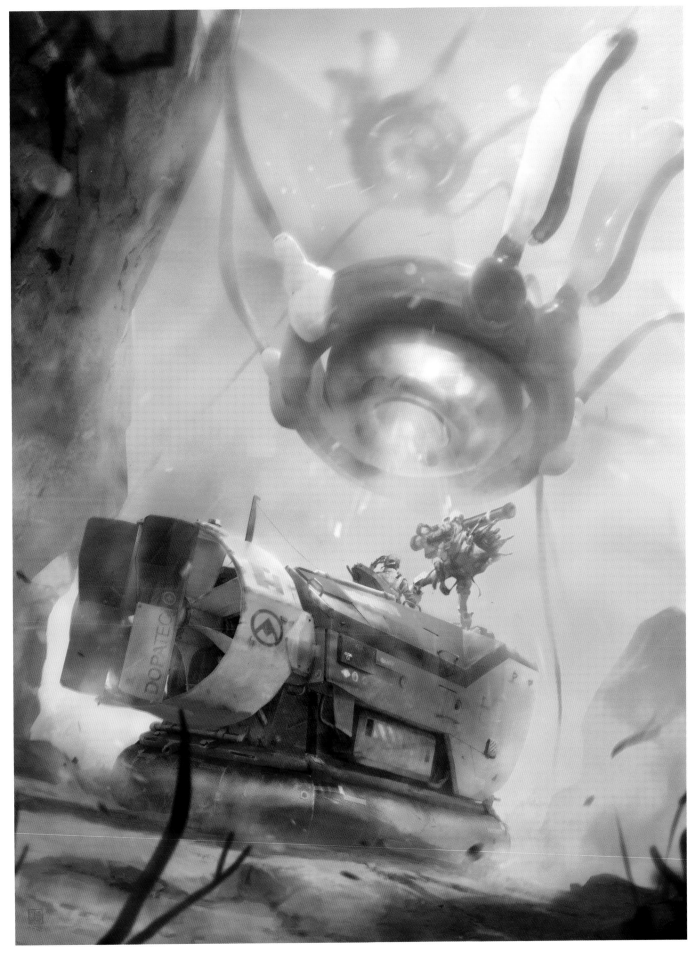

TyRuben Ellingson
SketchUp, KeyShot

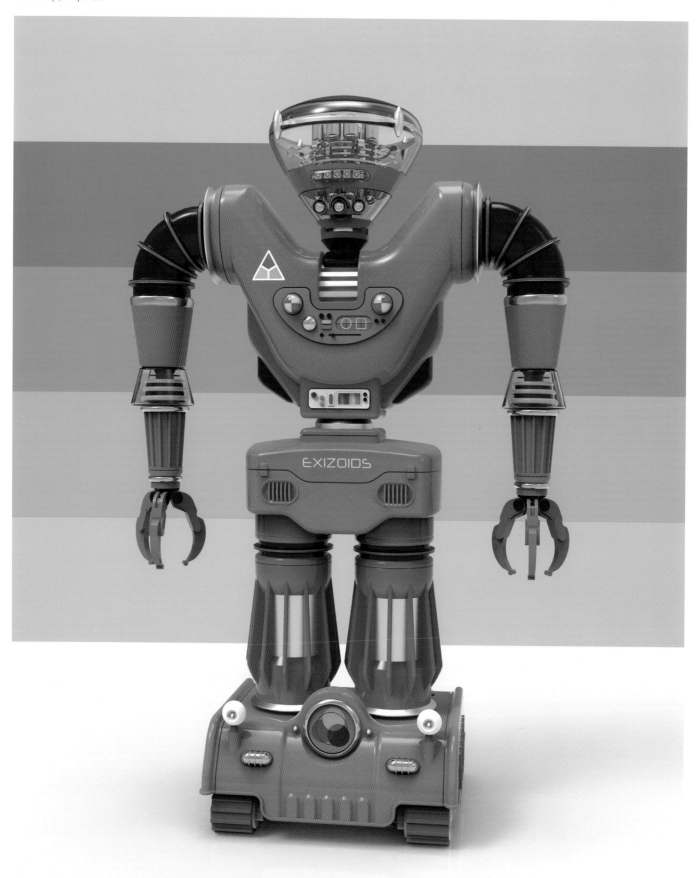

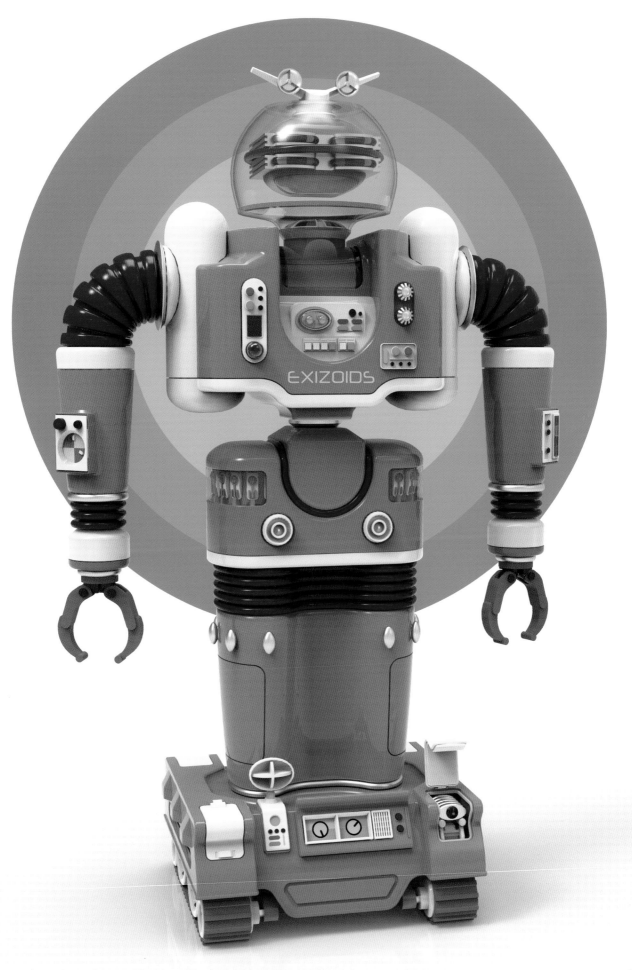

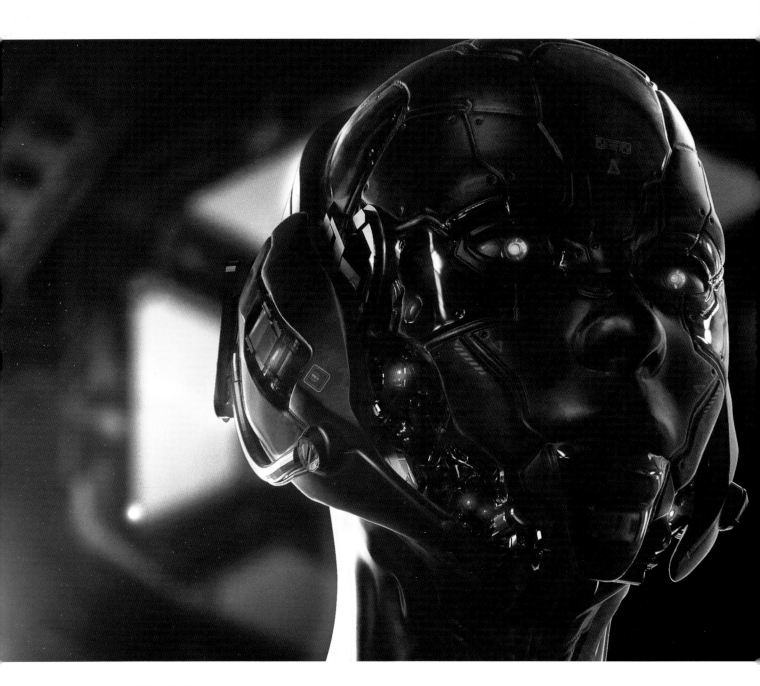

Justin Fields
ZBrush, Photoshop, KeyShot

J.FIELDS
IRONKLAD
S T U D I O S

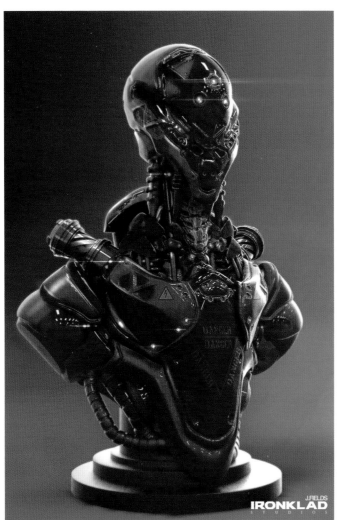

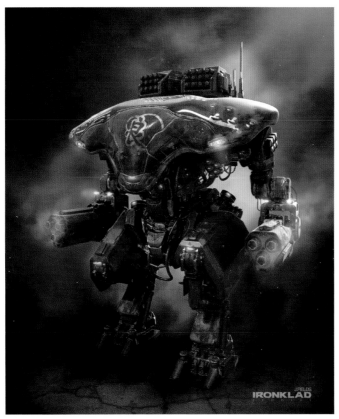

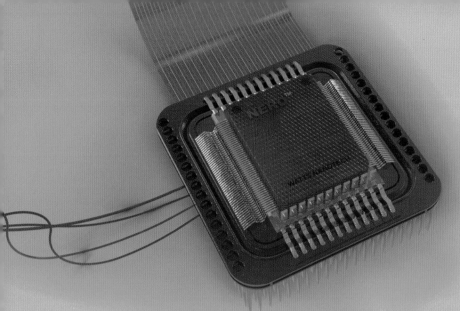

BASED ON
NERO A9
PROCESSOR FAMILY

IMPROVED
DECISION-MAKING
IN CRITICAL GOVERNMENT AND MILITARY OPERATIONS

KESTREL™

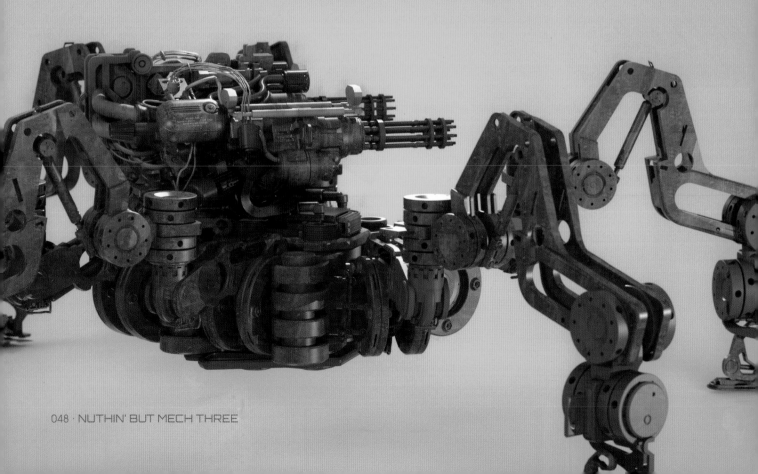

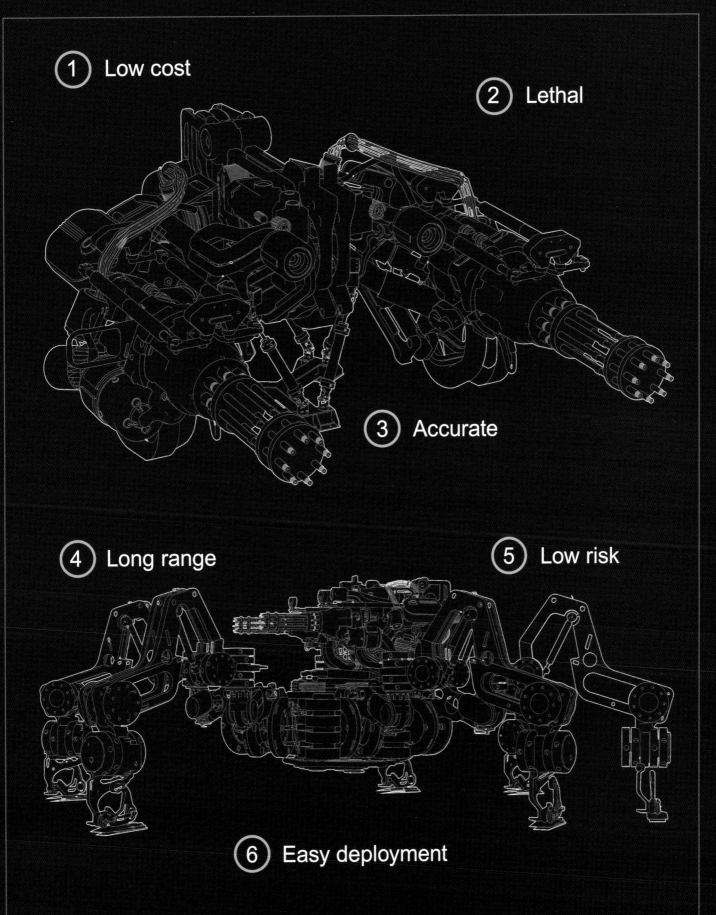

① Low cost

② Lethal

③ Accurate

④ Long range

⑤ Low risk

⑥ Easy deployment

JUSTIN FIELDS · 049

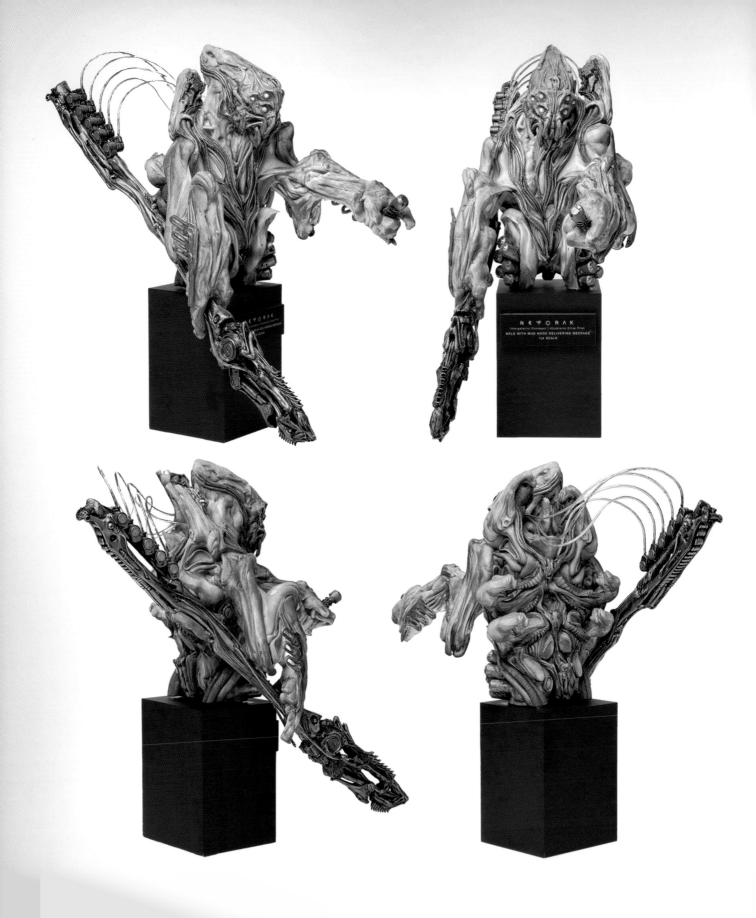

NEFORAK
Intergalactic Concept | Alcubierre Drive Pilot
MALE WITH MUD HOOK DELIVERING MESSAGE
1/4 SCALE

N E °F ⊙ R Λ K

MALE WITH MUD HOOK DELIVERING MESSAGE

Landis Fields

Maya, Mudbox, ZBrush, NextEngine, Stratasys

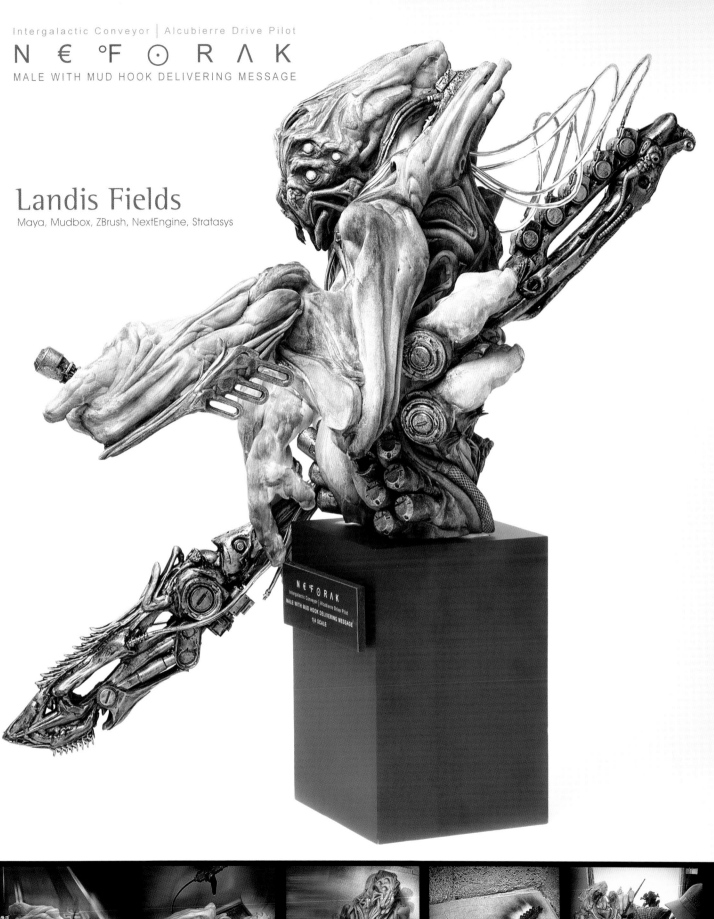

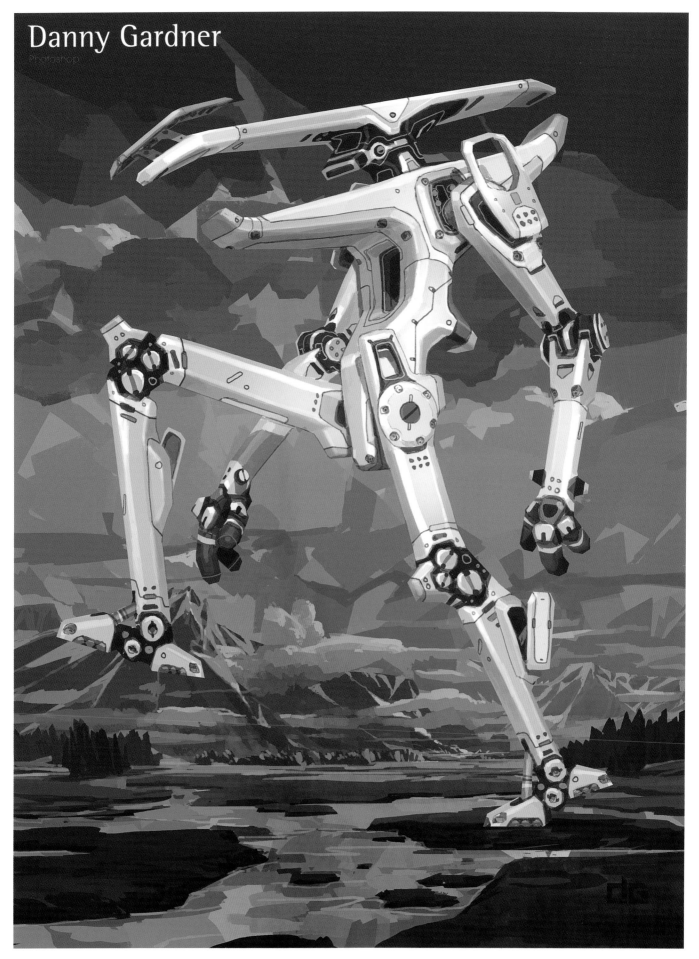

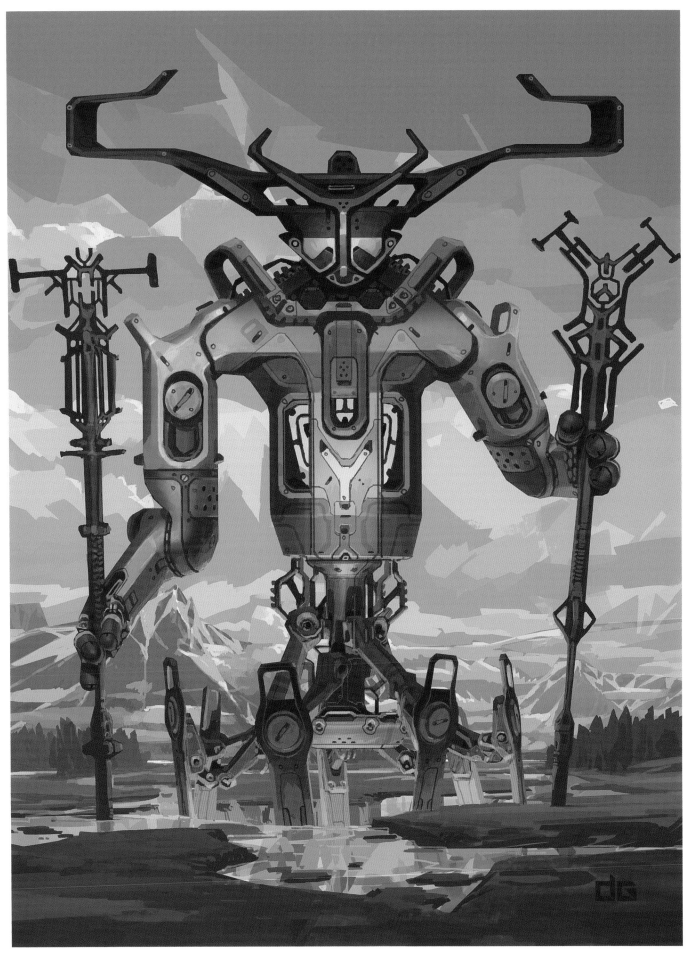

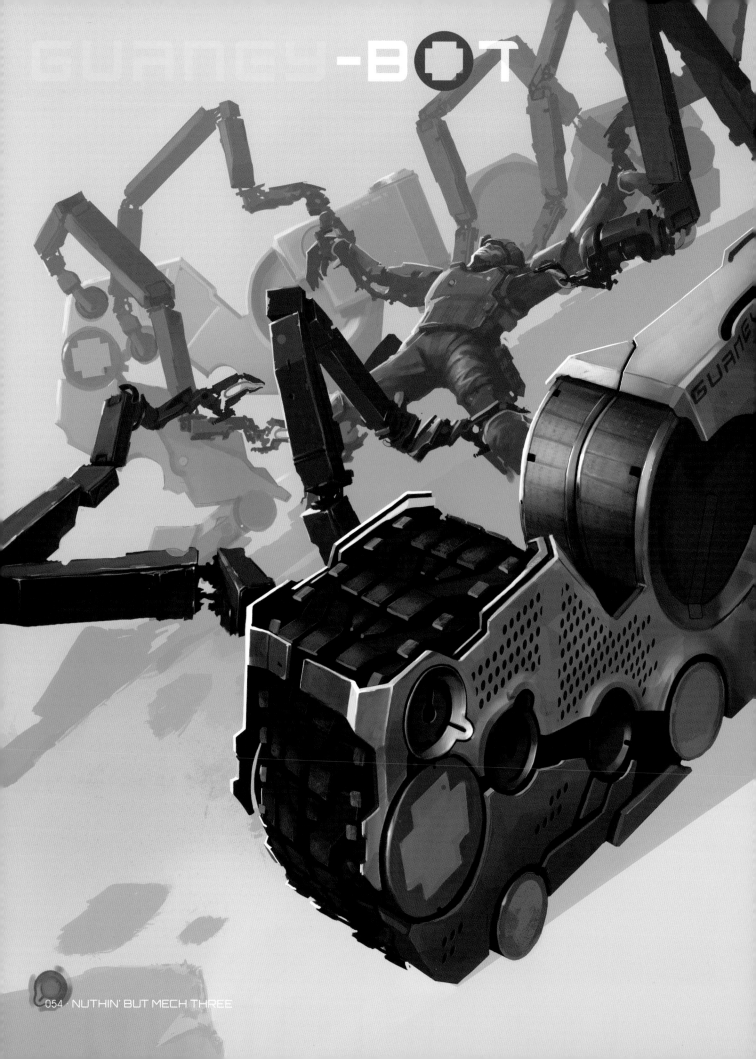

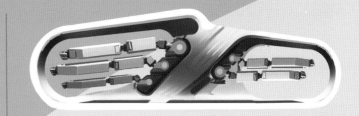
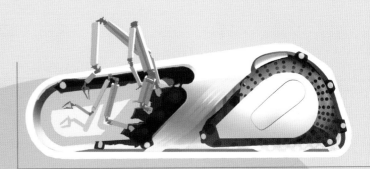
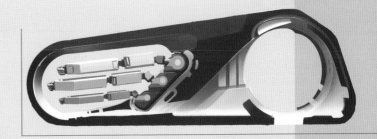
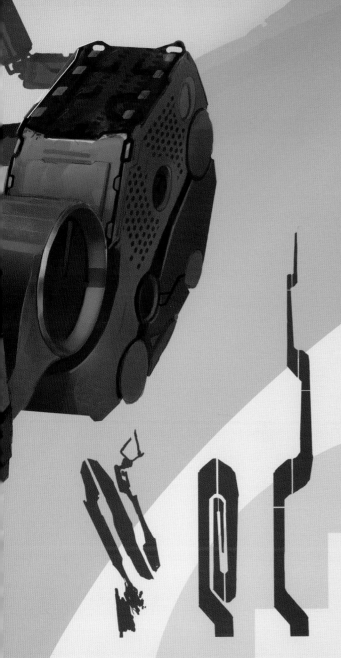
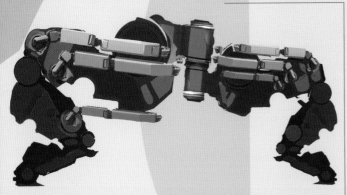
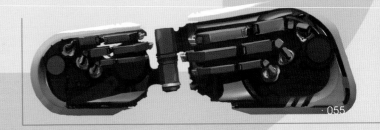

Edon Guraziu

Maya, ZBrush, Marvelous Designer, KeyShot, Photoshop

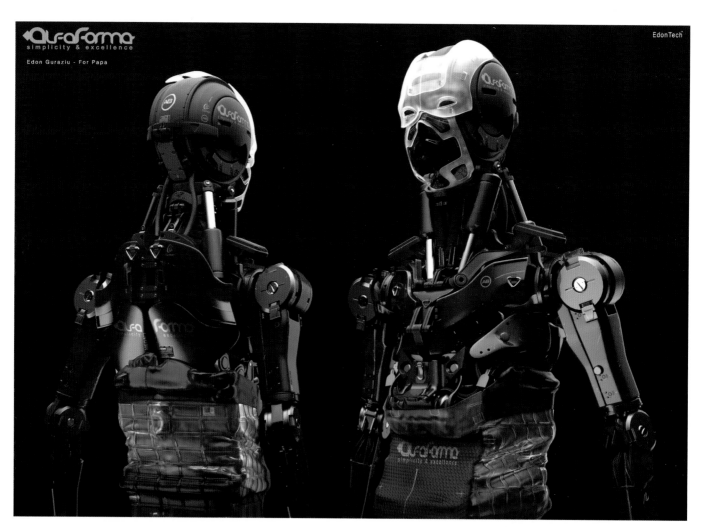

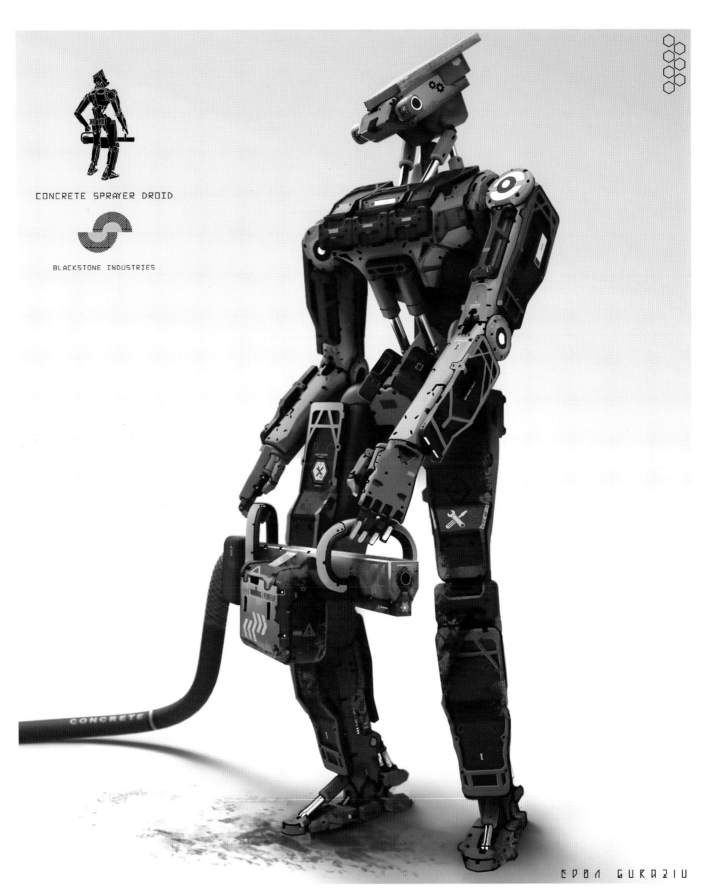

CONCRETE SPRAYER DROID

BLACKSTONE INDUSTRIES

EDON GURAZIU

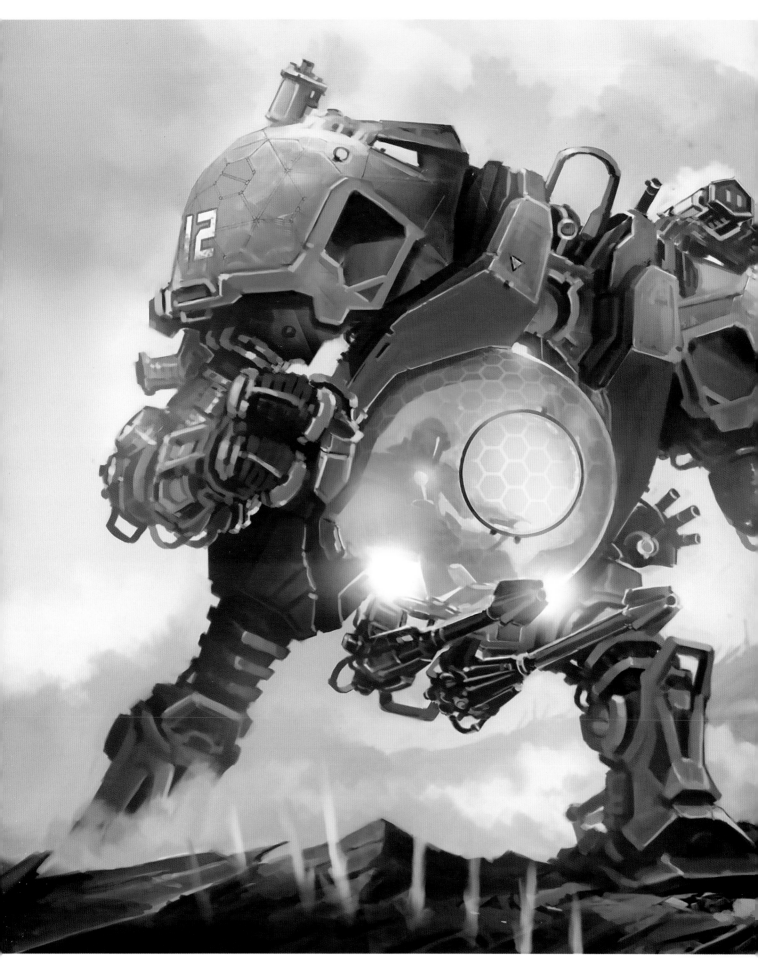

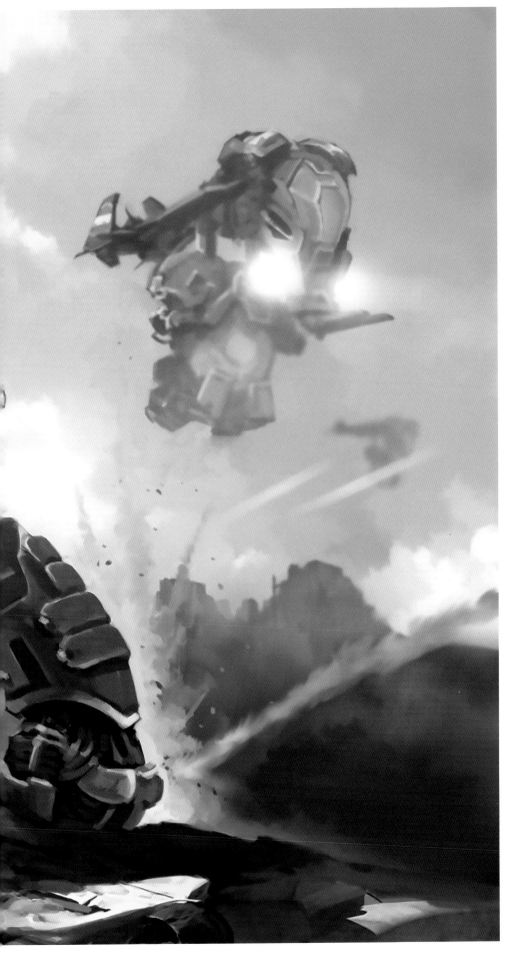

Patrick Hanenberger

Pen, marker, Modo, Photoshop

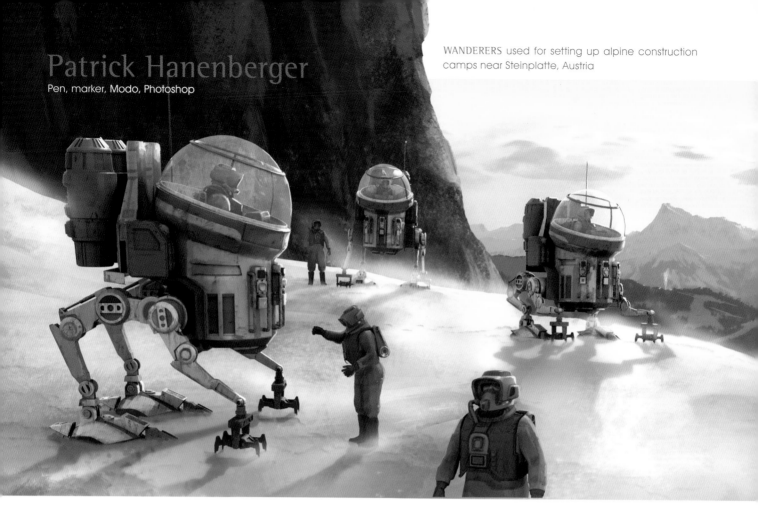

Wanderer

Two of my favorite things in the world are skiing in Austria and the art of Ralph McQuarrie and Joe Johnston. With the Wanderer, I attempt to pay homage to these two things. Along the German-Austrian border lies the area of Tirol with its breathtaking views, incredible food, and great skiing. As a kid we came here many times a year. Always in my backpack I carried a selection of science-fiction toys, many of them based on the designs of McQuarrie and Johnston. Now that I get to work as a concept artist for a living, I am grateful for how much inspiration these childhood experiences have brought me.

Patrick Hanenberger

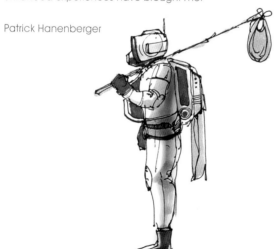

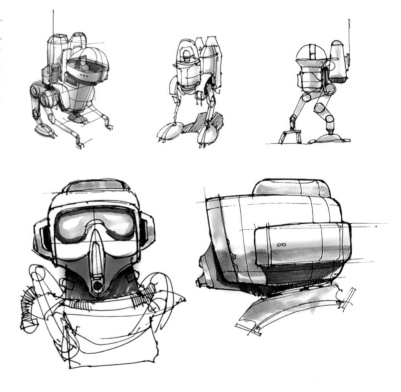

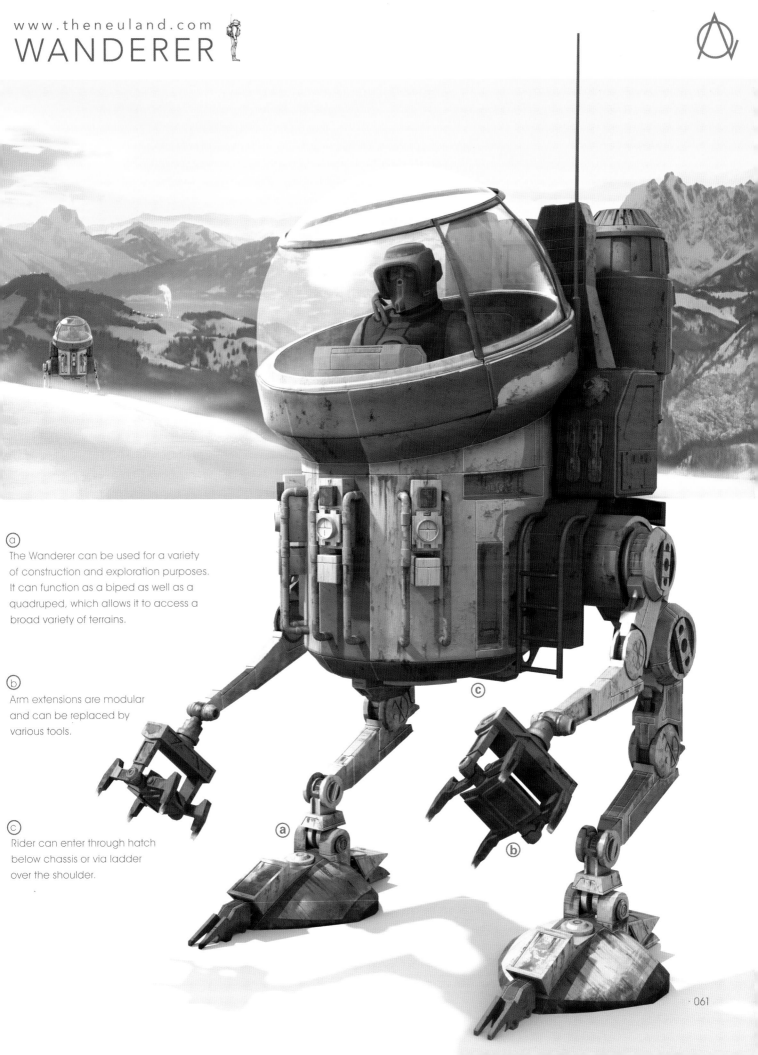

(a)

The Wanderer can be used for a variety of construction and exploration purposes. It can function as a biped as well as a quadruped, which allows it to access a broad variety of terrains.

(b)

Arm extensions are modular and can be replaced by various tools.

(c)

Rider can enter through hatch below chassis or via ladder over the shoulder.

Eric Joyner

Pencil, oil on board

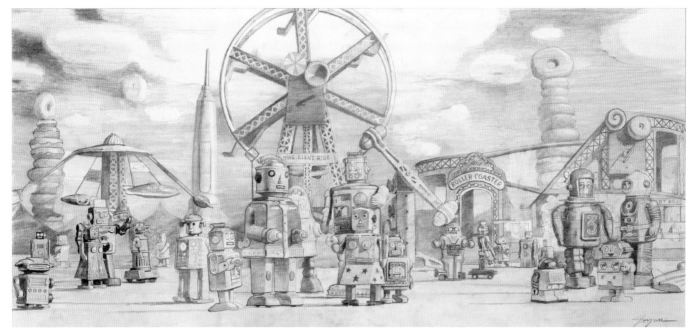

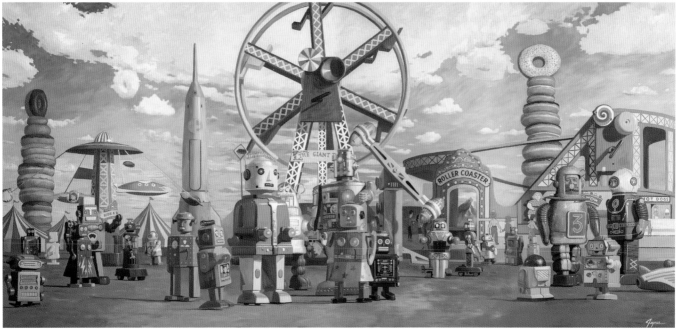

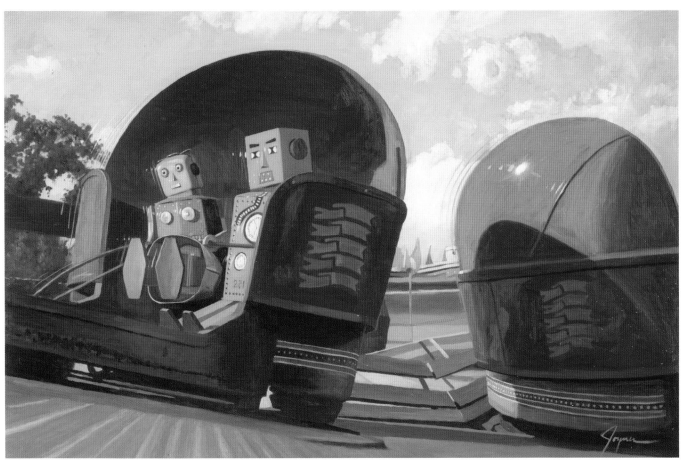

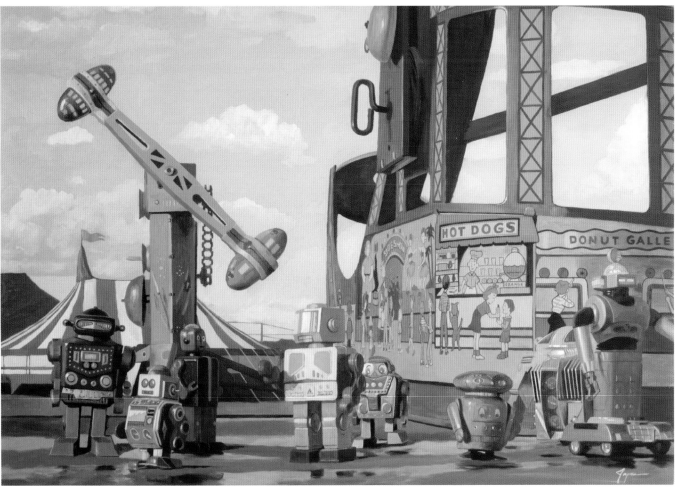

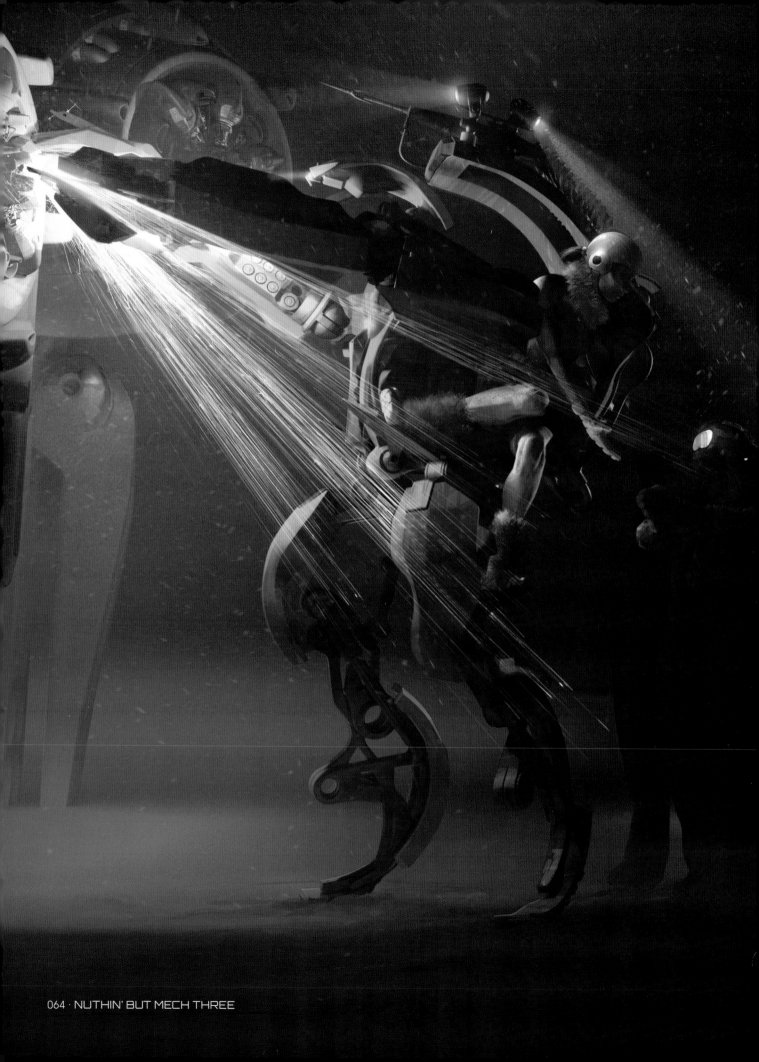

Kurt Kaufman
Pen, Maya, V-Ray, Photoshop

Ara Kermanikian

Maya, ZBrush, KeyShot, Photoshop

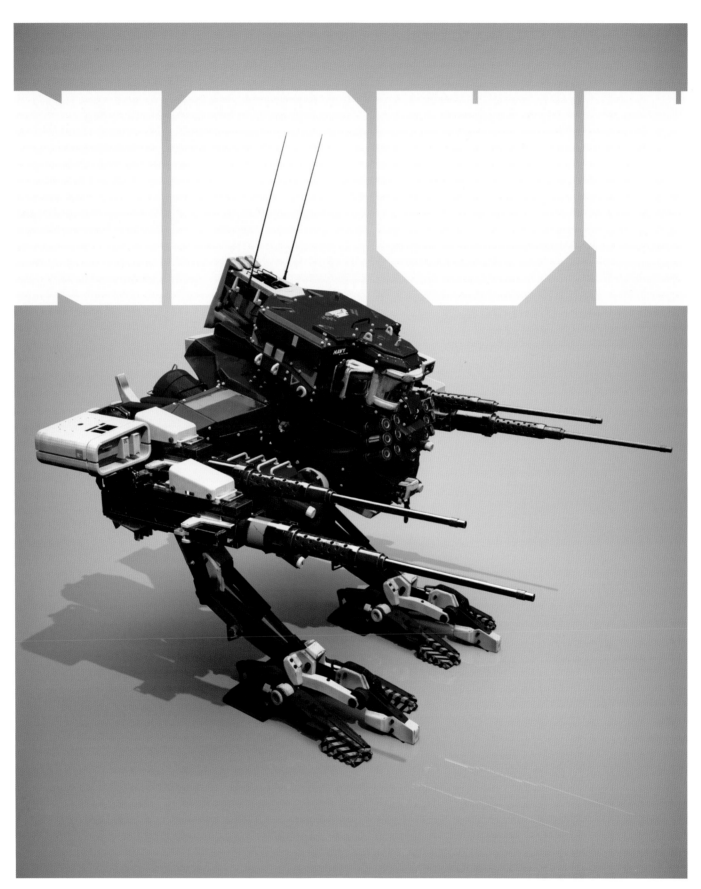

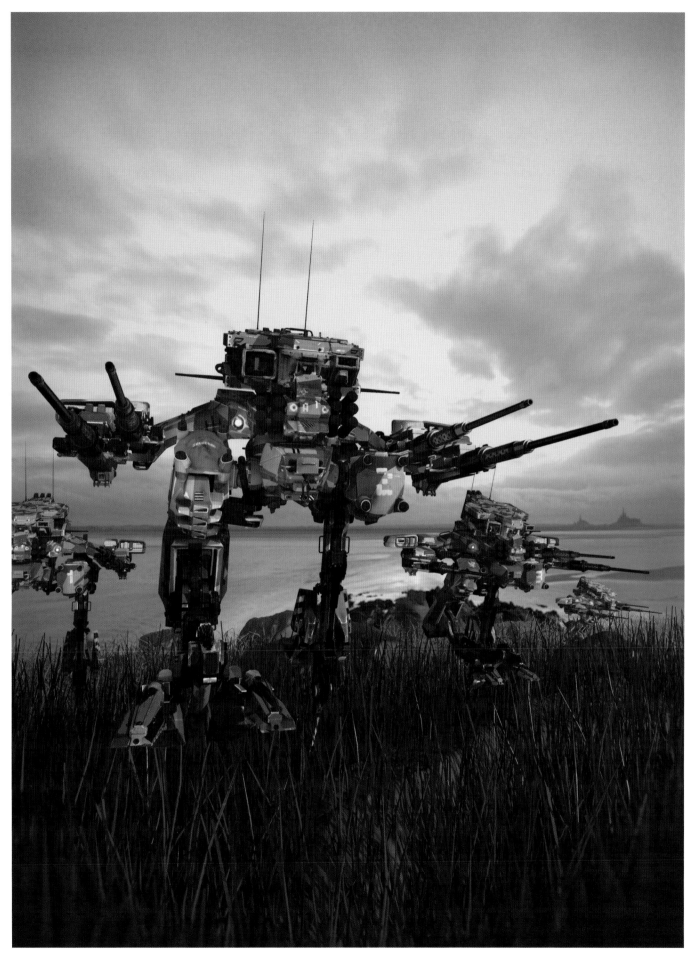

Gavriil Klimov
Fusion 360, 3ds Max, KeyShot

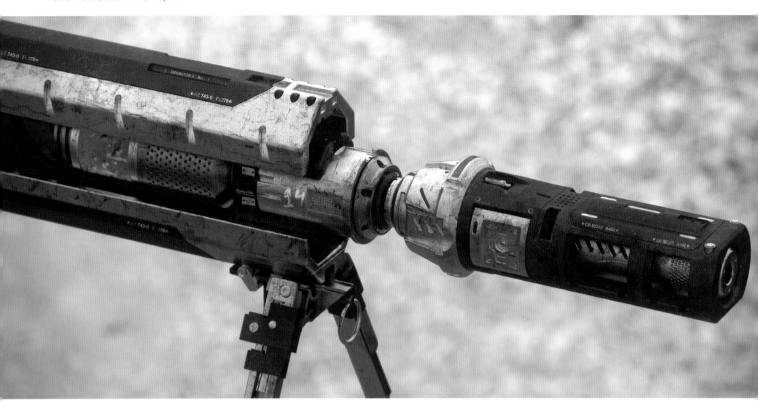

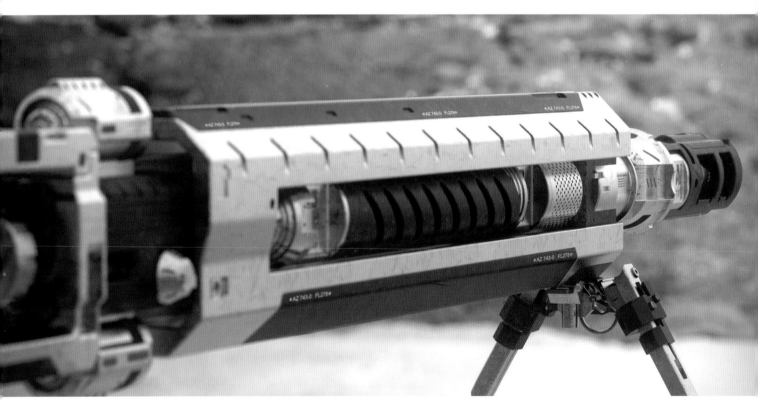

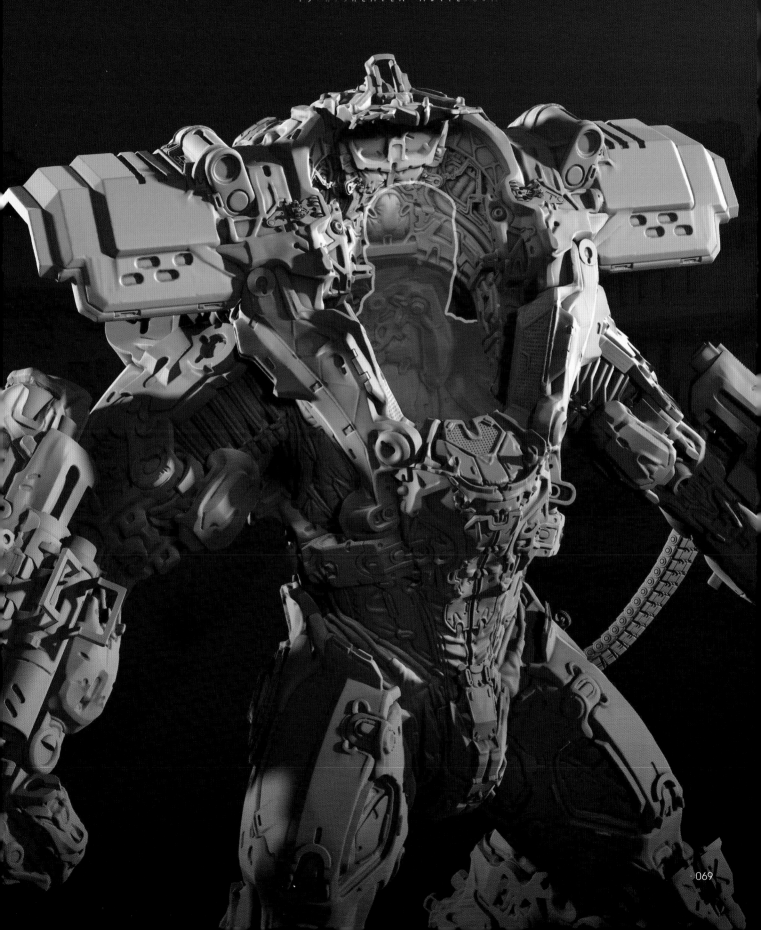

Bastiaan Koch and Ben Erdt
ZBrush, Modo
ISTHISHEAVEN-MOVIE.COM

069

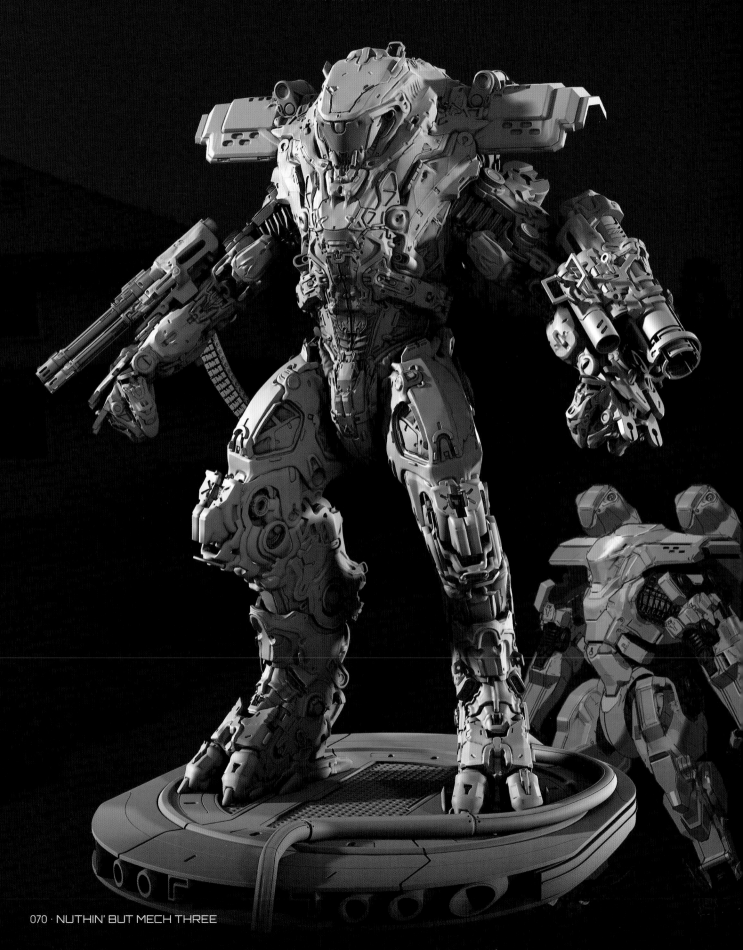

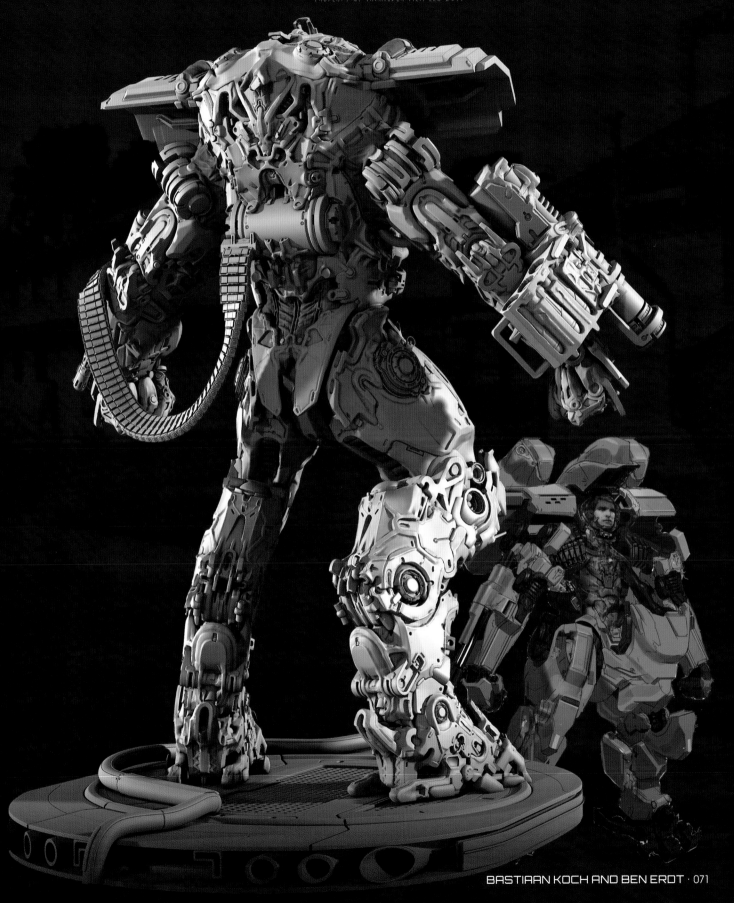

SCULPTED BY BEN ERDT, THE KRIEGER IS AN INFANTRY EXOSKELETON
DESIGN FOR BASTIAAN KOCH'S *IS THIS HEAVEN*
BASED ON ORGINAL DESIGNS BY CARLO ARELLANO.
PROPERTY OF MARAUDER FILM LLC 2014

John Liew
Photoshop

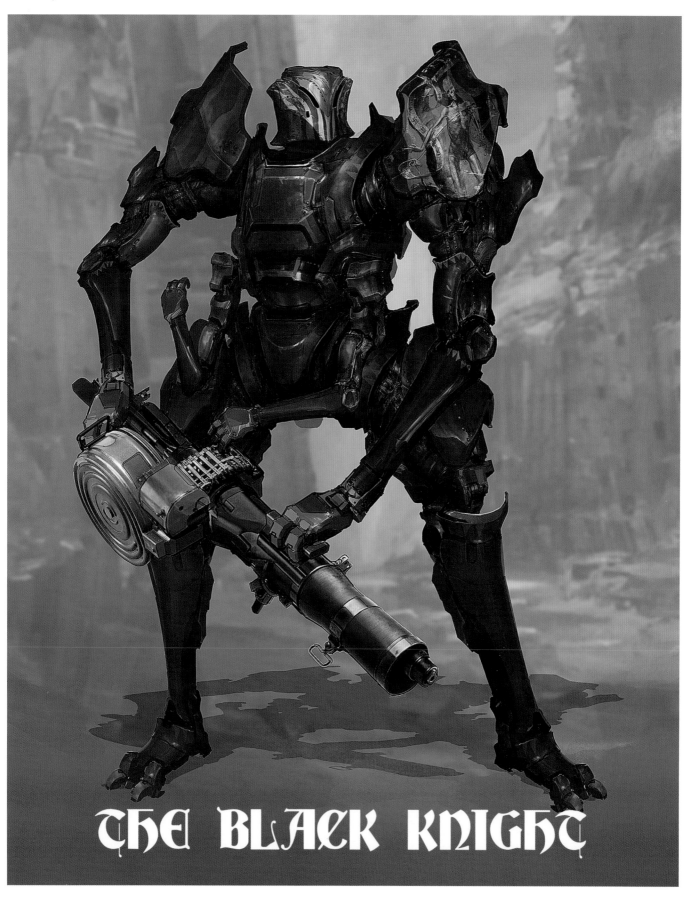

THE BLACK KNIGHT

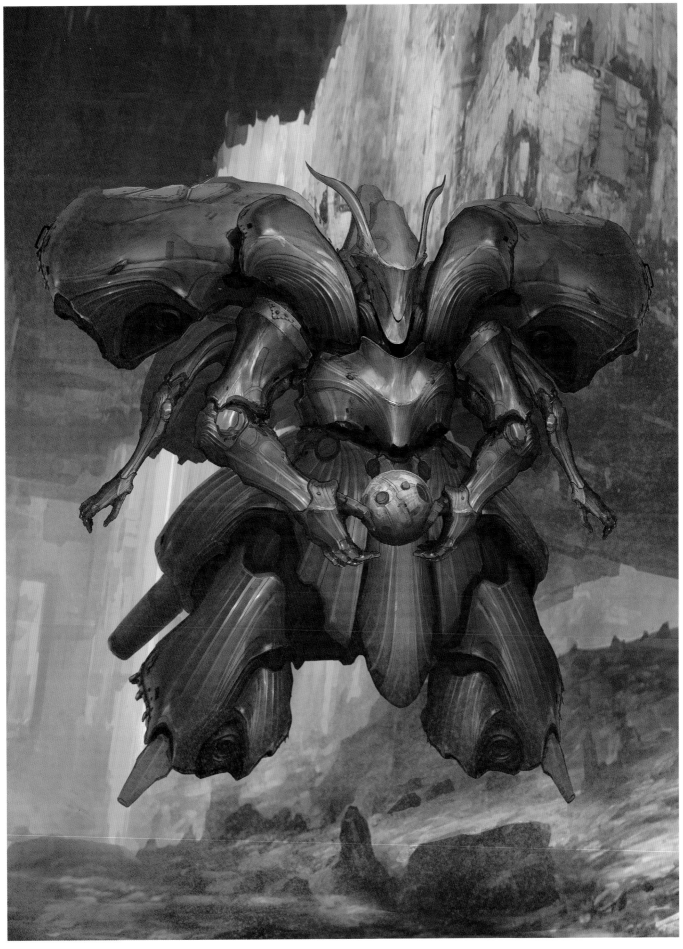

Vaughan Ling
Sculptris, Photoshop

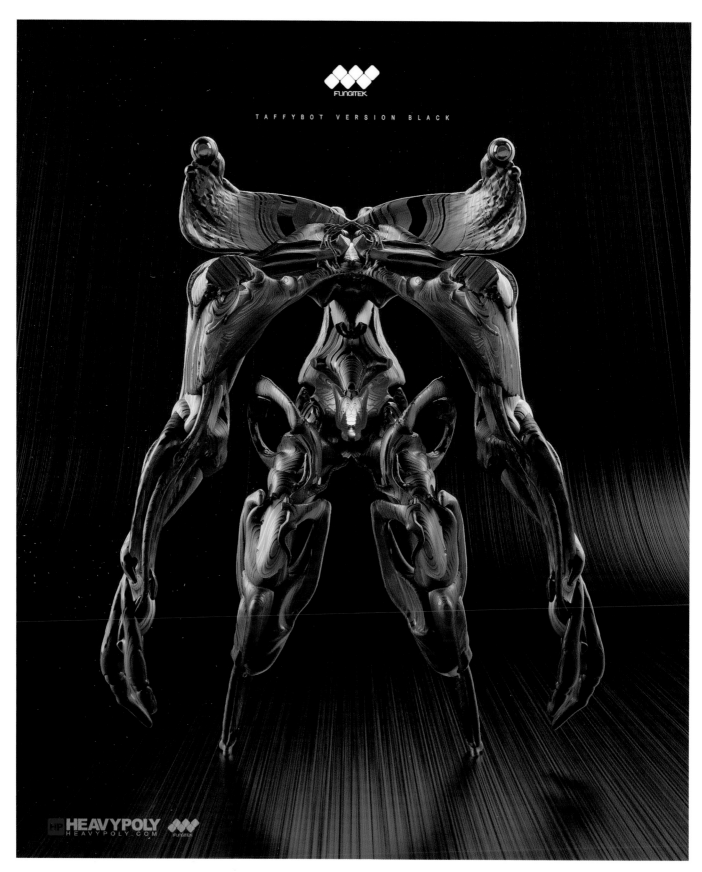

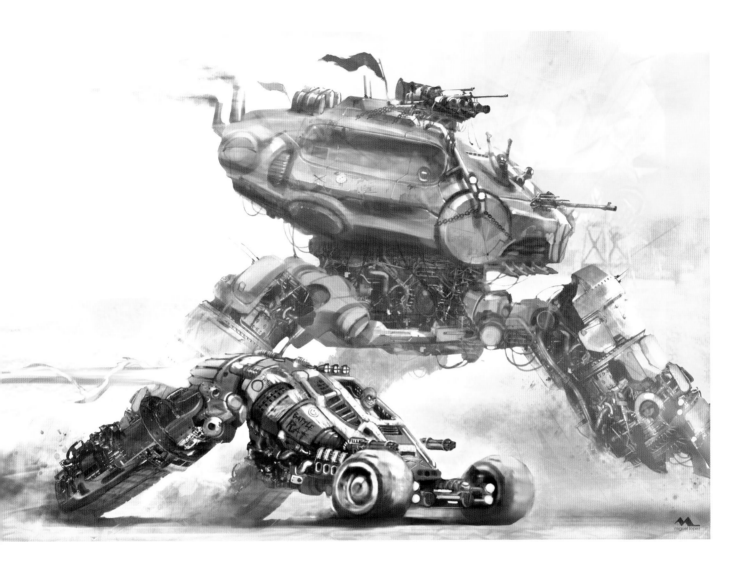

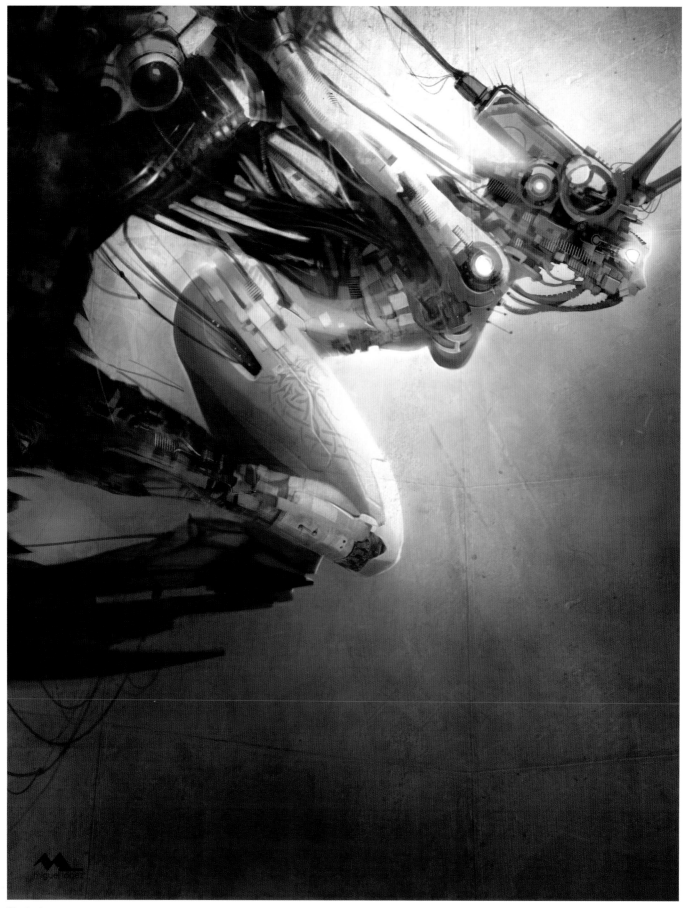

Photoshop

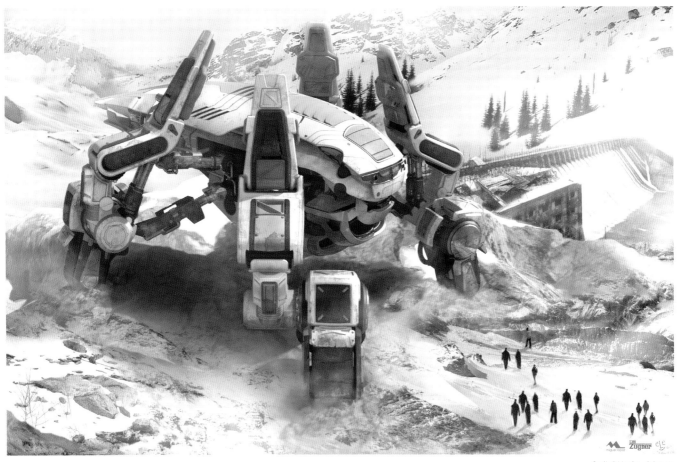

SolidWorks, Maya

Above
Snow Mech

With collaborators
Leo Zugner, senior designer at Mattel
(3D modeled the mech in Solidworks)
Zugdesign.com
Leozug@gmail.com

Eleazar Carmeli, 3D modeler at Mattel
(applied color and environment
lighting in Maya)

Benjamin Louis
Alias, Patchwork 3D, Photoshop

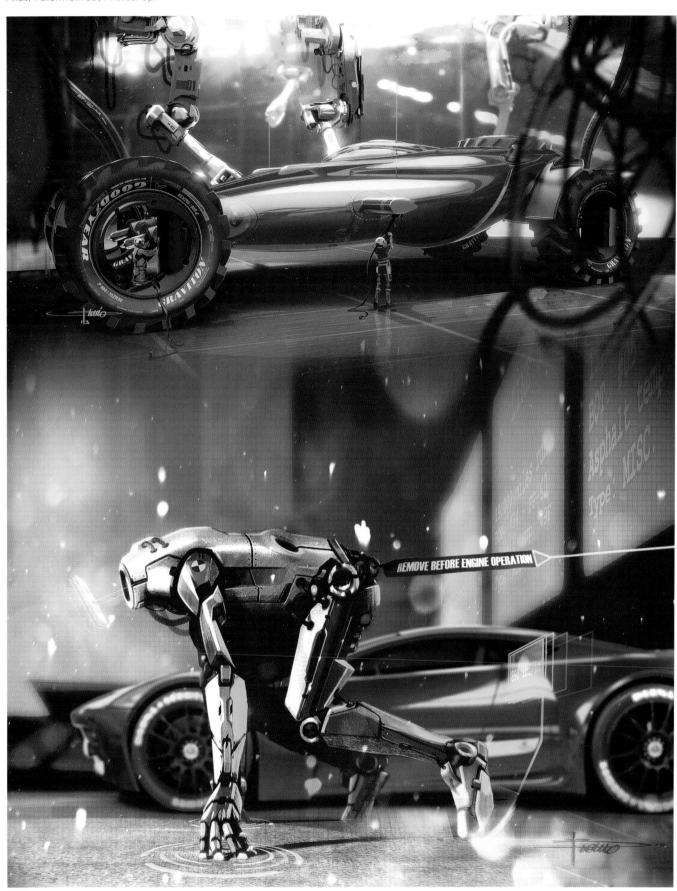

REMOVE BEFORE ENGINE OPERATION

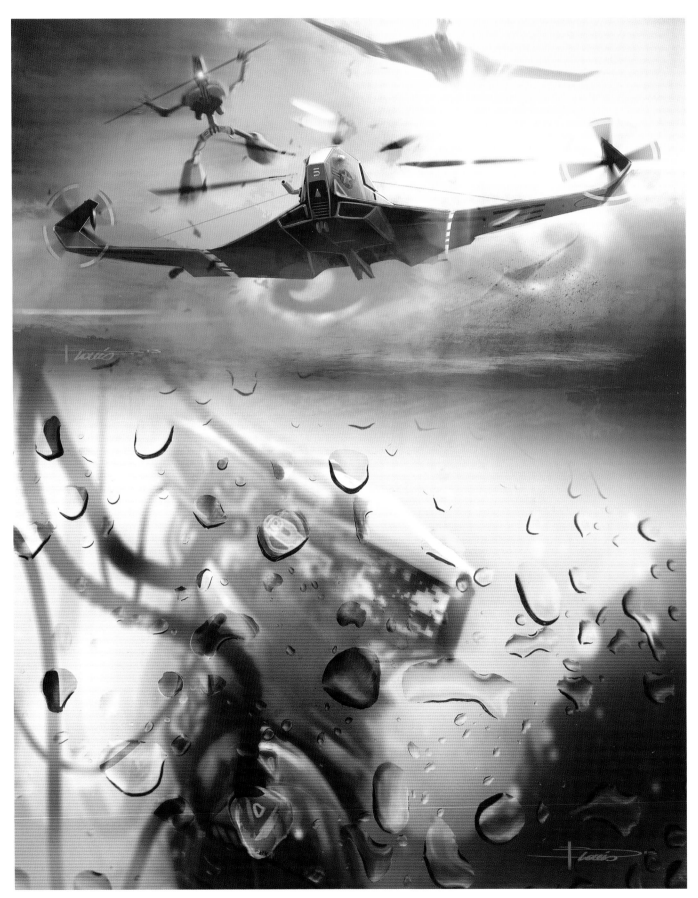

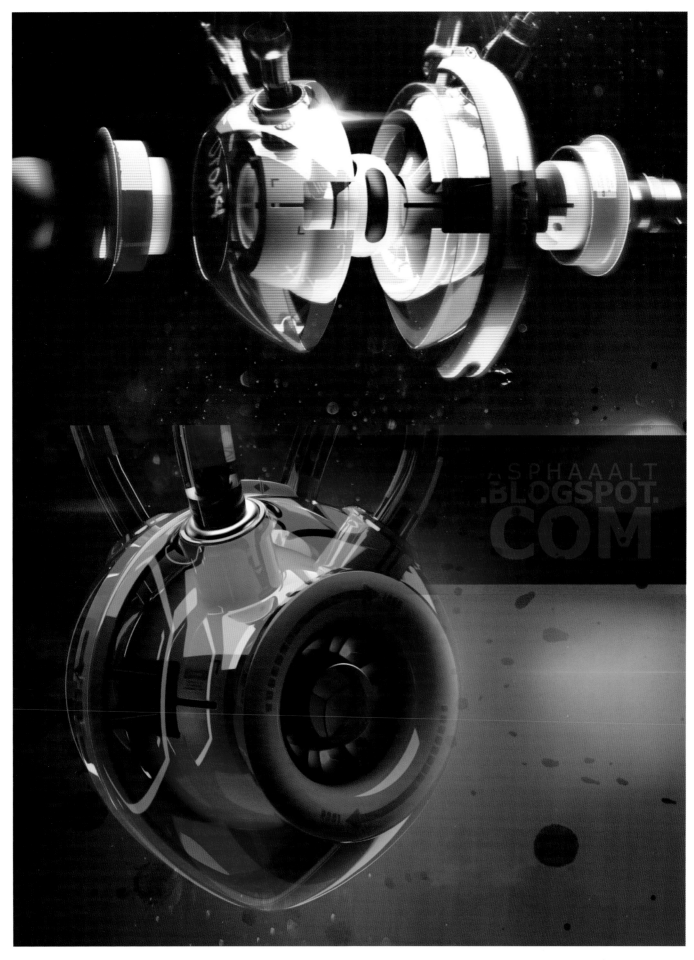

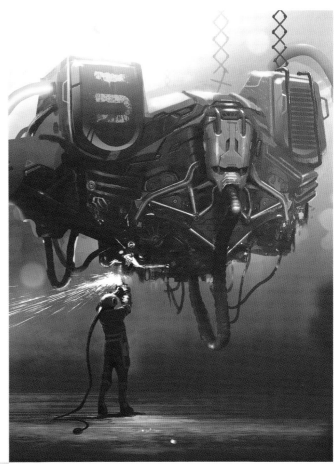

Human concept heart featured in the film *Whipping Boy*, produced by Michael Chance, was a finalist at the Prototype Films Competition.

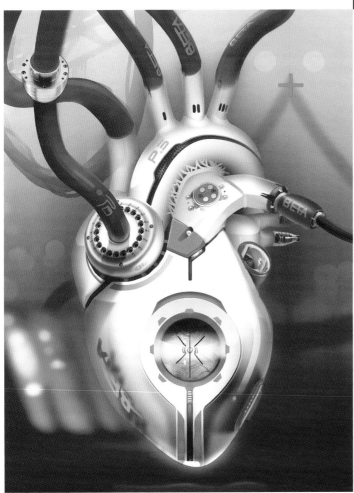

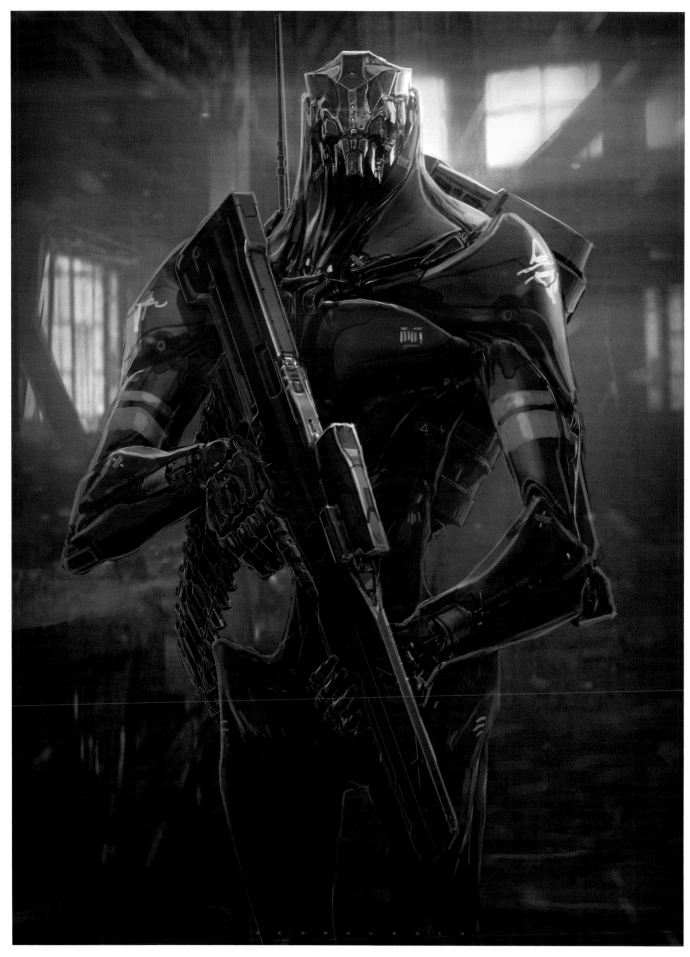

Ben Mauro
Pencil, ZBrush, KeyShot, Photoshop

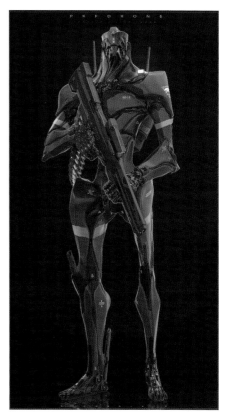

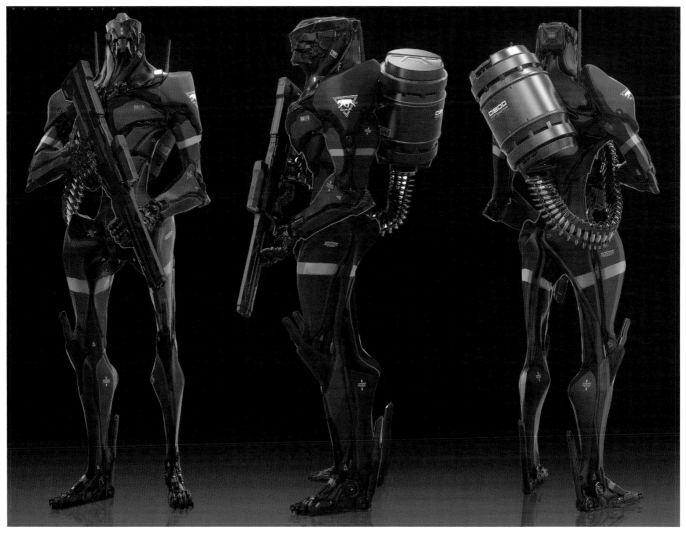

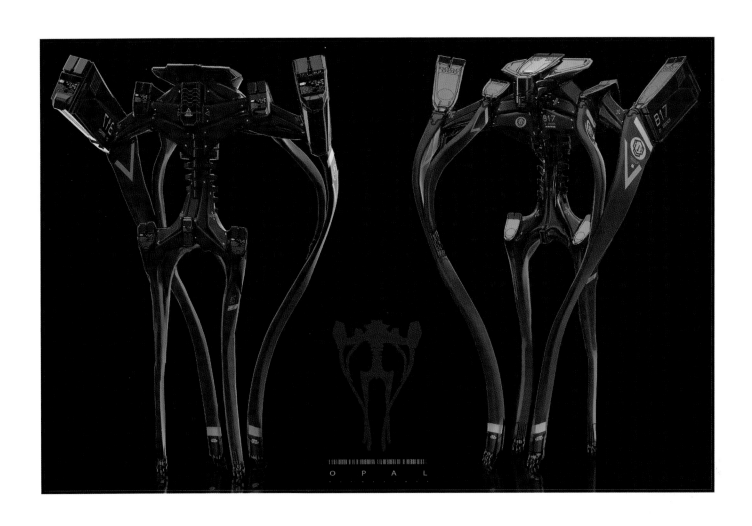

OPAL

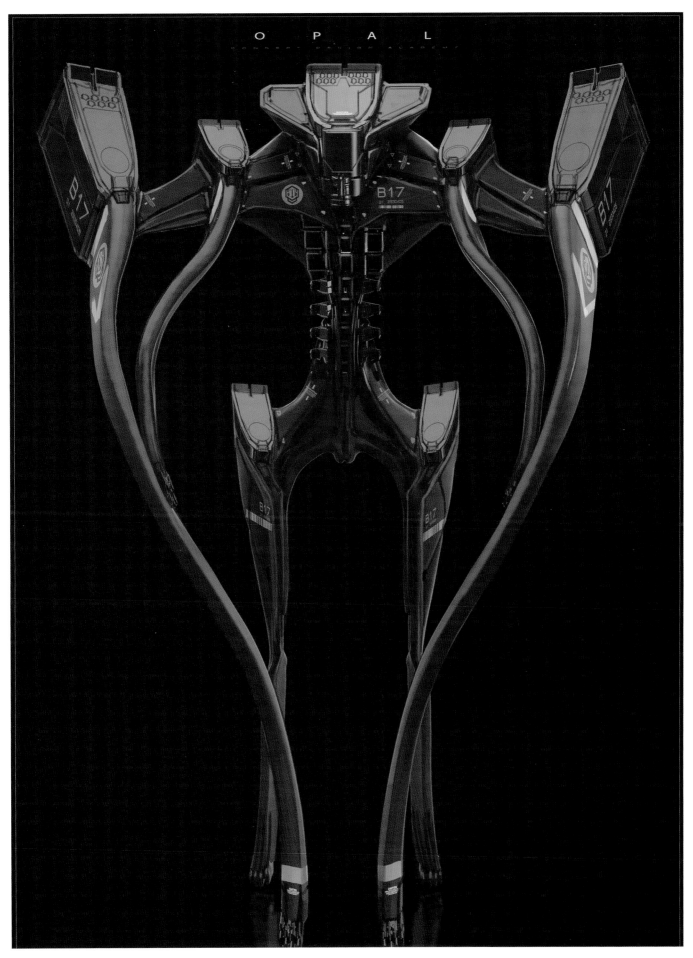

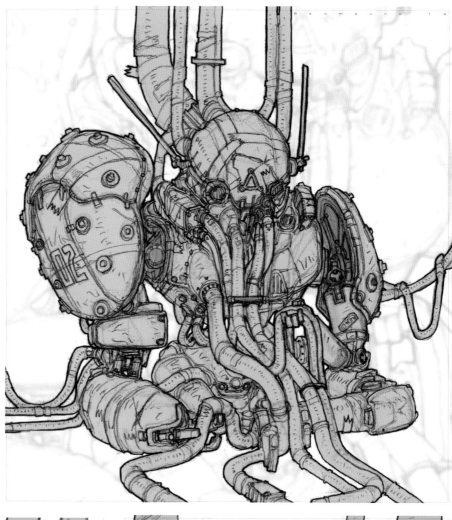

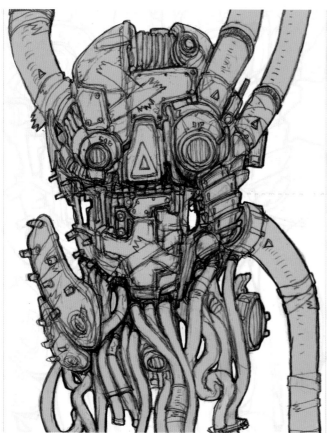

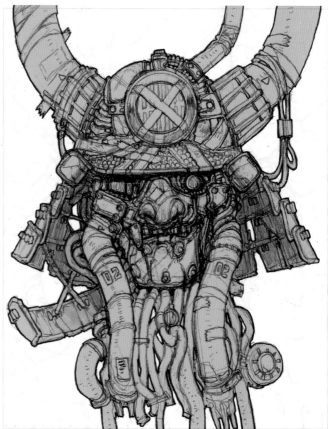

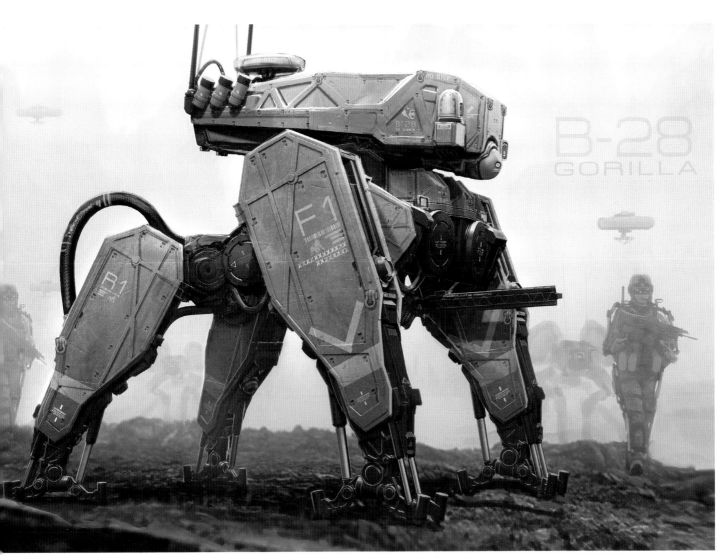

B-28
GORILLA

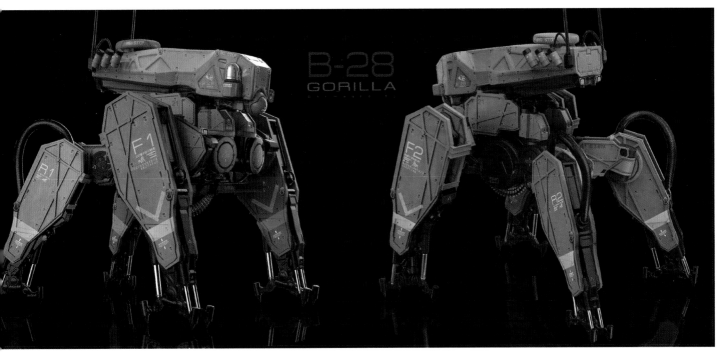

B-28
GORILLA

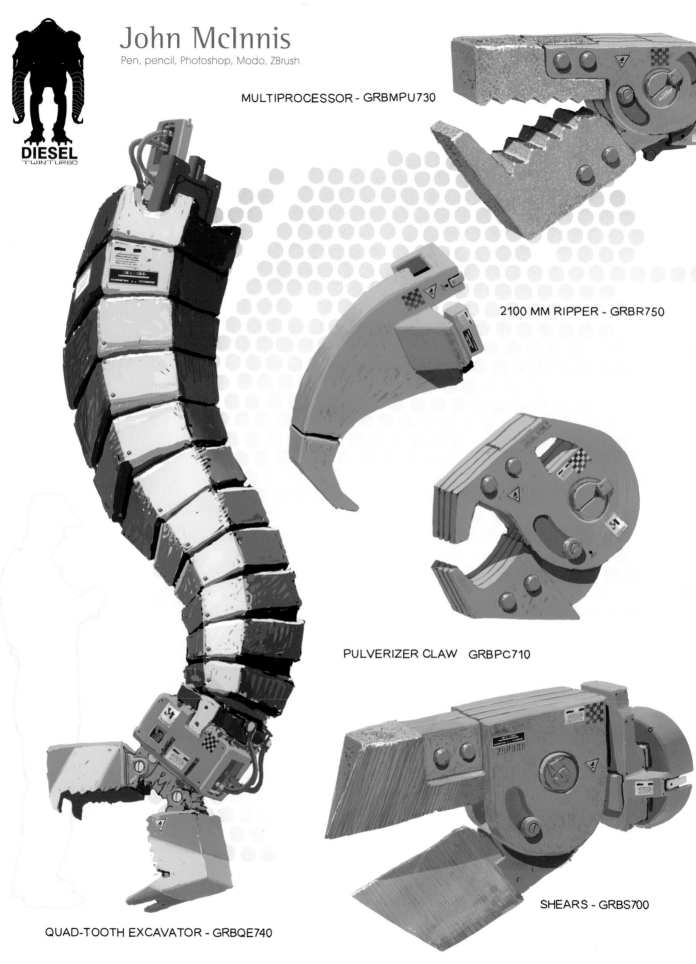

John McInnis

Pen, pencil, Photoshop, Modo, ZBrush

DIESEL
TWINTURBO

MULTIPROCESSOR - GRBMPU730

2100 MM RIPPER - GRBR750

PULVERIZER CLAW GRBPC710

SHEARS - GRBS700

QUAD-TOOTH EXCAVATOR - GRBQE740

MOBILE CONSTRUCTION UNIT – GRBMCU07

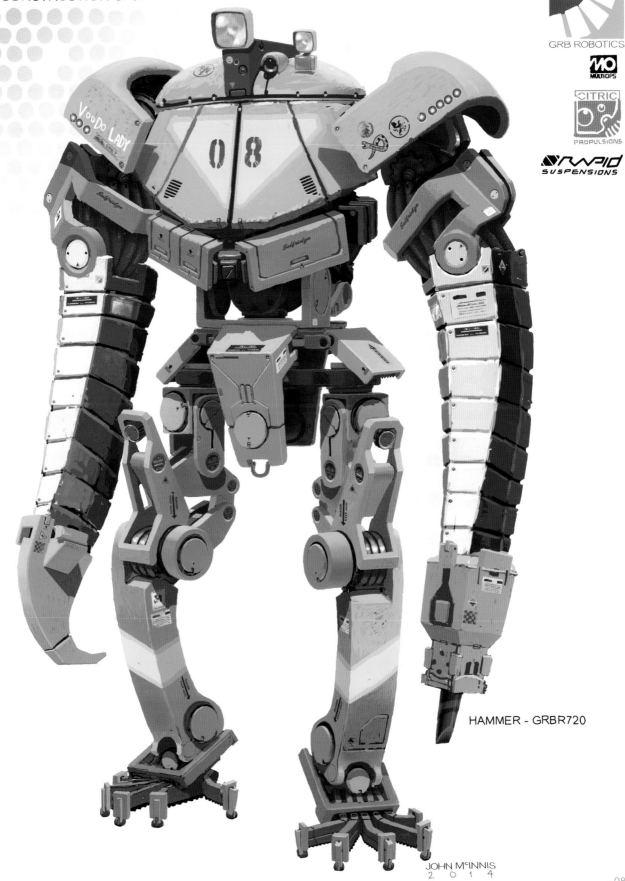

GRB ROBOTICS

HAMMER - GRBR720

JOHN McINNIS
2014

Elijah McNeal

3ds Max, Sketchbook Pro, ZBrush, KeyShot, Photoshop

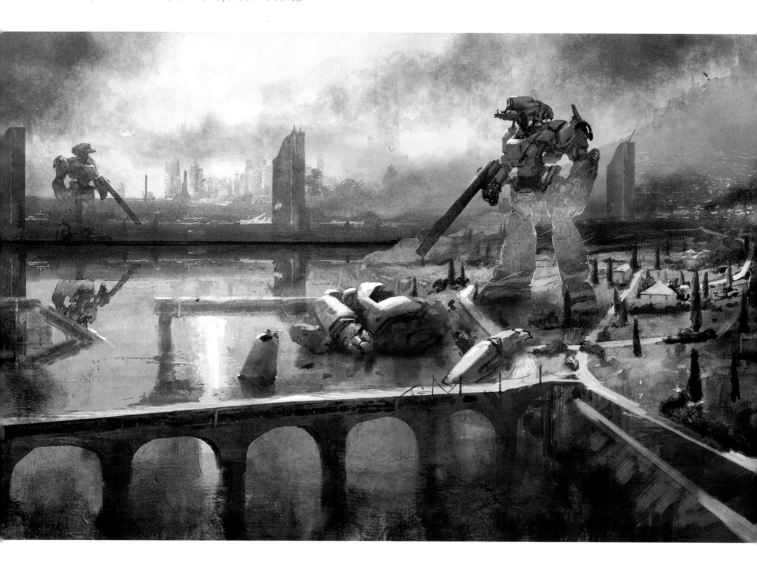

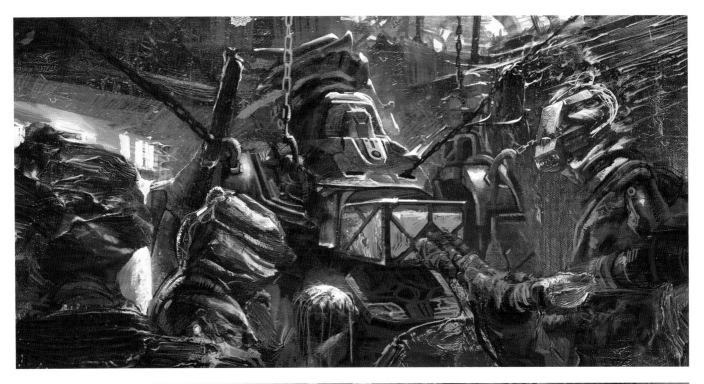

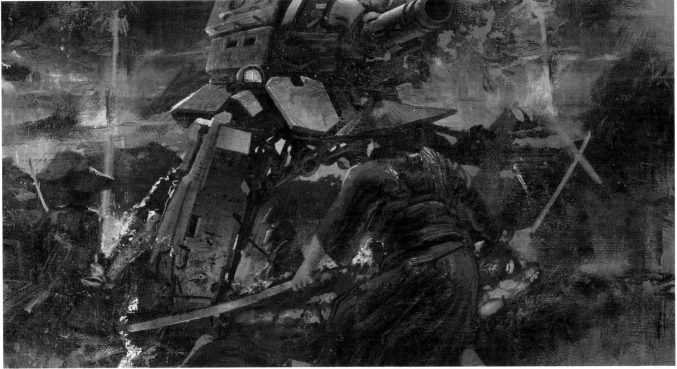

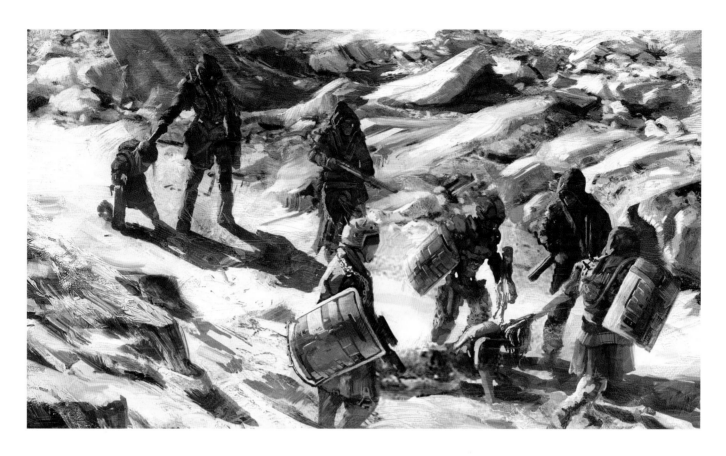

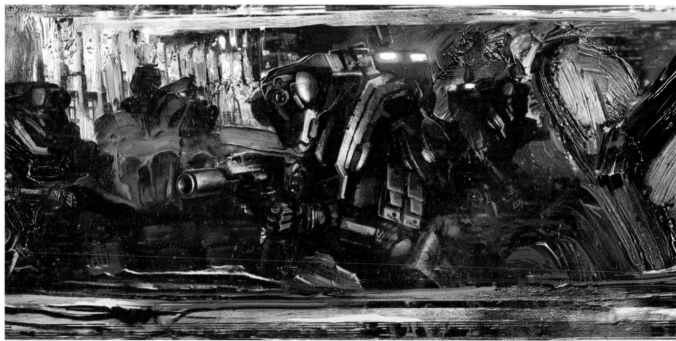

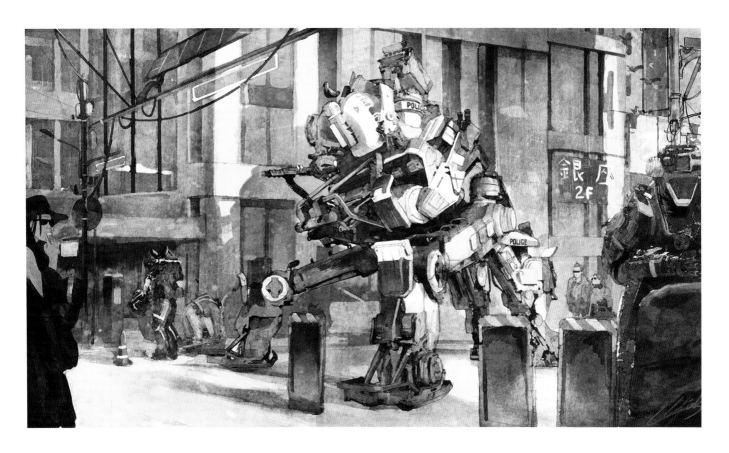

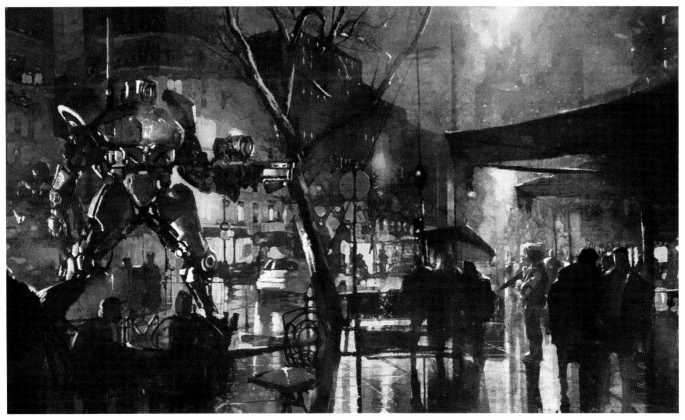

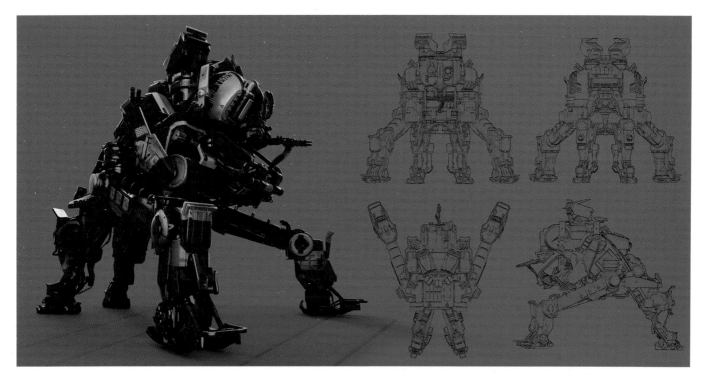

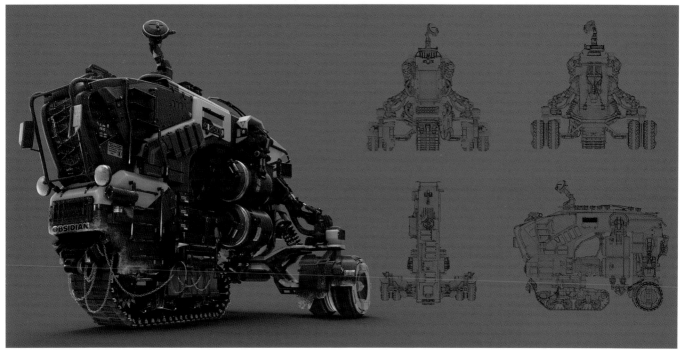

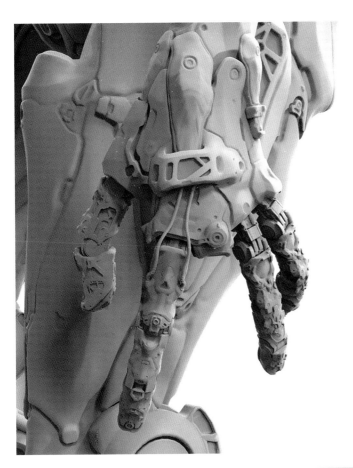
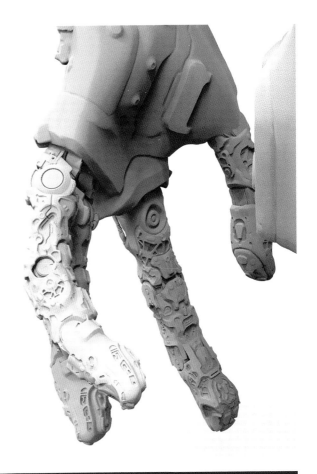
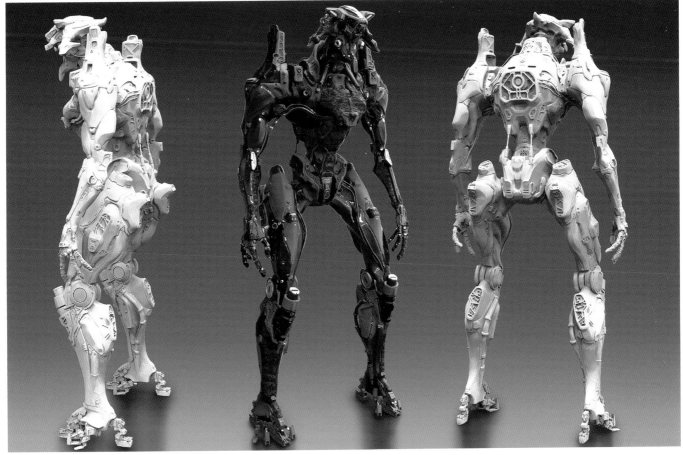

Ian McQue

Pen, pencil, Photoshop

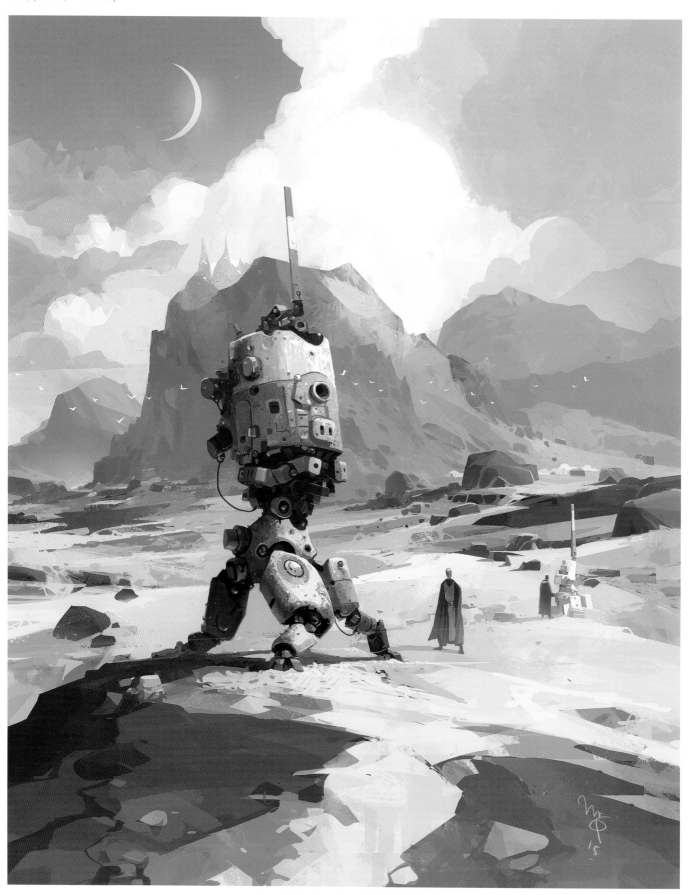

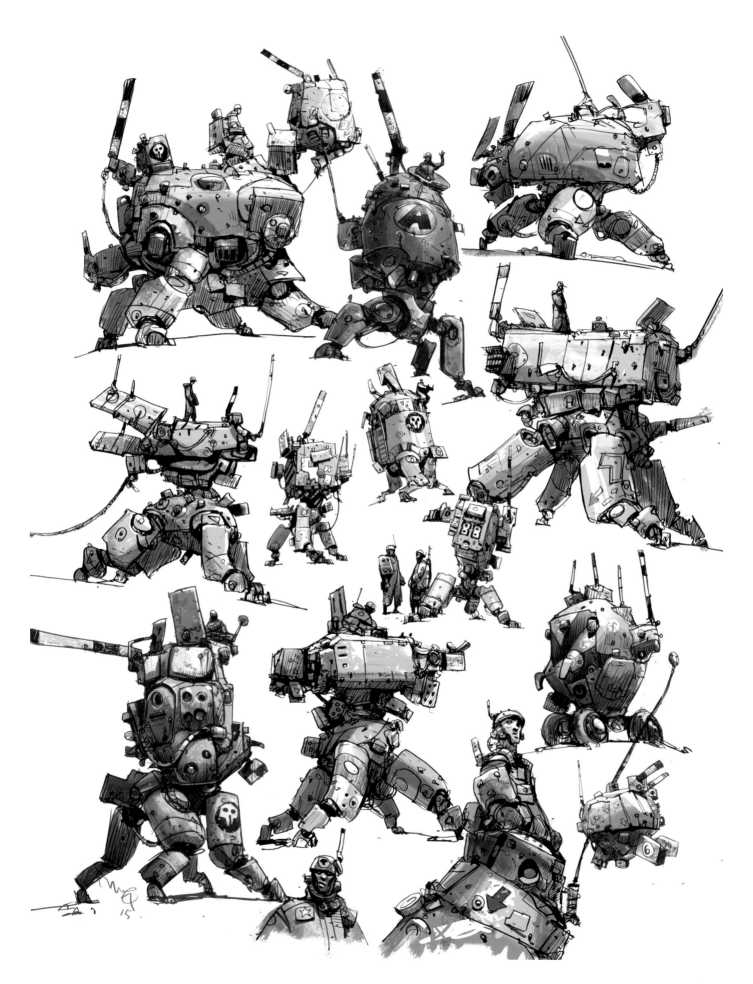

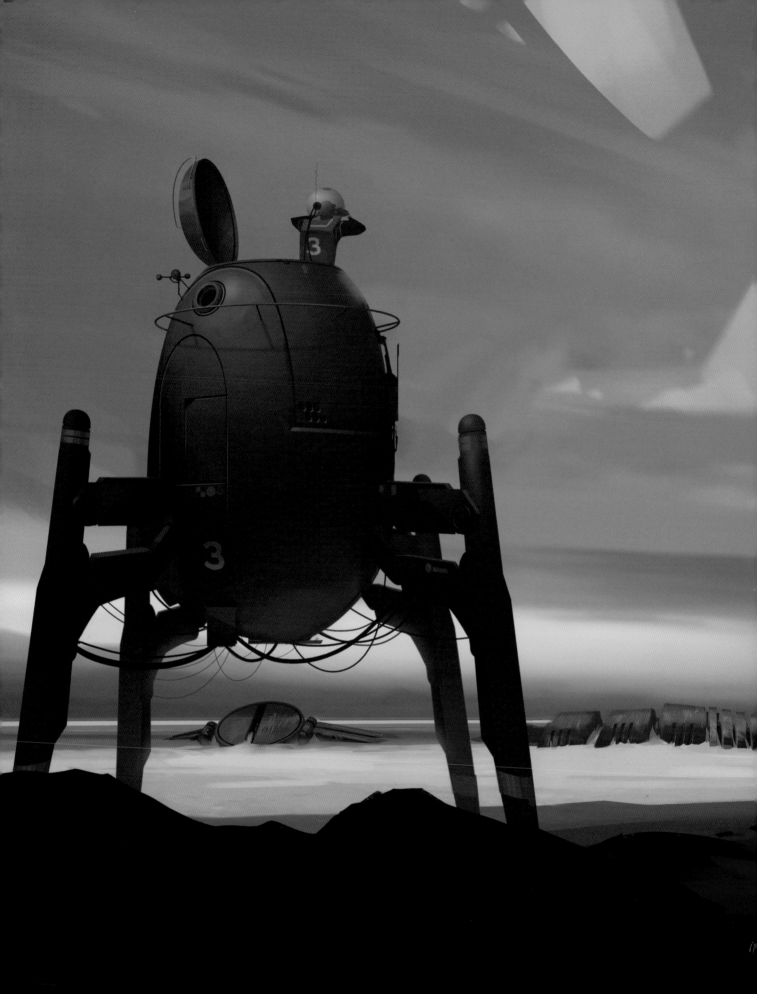

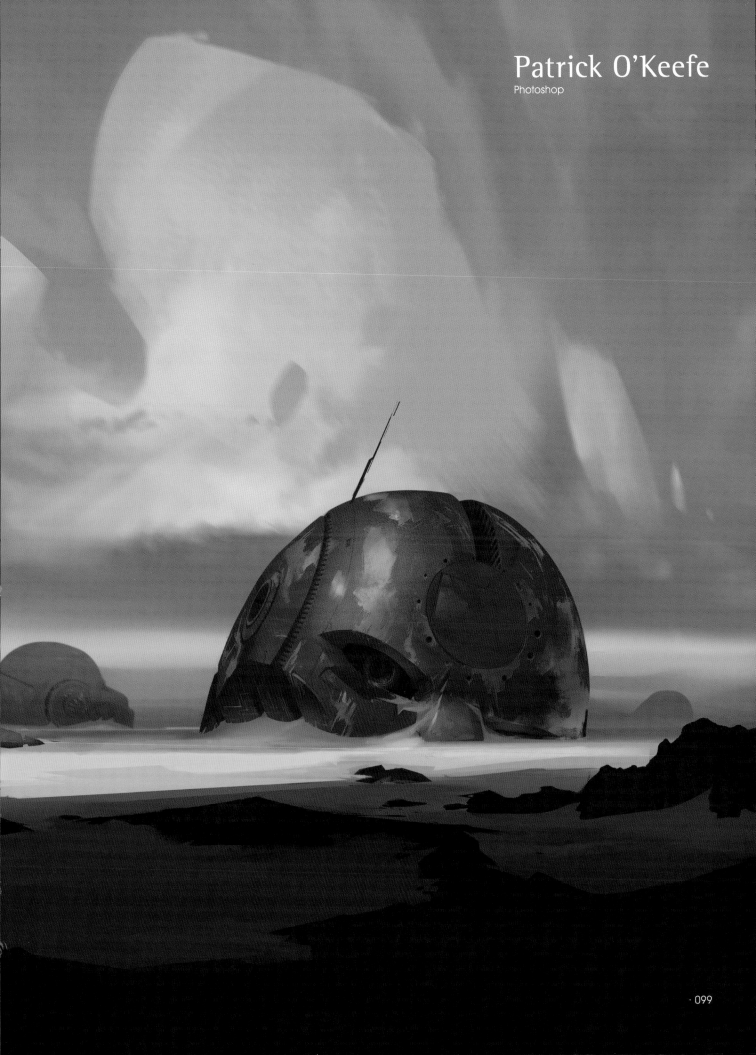

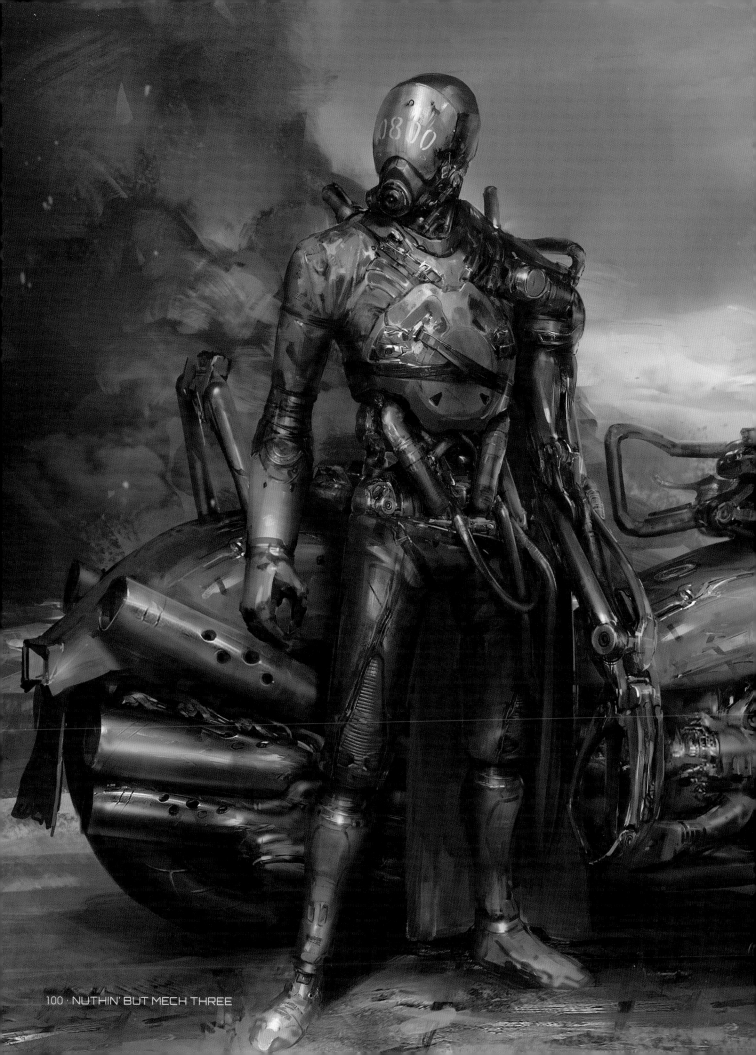

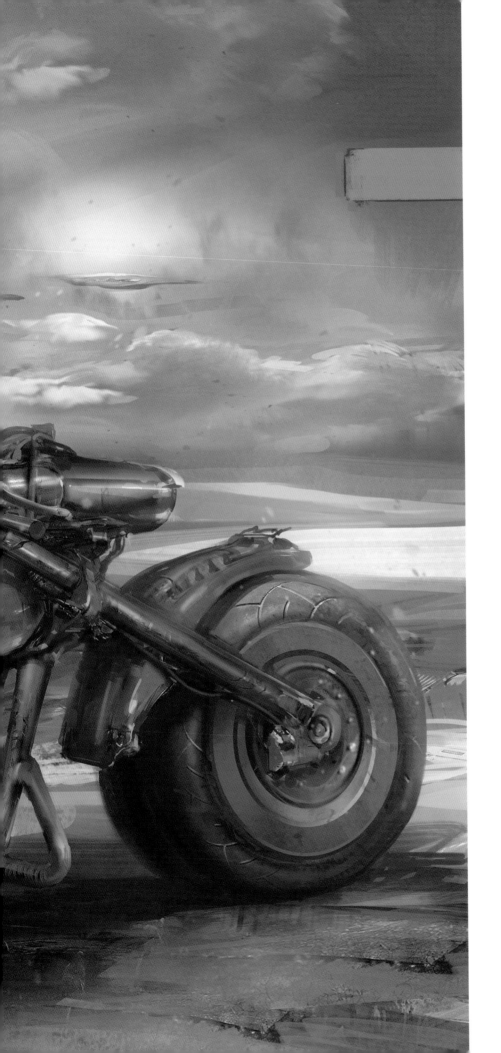

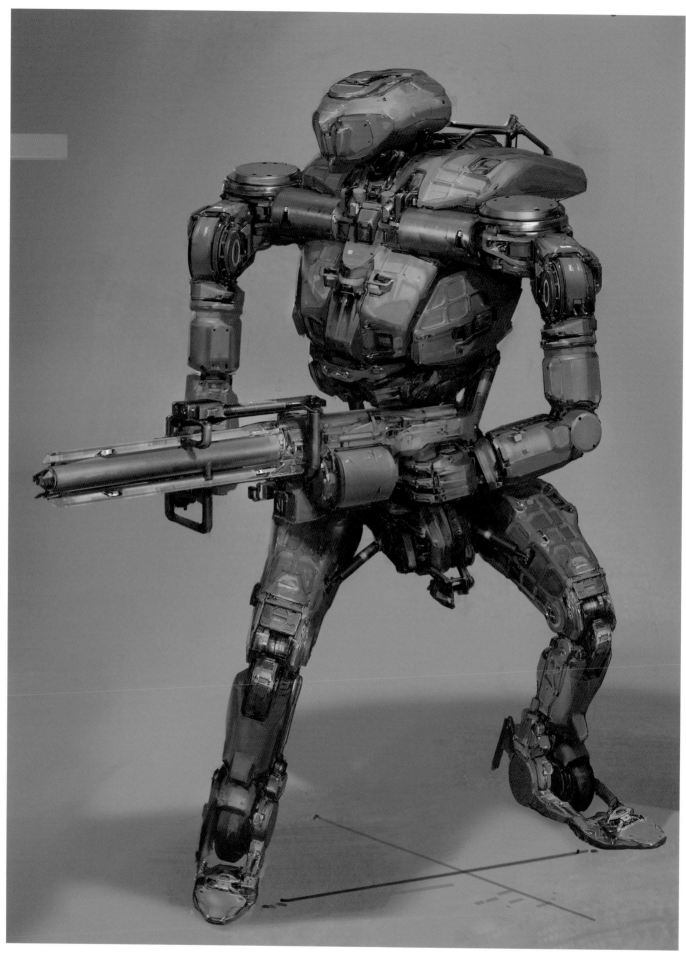

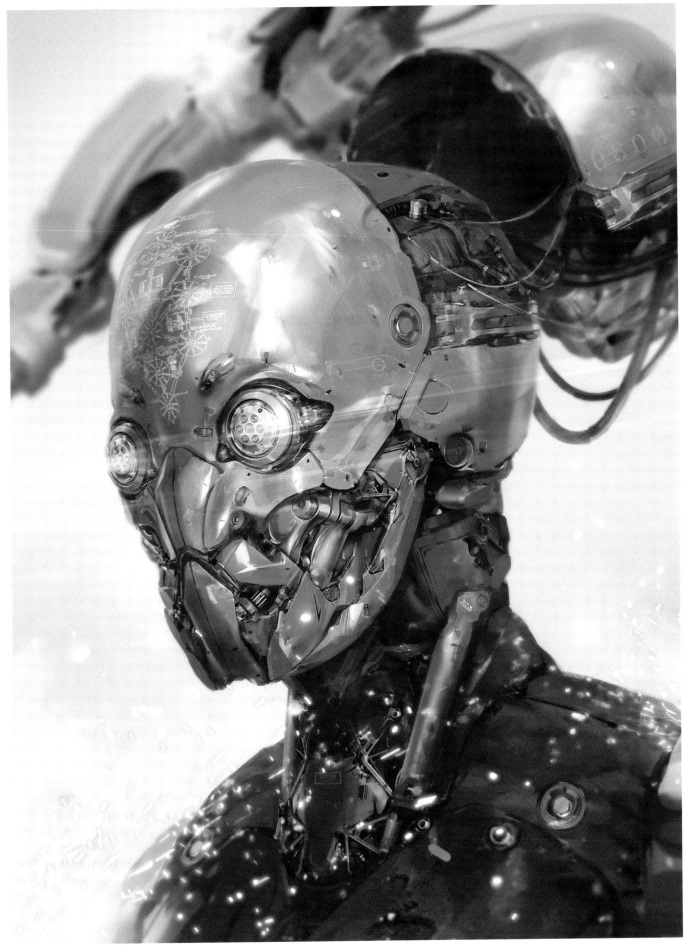

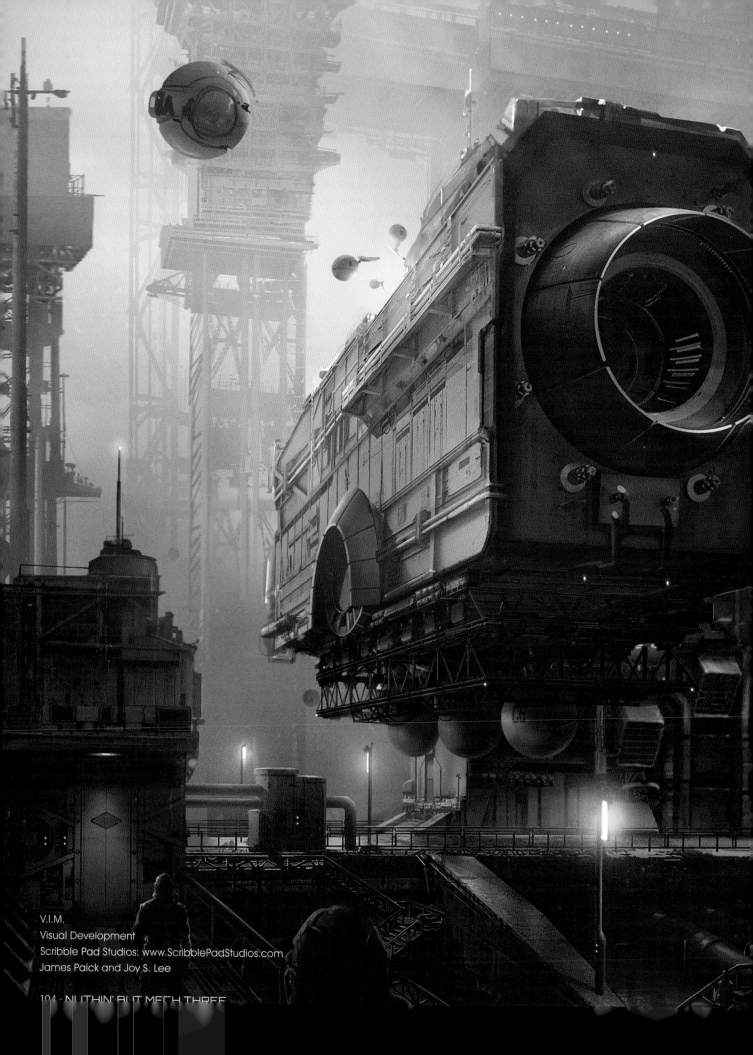

V.I.M.
Visual Development
Scribble Pad Studios: www.ScribblePadStudios.com
James Paick and Joy S. Lee

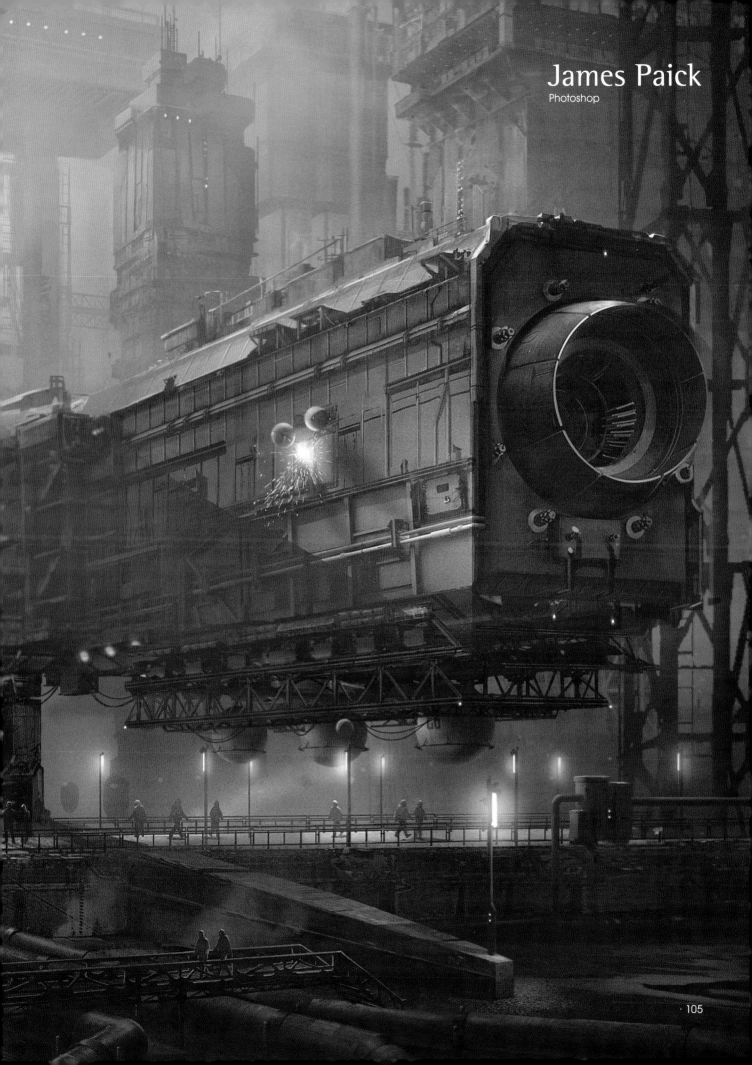

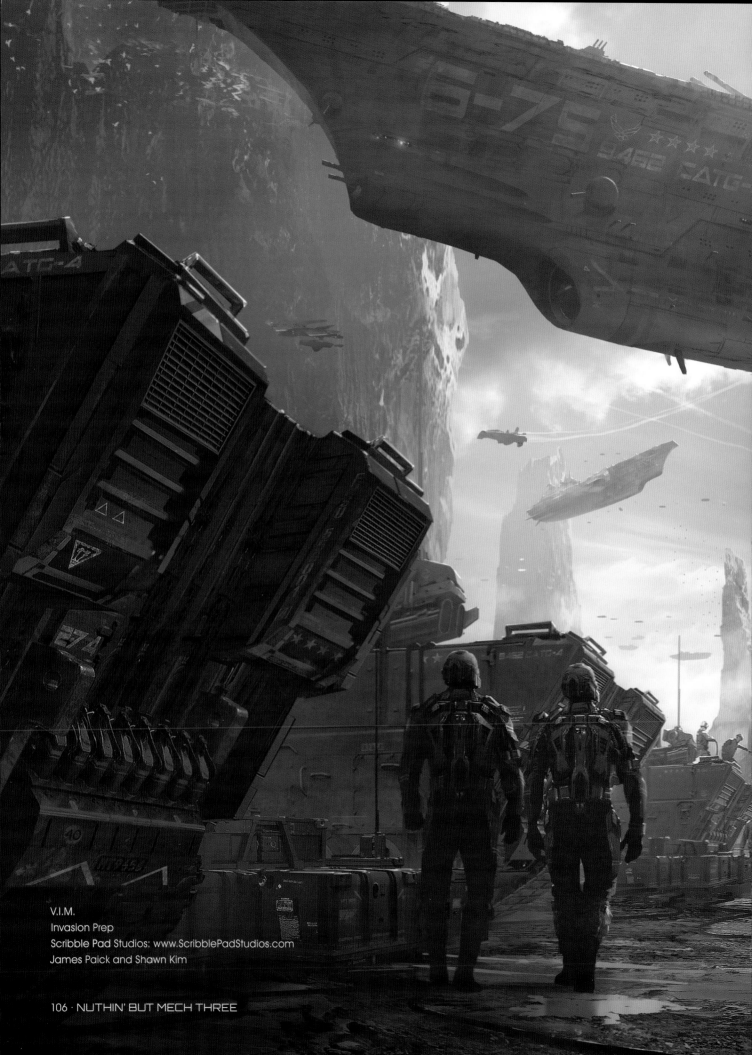

V.I.M.
Invasion Prep
Scribble Pad Studios: www.ScribblePadStudios.com
James Paick and Shawn Kim

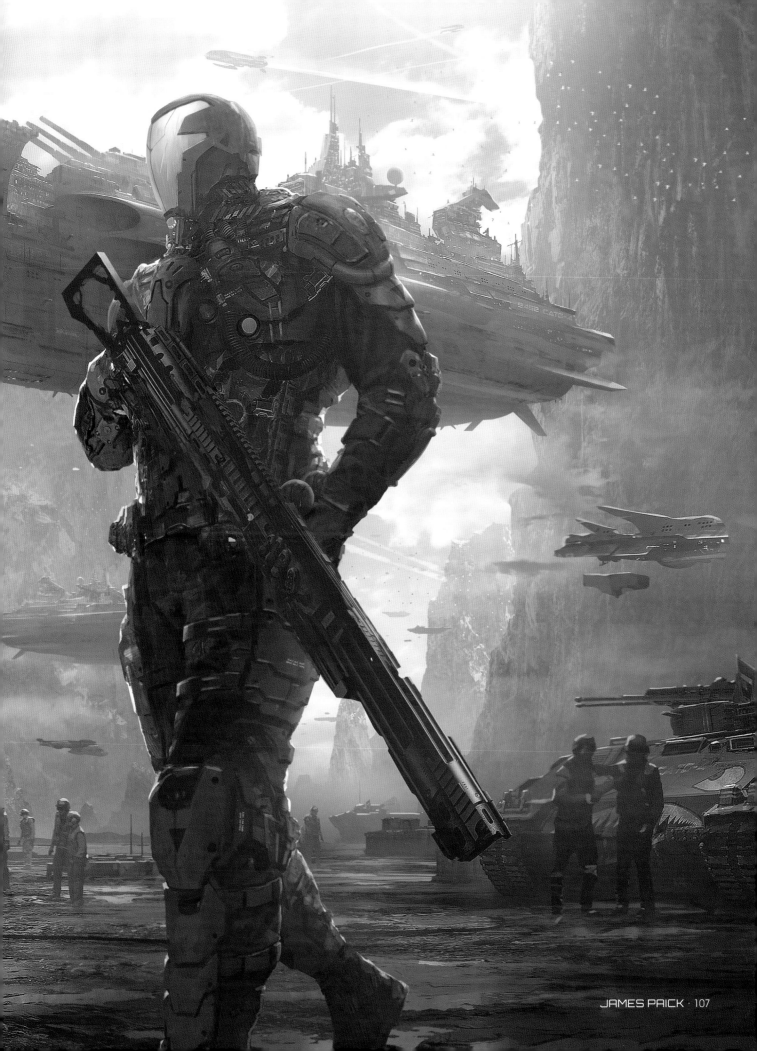

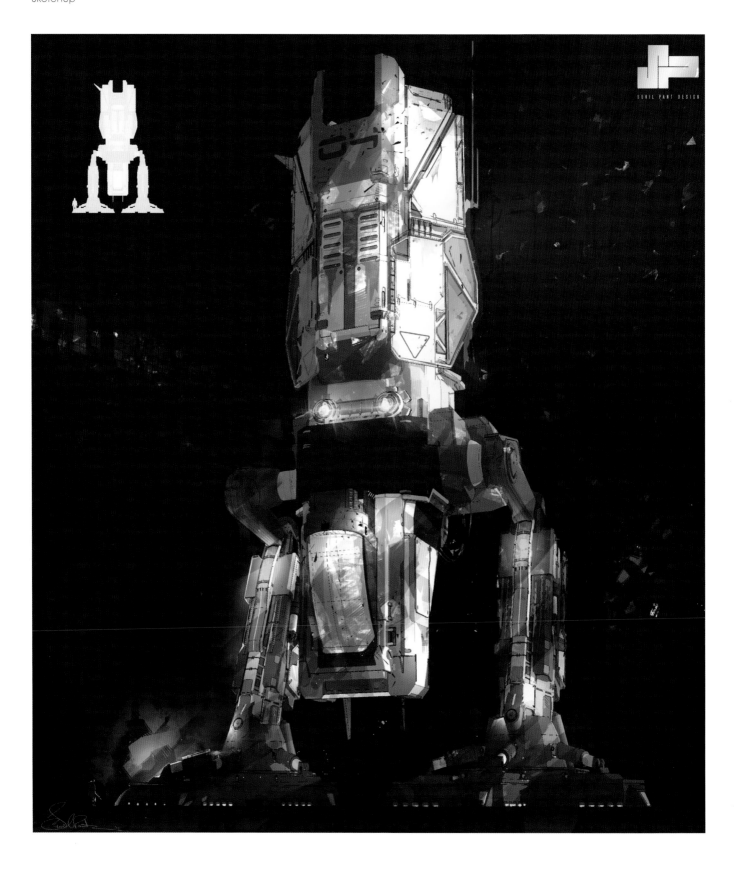

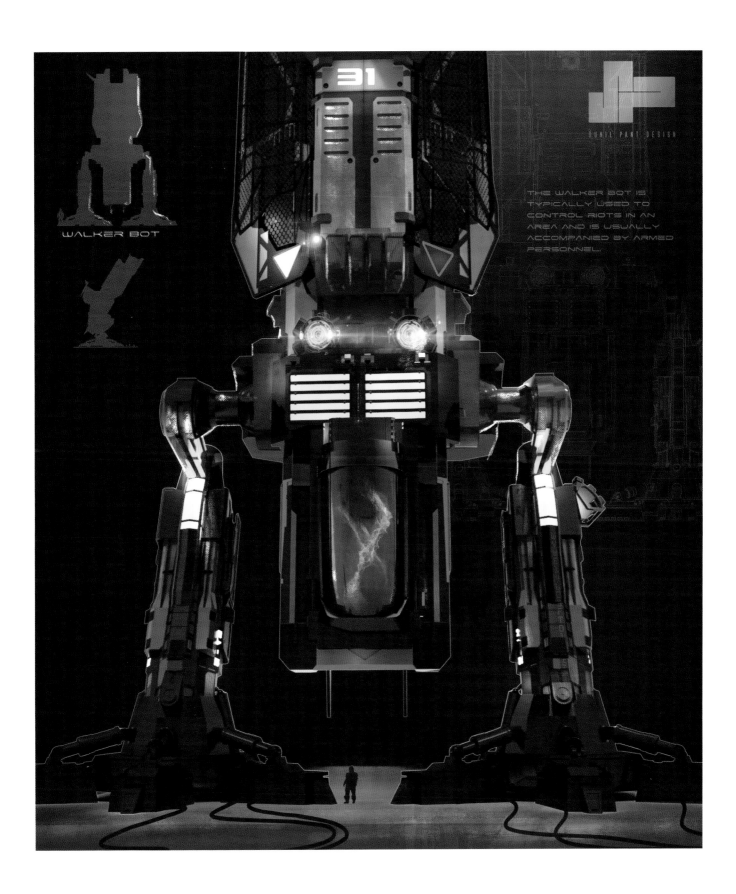

WALKER BOT

31

SUNIL PANT DESIGN

THE WALKER BOT IS
TYPICALLY USED TO
CONTROL RIOTS IN AN
AREA AND IS USUALLY
ACCOMPANIED BY ARMED
PERSONNEL

Jake Parker

Pen, Photoshop

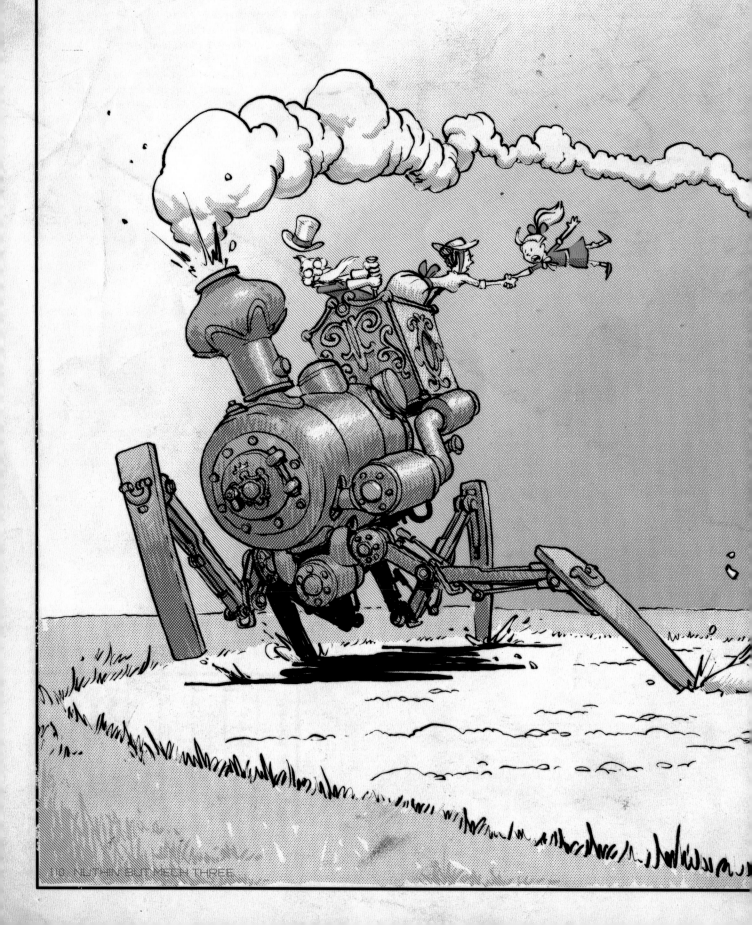

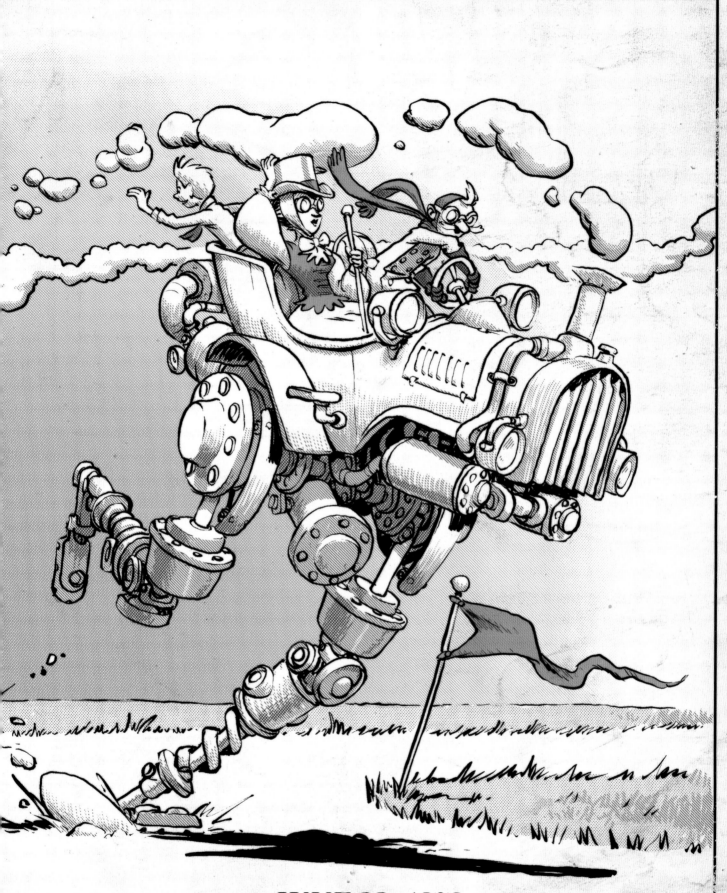

JUNE 23, 1876
INVENTOR HAROLD R. RICKETT DEFEATS REIGNING CHAMPION JACQUES E. CUGNOT IN THE 7TH ANNUAL 5-MILE STEAM-POWERED VELOCIMECH RACE.

Peter Popken

Photoshop

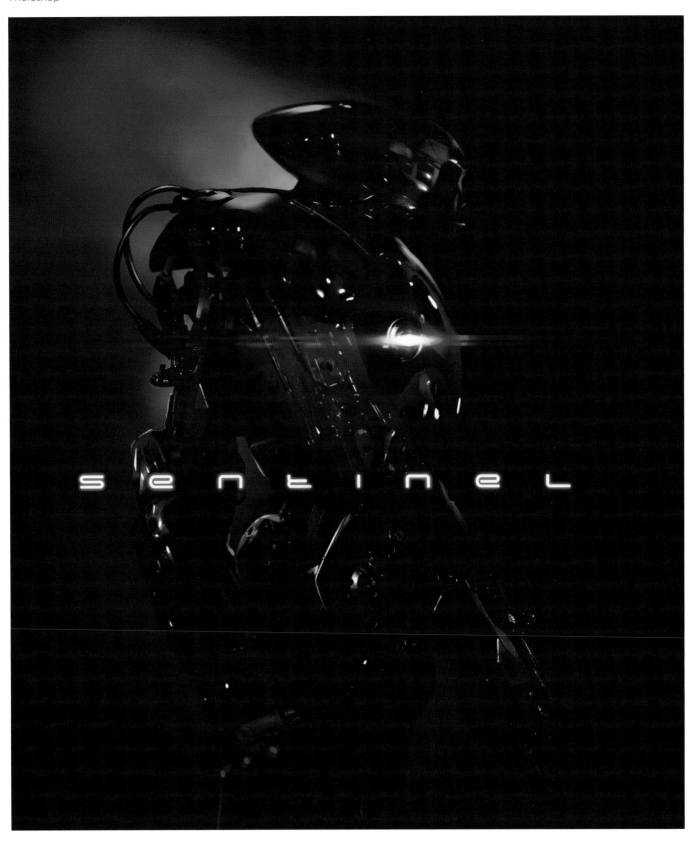

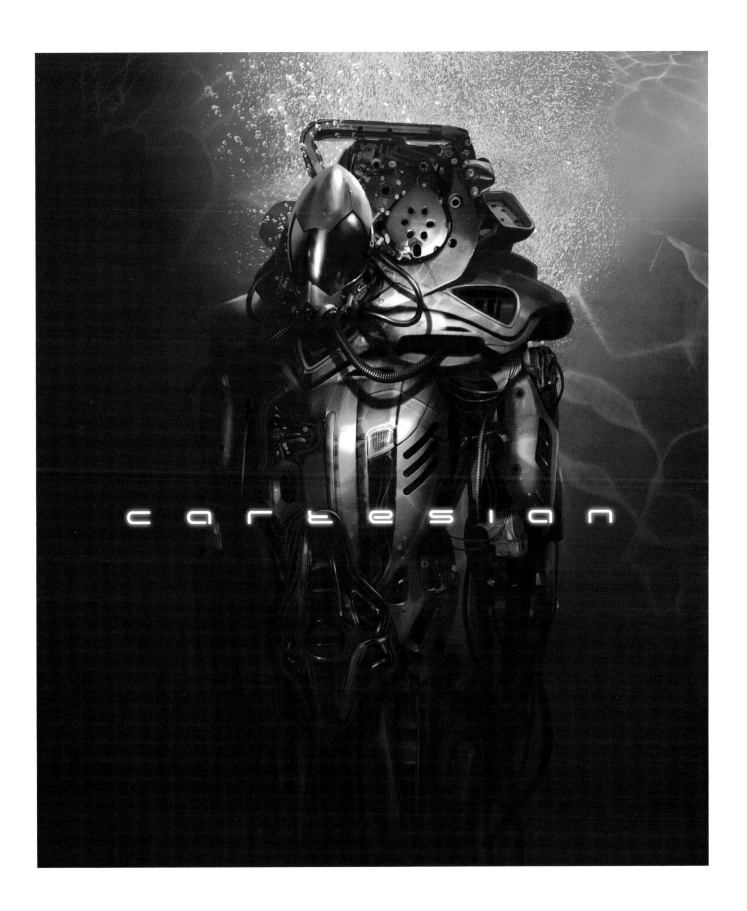

cartesian

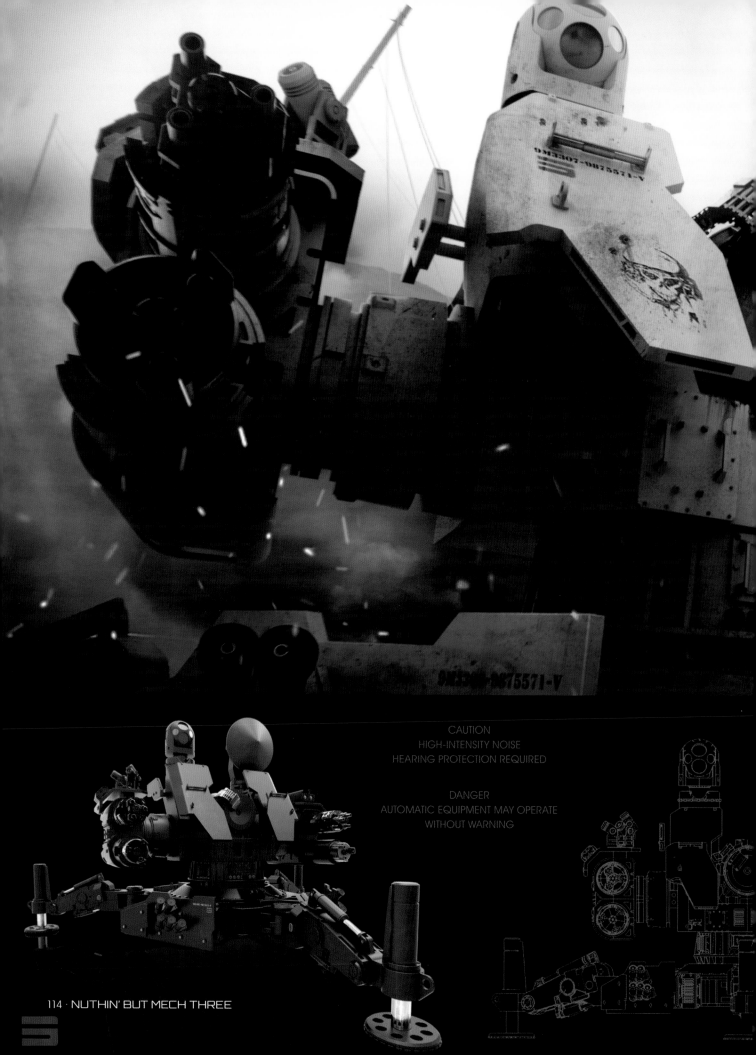

CAUTION
HIGH-INTENSITY NOISE
HEARING PROTECTION REQUIRED

DANGER
AUTOMATIC EQUIPMENT MAY OPERATE
WITHOUT WARNING

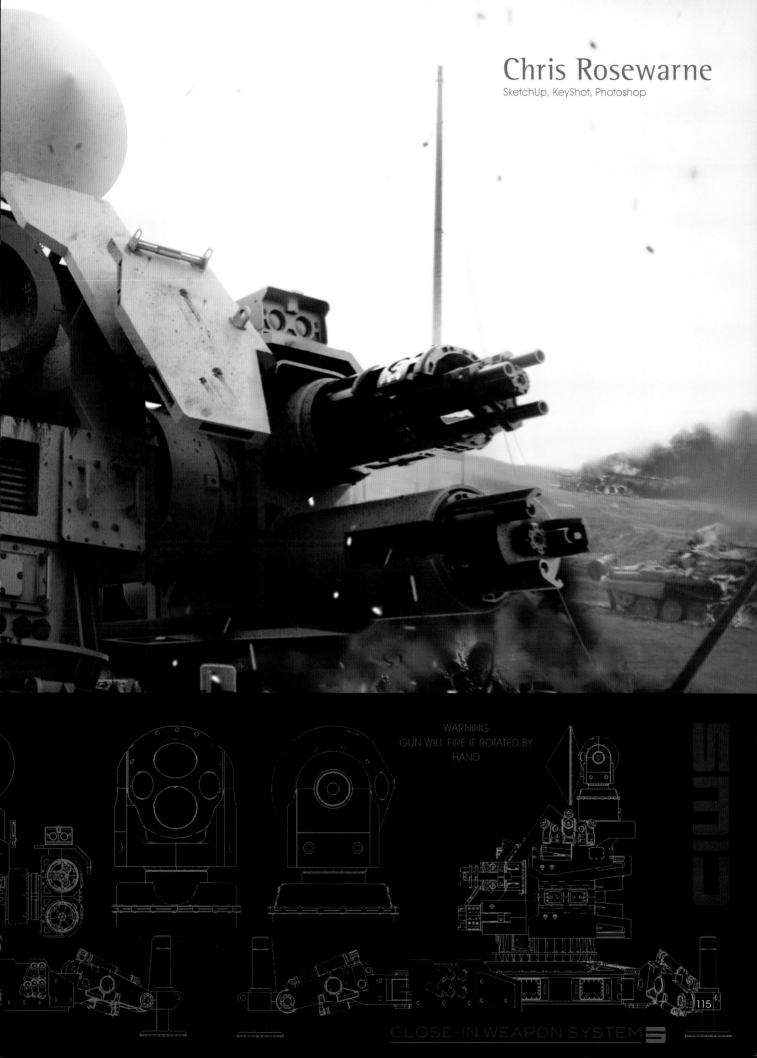

Chris Rosewarne

SketchUp, KeyShot, Photoshop

WARNING
GUN WILL FIRE IF ROTATED BY
HAND

CWS

115

CLOSE-IN WEAPON SYSTEM

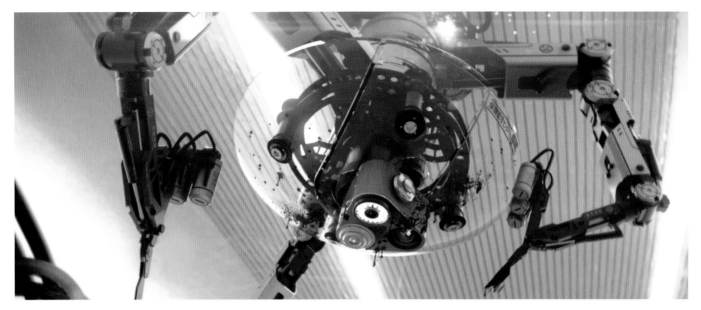

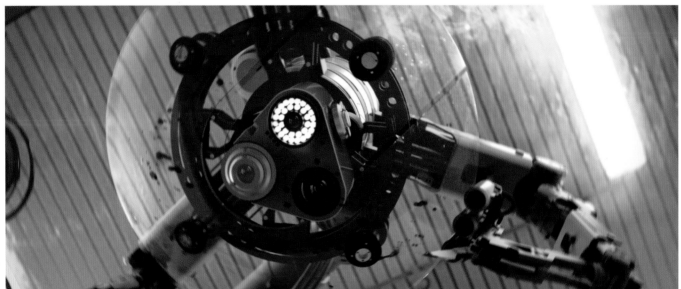

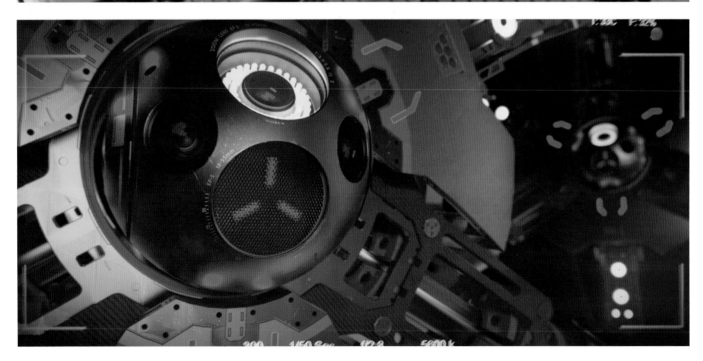

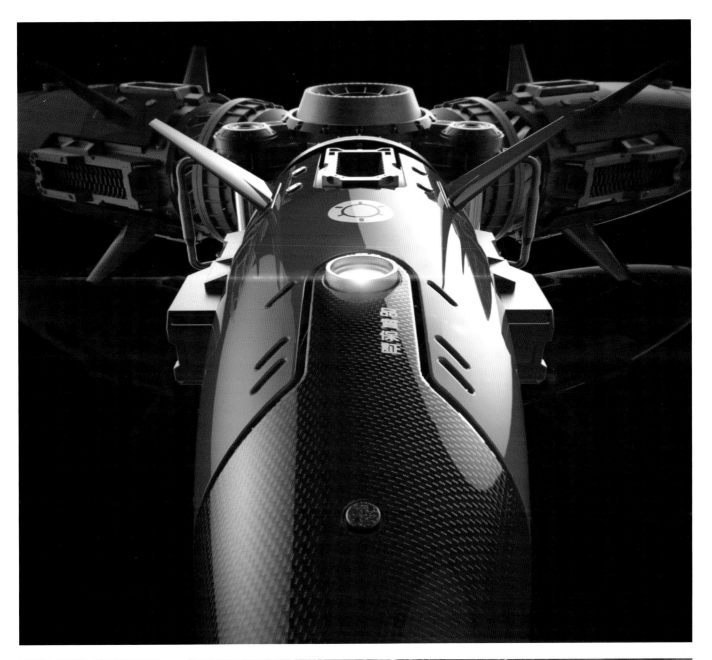

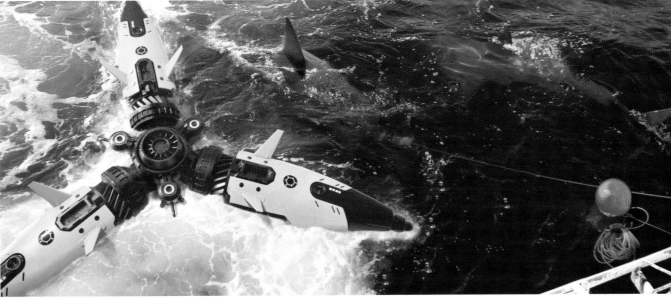

Emmanuel Shiu
Photoshop

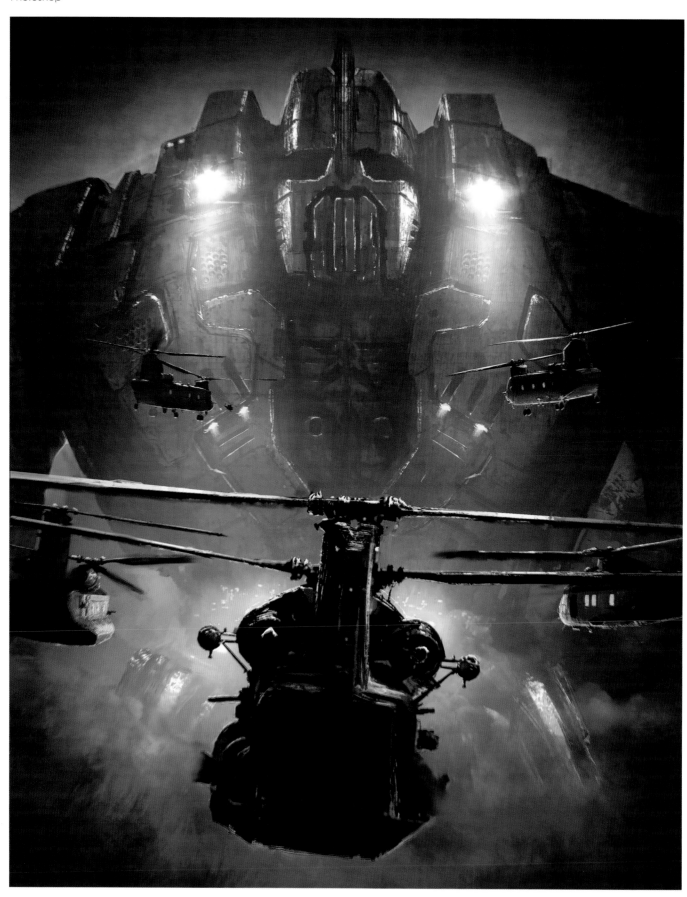

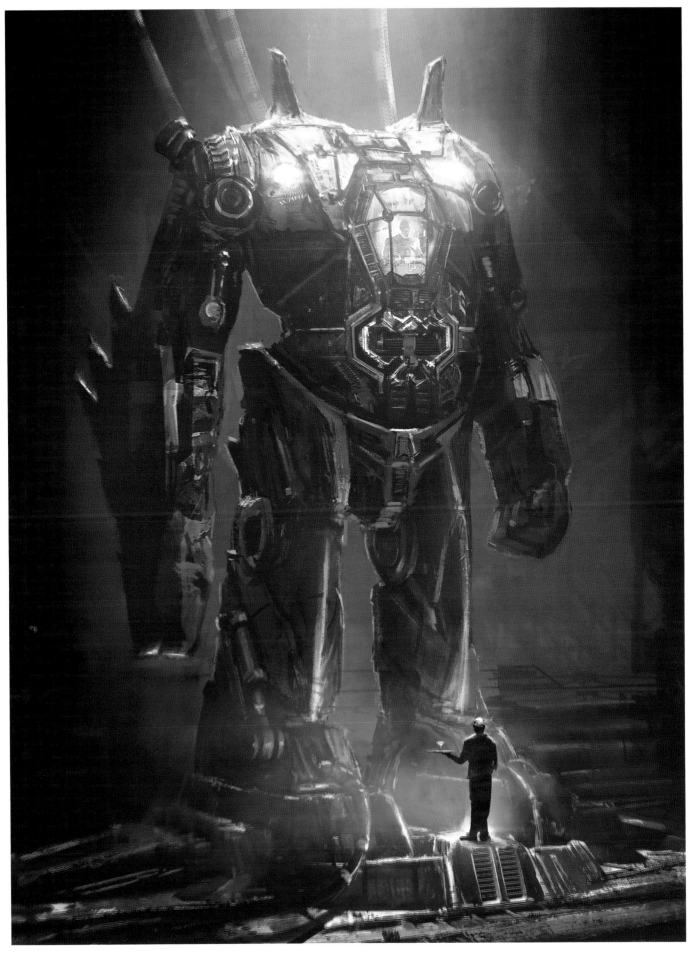

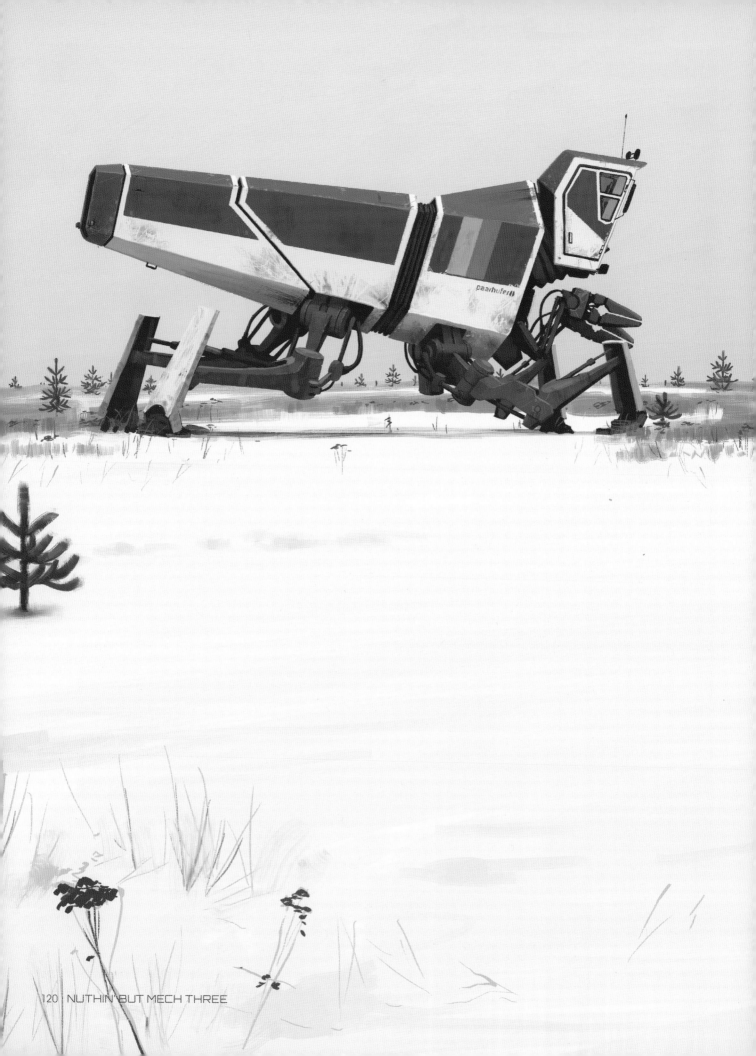

Simon Stålenhag
Photoshop

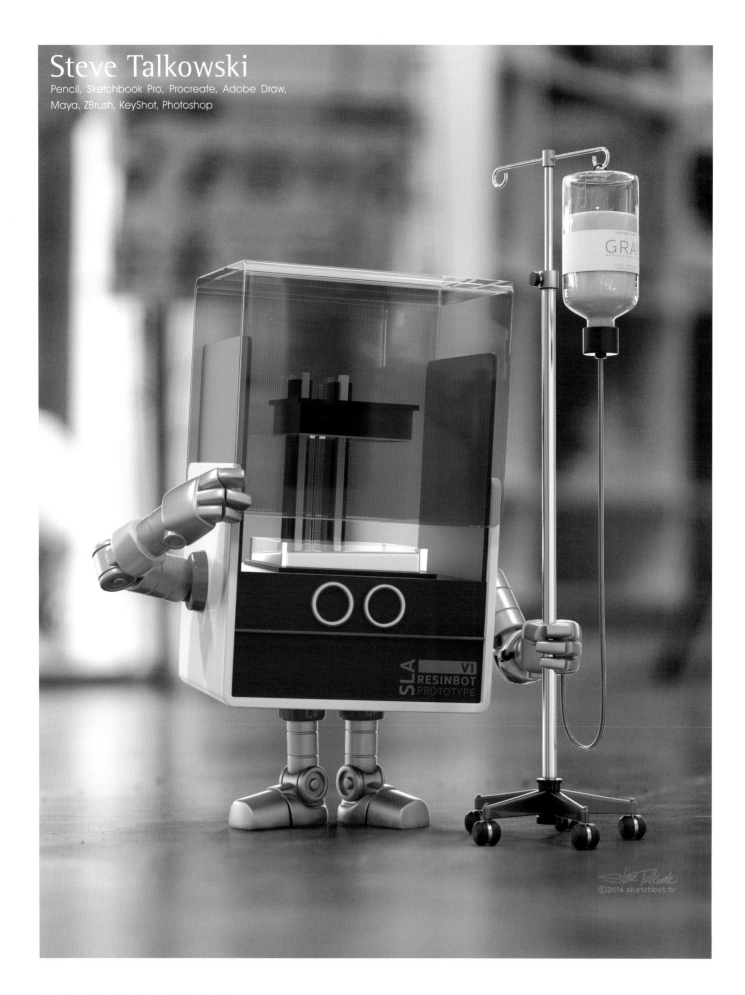

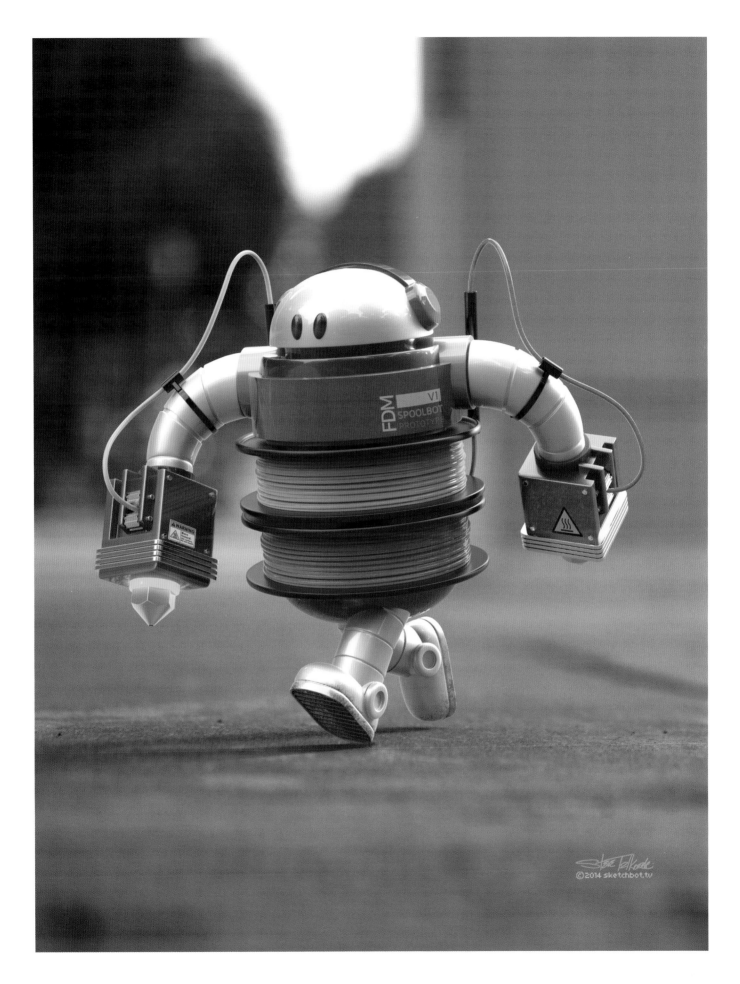

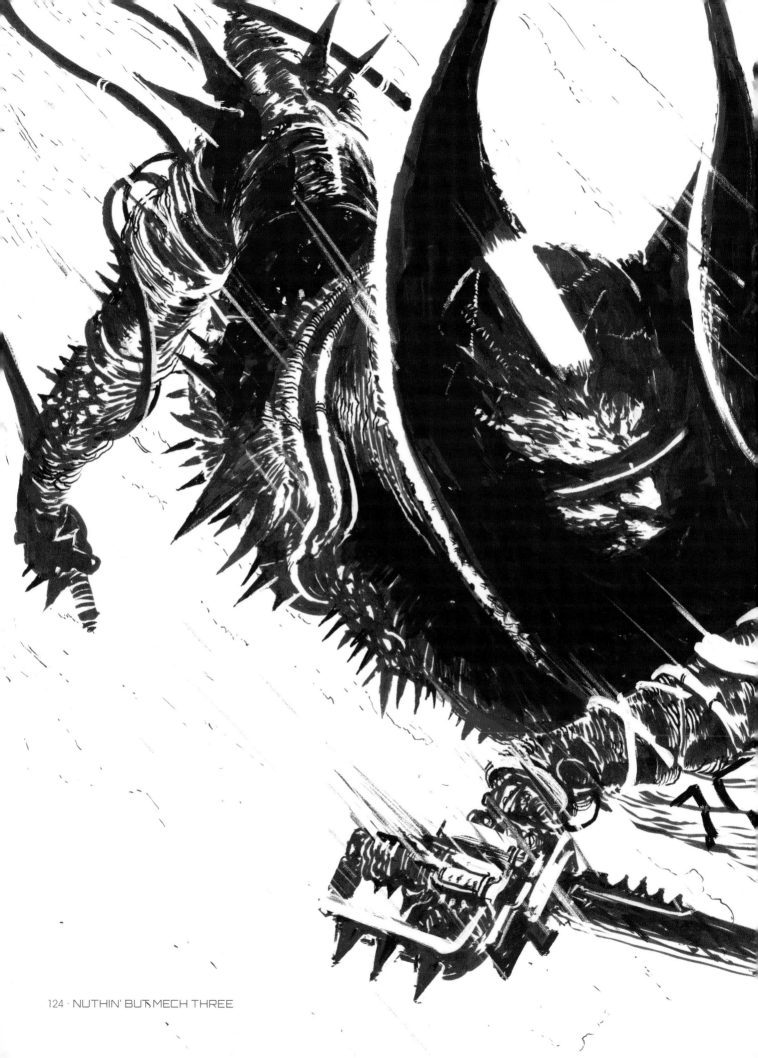

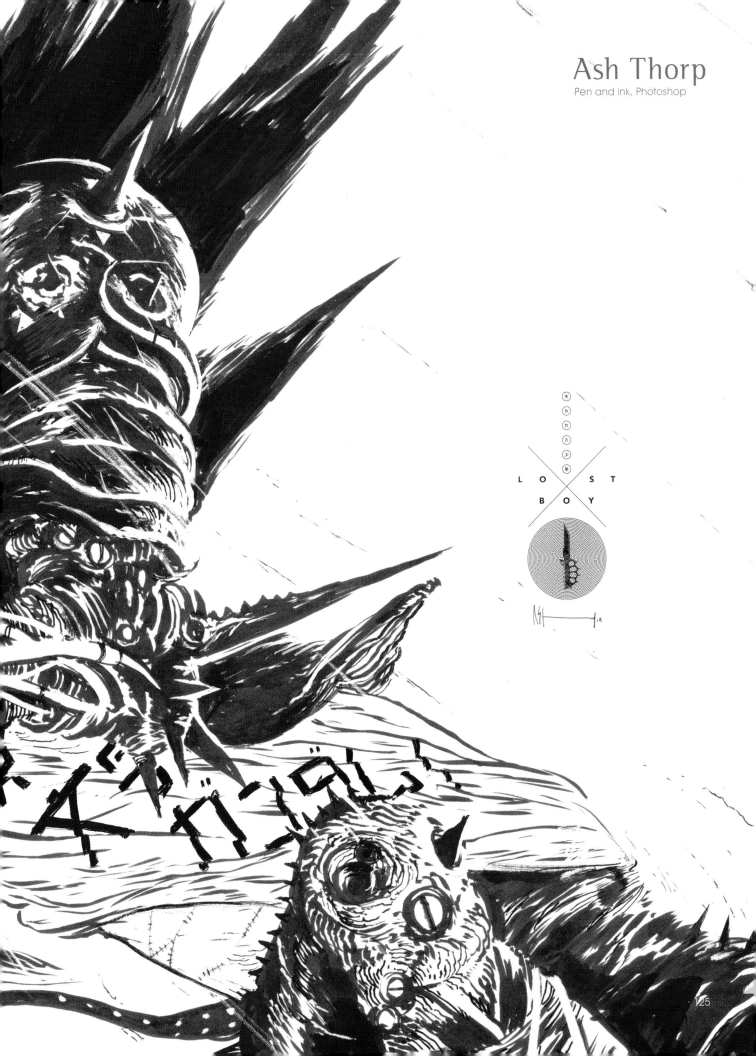

Ash Thorp
Pen and ink, Photoshop

125

Matt Tkocz
Modo, Photoshop

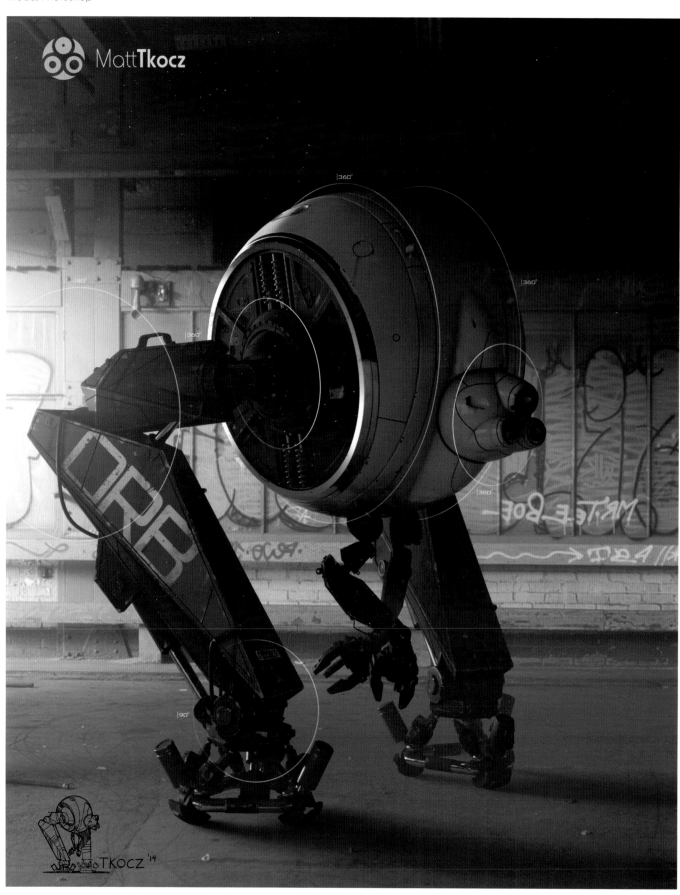

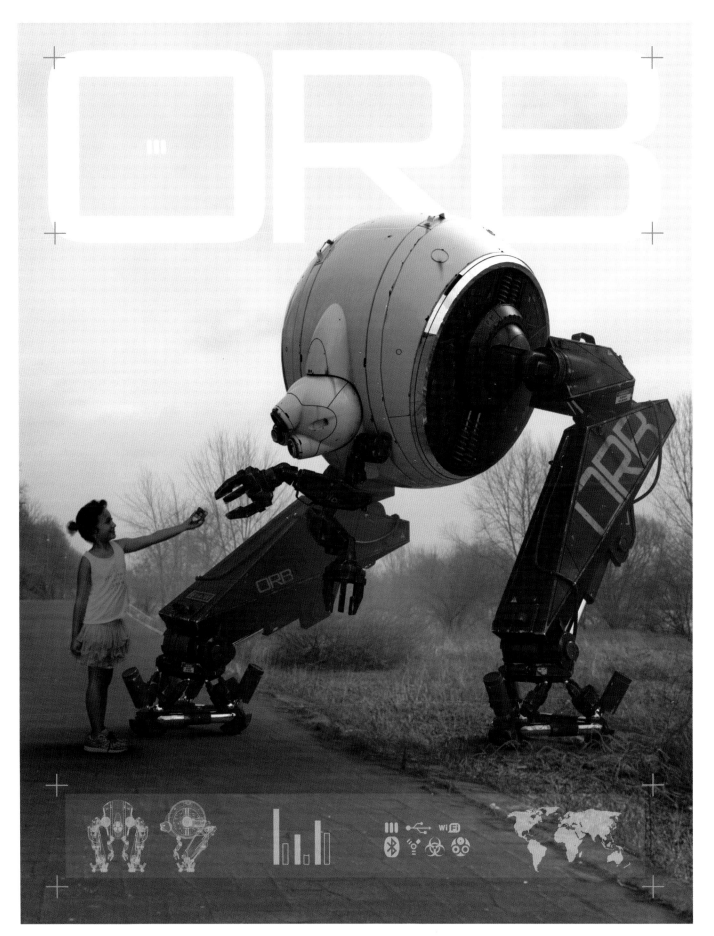

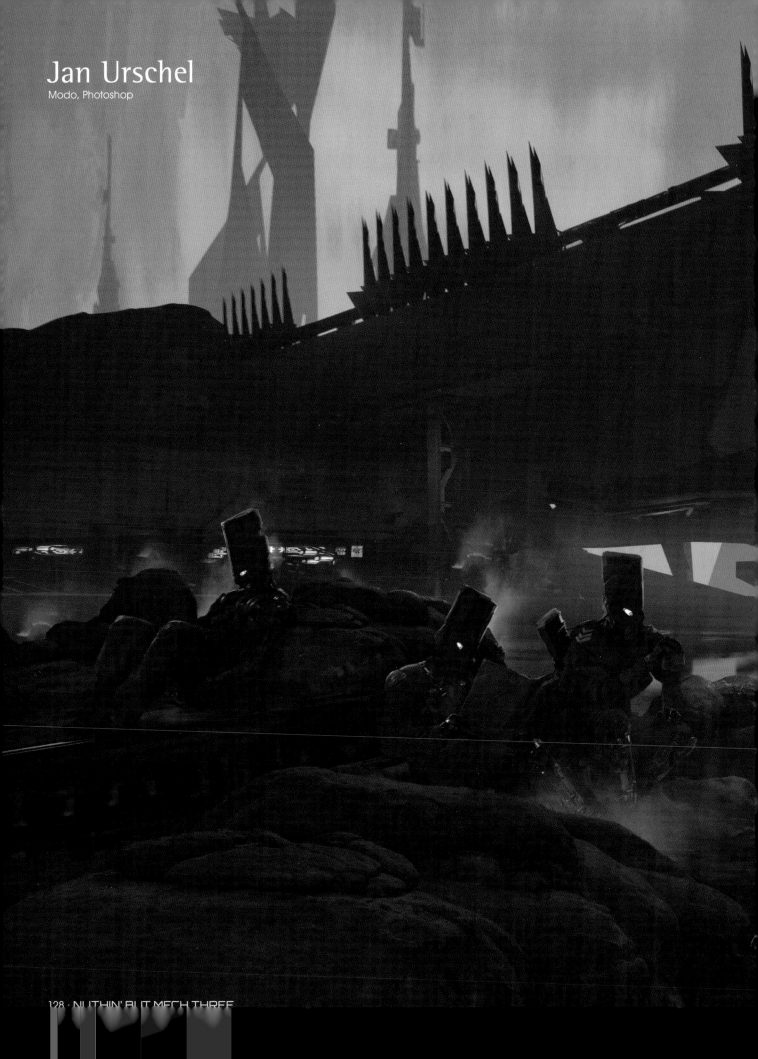

Jan Urschel
Modo, Photoshop

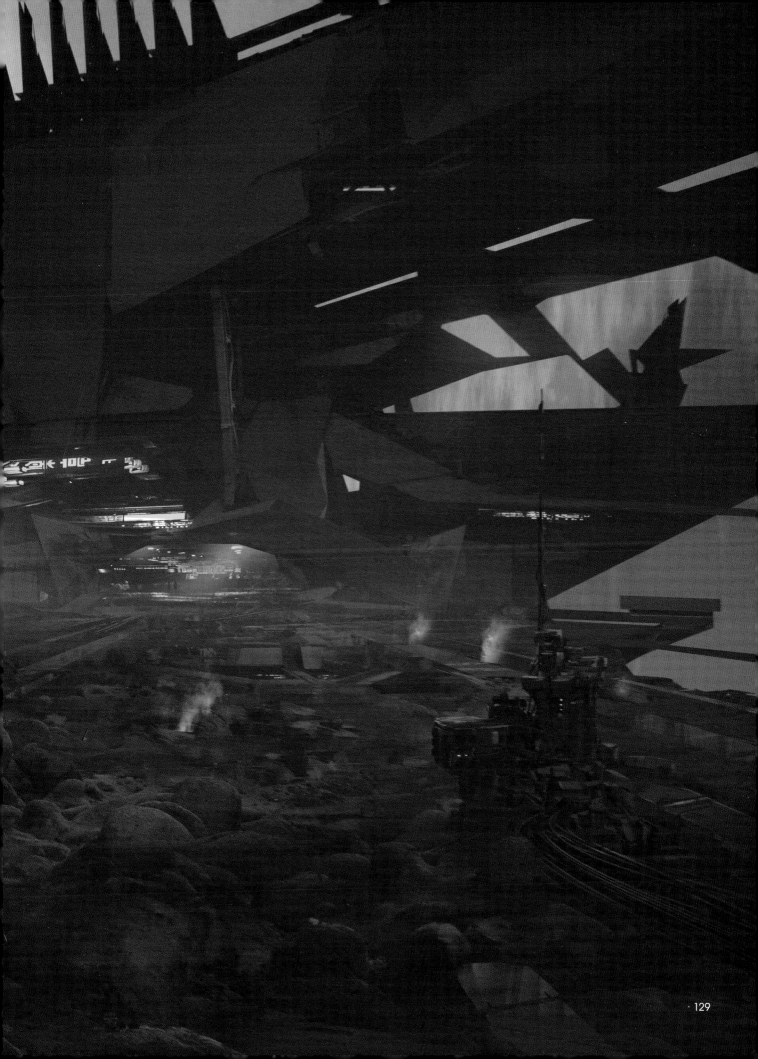

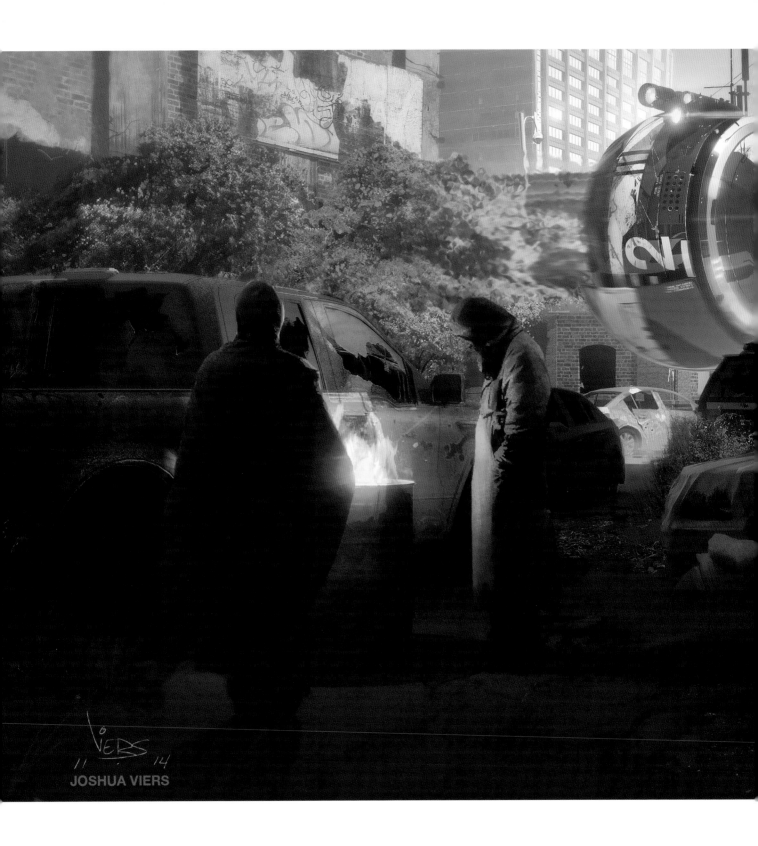

JOSHUA VIERS

Josh Viers
Modo, Photoshop

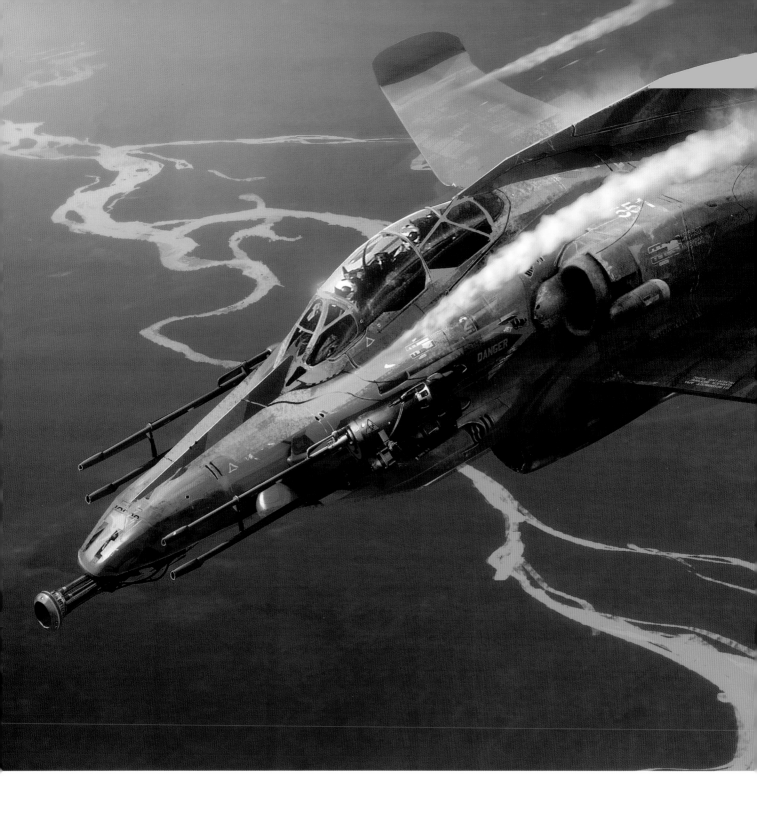

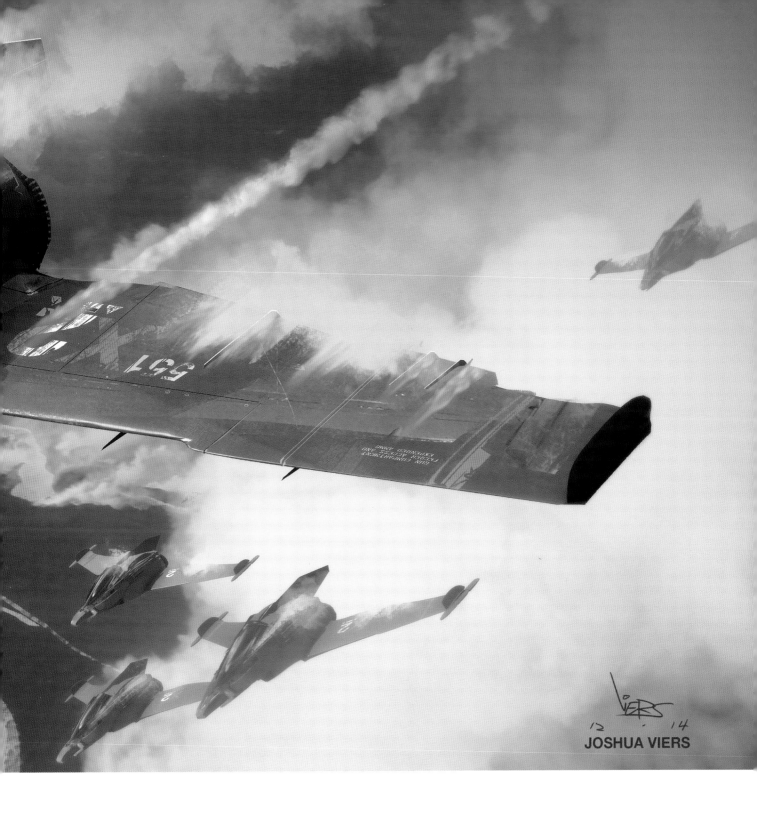

JOSHUA VIERS

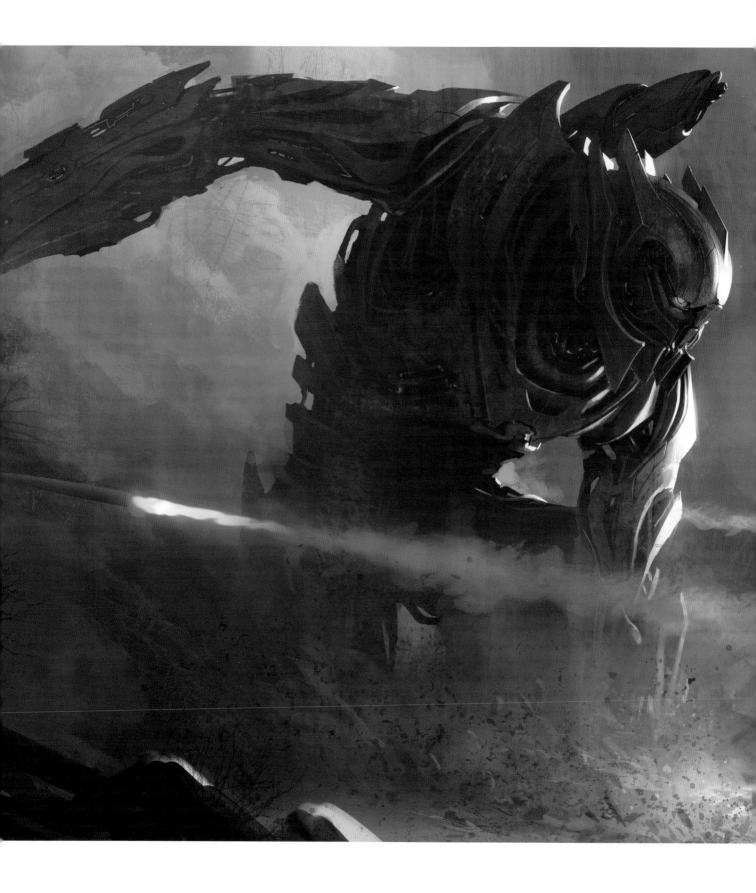

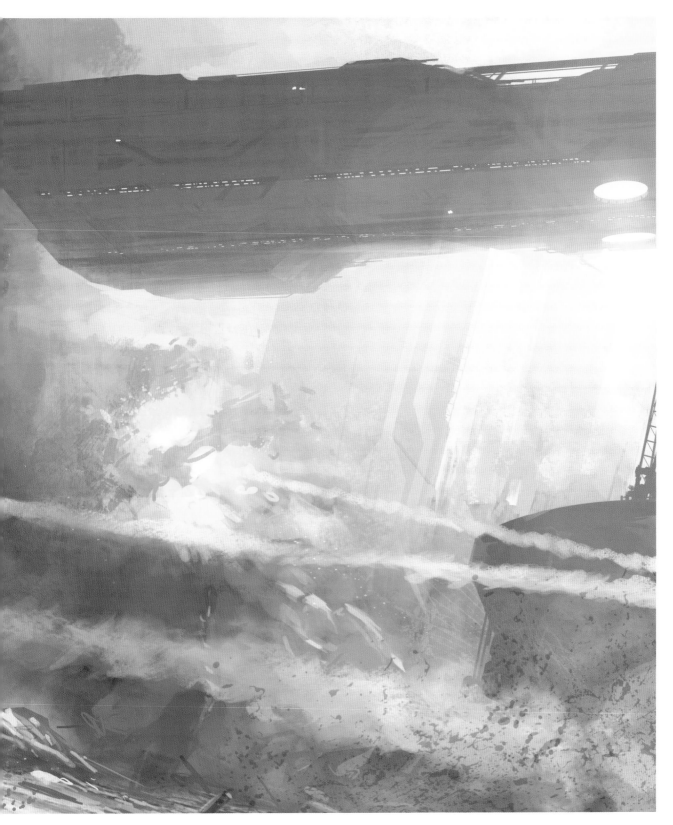

Andrée Wallin
Photoshop

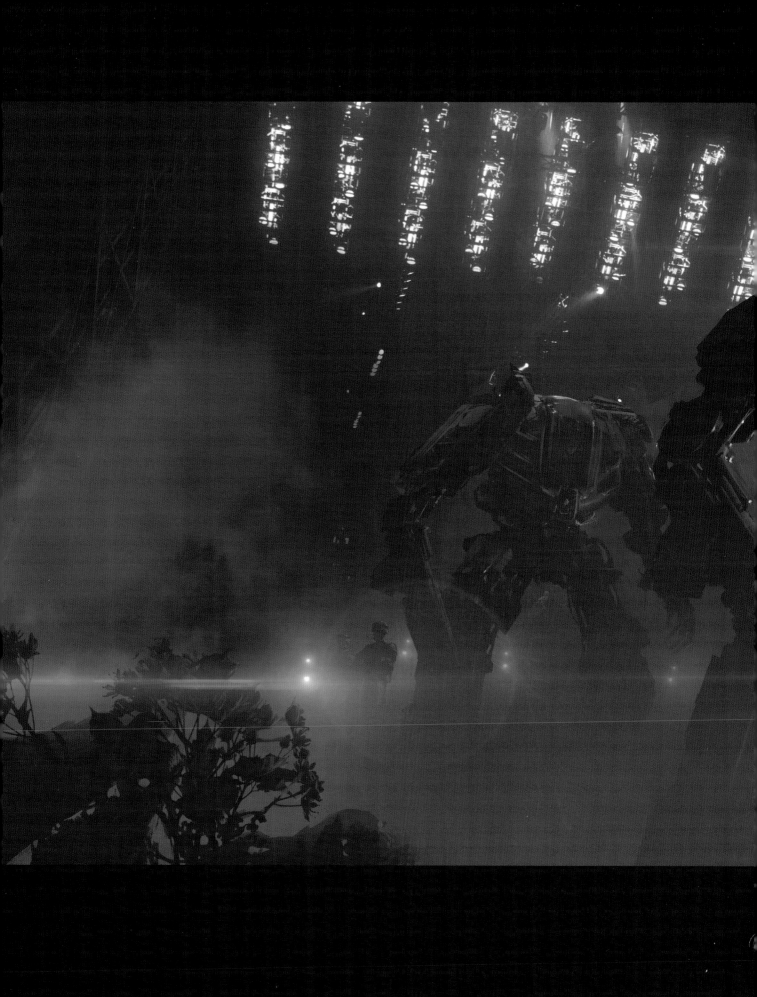

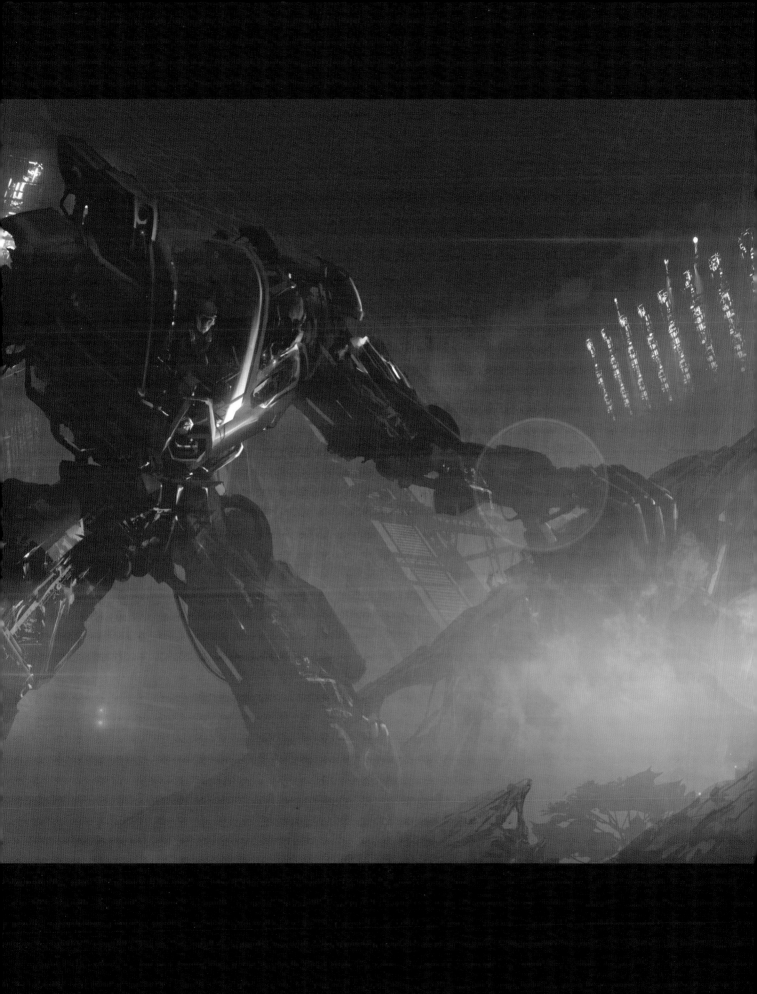

Colie Wertz
Photoshop

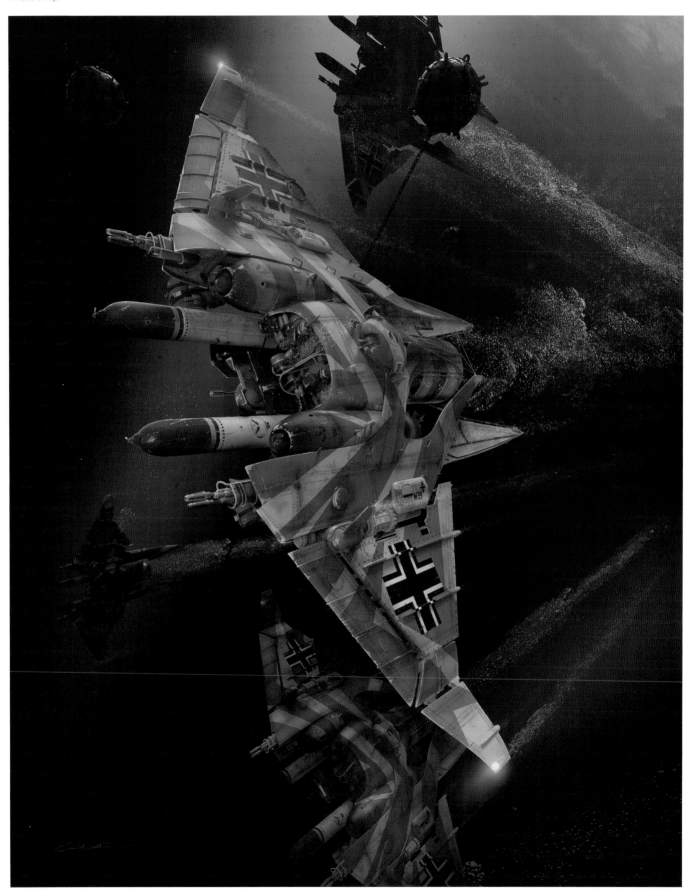

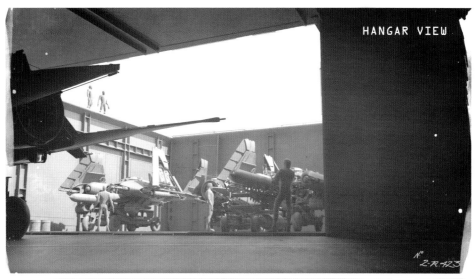

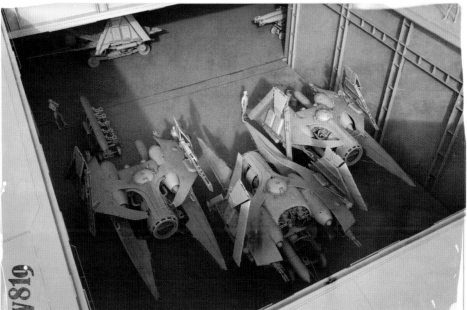

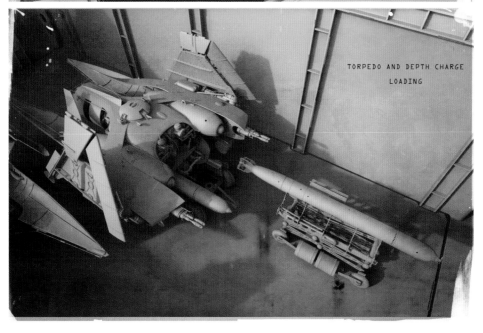

TORPEDO AND DEPTH CHARGE
LOADING

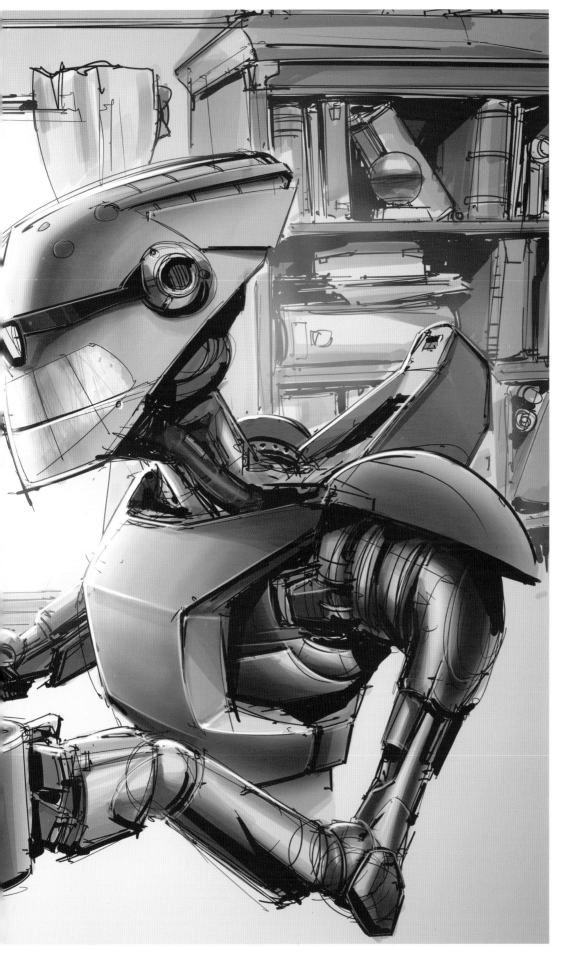

Artist Bios

Darren Bacon

Darren Bacon is a concept artist living in Issaquah, Washington, with his wife and two sons. Formerly of Bungie Studios and Disney, Darren is currently the lead concept artist developing the *Halo* franchise at Microsoft's 343 Industries.

www.darrenbacon.tumblr.com

Aaron Beck

Aaron Beck draws robots. At least until robots draw robots. Then we're all out of a job.

www.aaronbeck.com

Søren Bendt

Søren Bendt is art director and one of the founders of IO Entertainment. Located on the Pinewood Studios lot in the United Kingdom, he produces a broad range of work, from storyboards to concept art and previsualization.

He studied 2D and 3D animation at the Animation Workshop in Viborg, Denmark, and graduated in 2007 with his award-winning short film *Hum*. Since then he has worked at several world-leading studios, including Framestore, the Moving Picture Company, and Double Negative.

His credits include *In the Heart of the Sea, Transcendence, Thor: The Dark World, Captain Phillips, The Dark Knight Rises, John Carter, Harry Potter and the Deathly Hallows: Part 2, The Chronicles of Narnia: The Voyage of the Dawn Treader, Harry Potter and the Deathly Hallows: Part 1, Prince of Persia: The Sands of Time, Clash of the Titans*, and *The Tale of Despereaux*.

www.artofsorenbendt.com
www.ioent.net
www.sonobeno.blogspot.com
www.humfilm.com

Gerald Blaise

London-based Gerald Blaise is a concept/modeling artist in the film industry. He graduated from the ArtFX School of Visual Effects in Montpellier, France.

His passion and skill for drawing robots, spaceships, weapons, and other technical designs has contributed to projects such as *Prometheus, X-Men: First Class, Man of Steel, X-Men: Days of Future Past, Guardians of the Galaxy, Interstellar*, and *Terminator: Genisys*.

www.gerald-blaise.com
blaise.gerald@gmail.com

Neil Blevins

Neil Blevins has been an artist for as long as he can remember. Raised on a healthy dose of sci-fi and fantasy films, books, and video games, he started off painting and drawing traditionally, and then got into 3D graphics while he still lived in his Canadian hometown of Pointe Claire, Quebec. After getting a bachelor of fine arts degree in design art at Concordia University, he moved to Los Angeles where he worked for Blur Studio, creating graphics for video games, commercials, TV, and feature and ride films. He now lives in San Francisco working as a digital artist for Pixar Animation Studios, creating environments and doing previsualization and visual development. Neil also has worked on such films as *The Incredibles, Cars, Wall-E, Up,* and *Brave*.

In his spare time, he makes sci-fi 3D/2D hybrid artwork depicting creatures, robots, and alien landscapes, and he also creates CG tools and writes art-related lessons and tutorials to give back to the community that has been so gracious in helping him get to where he is today. Neil is currently working on his first visual development book along with several other industry professionals, and hopes to see it released in early 2016.

www.neilblevins.com

Chris Bonura

Chris Bonura is from northern New Jersey, where he grew up on a diet of monsters and muscle cars. Shortly after his college graduation he became a concept artist at a small game company. Since that time he has worked his way up to his current role as a concept artist in the film industry. Some of his most recent work can be seen in *Star Trek Into Darkness, Transformers: Age of Extinction, Avengers: Age of Ultron*, and *Star Wars Episode VII: The Force Awakens*. Christopher feels fortunate to be where he is today as a person and an artist. Along his endeavors, he has met many other great artists and looks forward to what the future holds for him.

www.chrisbonura.carbonmade.com

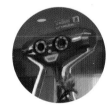

Al Brady

Based in the United Kingdom, Al Brady works for game companies as a concept artist and enjoys painting all kinds of other things for a hobby.

boac.artstation.com
www.aj-brady.squarespace.com

Sam Brown

Sam Brown received his bachelor of science degree in industrial design from the University of Cincinnati. He has been employed as a concept artist in the entertainment industry since 2006 and has spent more than eight years at Massive Black. Sam is currently working with the talented folks at 343 Industries.

www.sambrown36.tumblr.com

Vitaly Bulgarov

Vitaly Bulgarov is a concept designer currently working in the field of surgical robotics for Intuitive Surgical, Inc., and industrial design for Intel's New Devices Group, Inc. His previous experience includes working in the video game and film industries on such projects as *Starcraft II: Wings of Liberty, Diablo III, World of Warcraft, Transformers: Age of Extinction,* 2014's *RoboCop,* and other unannounced projects. The list of clients Vitaly has worked for includes Metro-Goldwyn-Mayer, Skydance Productions, Oakley, Industrial Light & Magic, Blizzard Entertainment, Paramount Pictures, and DreamWorks Pictures, among others.

www.bulgarov.com

Kirill Chepizhko

Kirill Chepizhko is a concept artist/industrial designer who was raised by wild bears in Mother Russia. Specializing in, but not limited to, hard-surface design, Kirill puts an original spin on his real-world-influenced designs. He is currently working as a freelancer in the entertainment industry.

www.kirillmadethis.com

Robert Chew

Currently living in Los Angeles, Robert Chew works as a freelance illustrator/concept artist in various industries. Combining influences of nature, science/technology, and elements of fantasy, he strives to create high-quality artwork that is both exciting and thought provoking. In his work, Robert places emphasis on believability and functional design.

After graduating from art school in San Francisco in 2012, he moved to Los Angeles to start his career. Since then, he's done work for a theme park project, illustrations for various mobile/social games, book covers, advertising, and commercials. His future aspiration is to work in the video game industry. His current priorities are his personal projects, particularly Big Five, which focuses on drone application toward anti-poaching efforts in Africa.

When Robert is not drawing or painting, he enjoys traveling abroad, building Japanese model kits, and playing video games.

www.robertbchew.carbonmade.com

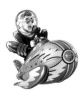

Kevin Conran

Kevin Conran cocreated and designed the landmark Paramount Pictures film *Sky Captain & the World of Tomorrow,* which starred Jude Law, Angelina Jolie, and Gwyneth Paltrow. Working as an art department of "one," the interior and exterior sets, props, characters, vehicles, and costumes were all derived from his hand. The film itself was the first of its kind. Shot entirely against blue screen, its unique design and production process paved the way for such films as *Sin City, 300,* and James Cameron's *Avatar.*

Kevin has since worked on a wide range of film, television, and video game projects, including the movies *The Mummy: Tomb of the Dragon Emperor, G.I. Joe: Retaliation, the Bee Movie,* and *Monsters vs. Aliens,* as well as the Nickelodeon series *Supah Ninjas* and Cartoon Network's Annie Award–winning *Dragons: Riders of Berk.* His video game work includes *Call of Duty: Black Ops II* and Spark Unlimited's *Legendary.*

www.kevinconran.com

Thierry Doizon

Barontieri (Thierry Doizon) grew up surrounded by lemurs in Madagascar, spent his college years in Mali, and eventually got a diploma for industrial design in southern France. However, it was only after receiving a bachelor's degree (Hons) in interior design in 1995 from the University of Creative Arts, in Rochester, United Kingdom, that he fell into the weird world of entertainment.

Thierry has been an active concept designer/art director in the gaming industry and the online communities of digital concept artists since the early speed-painting days. He has had the privilege of working for different companies around the globe such as Acclaim Studios, Splash Damage, Ubisoft, Disney Interactive, and Eidos, where he was a driving force behind titles like *Assassin's Creed, Prince of Persia, Tron: Legacy, Deus Ex: Human Revolution, Warp, Shape Up,* and countless more. In addition, Thierry has been invited to speak at various workshops and conferences at Disney Imagineering, ADAPT, Ubisoft, The Gnomon Workshop, Montreal International Game Summit, Florida Interactive Entertainment Academy, and Massive Black, and he also cofounded Steambot Studios *(Exodyssey, Steampainting),* which he left to focus on a diverse array of personal projects, including illustrations, sports events, art books, and teaching.

When he is not snowskating the local mountains or riding the rapids of the Saint Lawrence River on his stand up paddle board, you can find him working as a brand manager/art director at Square-Enix in Montreal.

www.barontieri.blogspot.ca
www.barontieri.com

TyRuben Ellingson

The son of Minnesota artist and university professor William John Ellingson (1933–1994), TyRuben spent his childhood in his father's studio drawing, painting, and constructing cardboard "machines."

While completing his master's degree at St. Cloud State University from 1981 to 1982, he taught sections of drawing and design and exhibited his paintings in regional and national shows. In 1988, he completed his master of fine arts degree in painting at Southern Methodist University located in Dallas, Texas.

Combining his fine art successes with a lifelong interest in film, TyRuben landed a position at George Lucas's Industrial Light & Magic in 1989 as a visual effects art director. While at ILM, TyRuben contributed to the creation of groundbreaking special effects for films such as *Jurassic Park*, *Star Wars IV: A New Hope*, *The Flintstones*, *Casper*, and *Disclosure*. Later, in 1995, he accepted an invitation by director Guillermo del Toro to act as principal designer of the signature creature for the film *Mimic*, which launched TyRube's freelance career. In the following decades he provided designs for a number of del Toro's other films, including *Blade II*, *Hellboy*, *Hellboy II: The Golden Army*, and *Pacific Rim*.

In 2006, he joined the team at Lightstorm Entertainment to work as lead vehicle designer for director James Cameron's science-fiction epic, *Avatar*. Other films to which TyRuben has lent his creative talents include *Blade: Trinity*, *Signs*, *Surrogates*, *Priest*, *Battle: Los Angeles*, and *Elysium*.

Beginning in the fall of 2013, he joined the faculty of Virginia Commonwealth University as a professor in the Communication Arts department where he teaches classes focused on conceptual design.

www.alieninsect.com

Ben Erdt

In early 2006, after seven years of doing level design as a hobby, Ben Erdt started diving fully into CG specializing in monsters and characters, which became his passion. After graduating from Vancouver Film School in 3D animation and visual effects in 2012, he got a job with Guerrilla Games.

Today Ben is a professional character and creature artist, from concept to production model. He is at home with many styles and techniques from organic to hard surface, realistic to imaginary.

This passion, along with constant studies and learning new tools and workflows, helps him to expand and improve his skills with every new project.

www.ben-erdt.de

Justin Fields

Justin Fields is the owner of IronKlad Studios and a concept artist who studied at the Gnomon School of Visual Effects. He currently works in the film and game industries, and his clients have included such studios as Amalgamated Dynamics, Inc., Imaginary Forces, and Sony Pictures Imageworks. Originally from Springfield, Illinois, Justin has worked in the graphic design field since 2005. Some of his credits include DirecTV, *Jupiter Ascending*, *Maleficent*, *Noah*, *Dawn of the Planet of the Apes*, *Firelight*, *Blink*, *Falling Skies*, *The Wolverine*, *Scrapyard*, *Shannara*, *Eternals*, *Ragnarock*, *Goosebumps*, *Max Steel*, and *Kong*.

www.ironkladstudios.com

Landis Fields

Landis Fields is a filmmaker and artist in the visual effects, feature animation, television, video game, and amusement park industries. Having specialized in multiple phases of production from art directing to editing for various projects throughout his career, his portfolio ranges from work on *Star Wars* to Super Bowl commercials. Landis discovered his passion for filmmaking during his time in the military with the Untied States Air Force. He is currently working for Disney at Lucasfilm's Industrial Light & Magic and enjoys using his mix of a creative/technical background to push the limits of 3D printing as a visual tool for storytelling.

www.landisfields.com

Danny Gardner

From the beginning, Danny Gardner has had a passion for art. Born in 1989, he grew up in a family of creative people and has been drawing since he was three years old. He took figure drawing, painting, and animation classes in high school along with product and transportation design classes through Art Center College of Design's Saturday High program. Danny had always dreamed of attending Art Center to major in transportation design, but after a year at Pasadena City College, when he was ready to apply to Art Center, he became aware of a new major at the school, entertainment design. Having immediately fallen in love with concept design, he changed his focus (though he still has an immense passion for automobiles).

After graduating from Art Center, Danny worked as a freelance artist until he landed a position at Sony Santa Monica. He worked there for three years and is currently working at Respawn Entertainment. With a rapidly growing interest in traditional painting and product design, he looks forward to producing the ideas in his head through many different creative outlets.

www.dannydraws.com

Eduardo Gonzalez

Eduardo Gonzalez has been in the games industry for more than 10 years. He has influenced the art for some of the biggest hits in recent game history: AAA titles such as *Army of Two: The 40th Day*, *God of War*, *Kill Zone*, and *Twisted Metal*, among others. Now with Riot Games as a visual lead for the extremely popular MOBA PC title *League of Legends*, Eduardo is creating and leading the visual direction of numerous champions. He has also led the visual development of the new game mode Dominion. Eduardo is a graduate of Art Center College of Design, in Pasadena, California, where he earned a bachelor of fine arts degree in illustration.

www.ed-art.net

Edon Guraziu

Edon Guraziu is a concept designer located in the Netherlands. Focused on science fiction, his fields of expertise are industrial and conceptual design, using both 2D and 3D to achieve his results.

www.edonguraziu.blogspot.nl

Brian Hagan

Brian Hagan has been working in the fields of comics, games, and entertainment design for more than 17 years. Always looking for new angles to familiar ideas and trying to put a personal fingerprint on projects are the hallmarks of his work. He is currently working on a comic, *Ravenwing*, and developing a line of mech model kits for Masterpiece Models.

www.artofhagan.com

Patrick Hanenberger

Patrick Hanenberger was born in Melbourne, Australia, and raised in Wiesbaden, Germany. He earned a bachelor of fine arts degree in industrial and graphic design at the University of Michigan and a bachelor of science degree in transportation design at Art Center College of Design in Pasadena, California. He was the production designer for the DreamWorks film *Rise of the Guardians*, and during his nine years at DreamWorks Animation he also worked as an art director and concept artist on many other titles for the studio. Today he continues to work as a production designer in the animation industry, a concept artist for live-action film, and a visual consultant for the gaming industry. In addition, Patrick is a part-time instructor for visual communication at Art Center. Together with his wife, Margaret, he is the founder of The Neuland, an international design consultancy. Some of their recent clients include Crytek, Reel FX, and Paramount.

www.patrickhanenberger.com
www.theneuland.com

Eric Joyner

Award-winning artist Eric Joyner was born in 1960, in San Mateo, California. He attended the Academy of Art in San Francisco and later began to work professionally as an illustrator. For the next decade, Eric was a hired gun for various publishers, high-tech companies, and advertising agencies. In the 1990s, he began doing digital animation and background art for animations, and provided other artistic services for a variety of companies before rediscovering his original love of drawing and painting. His awards include a 1989 Judges Award from San Francisco Society of Illustrators, 2004 honorable mention from the New York Society of Illustrators, and the following from Spectrum: 1989 Gold medal, Unpublished category; 2003 Gold medal, Unpublished; and its 2004 cover.

www.ericjoyner.com

Kurt Kaufman

Kurt Kaufman is an entertainment concept artist in Los Angeles and the San Francisco Bay Area. He works on major feature films, as well as games, theme parks, and commercials. This volume's *Nuthin' But Mech* piece is the production model of last year's Multi-Tool Adventure-Bot "prototype," which was inspired by his adventure motorcycle and a general obsession with all gadgets, and is the ultimate all-purpose traveling companion.

www.kurtkaufman.com
kurtkaufman@comcast.net

Ara Kermanikian

Ara Kermanikian is a concept designer with a focus on futuristic character, creature, vehicle, and set design. He is a professor in the digital media department of Otis College of Art and Design and author of *Introducing Mudbox*, published by Sybex Wiley, and several articles in *3D Artist* magazine. His work is also showcased in galleries of several Sybex books, including several editions of *Mastering Maya* and *Introducing ZBrush*. Ara is currently working on his second book, *Polysculpting*, forthcoming from Design Studio Press, focusing on his strategic approach to creating well-organized 3D geometry using a hybrid of low-poly modeling tools such as Maya and multimillion polygon digital-sculpting tools such as ZBrush.

Ara has a bachelor's degree in computer science from California State University, Northridge, and has studied at Art Center College of Design and Gnomon School of Visual Effects.

www.kermaco.com

Gavriil Afanasyev Klimov

Gavriil Afanasyev Klimov is a concept artist working in the film and game industries. Born and raised in Europe, he moved to Los Angeles to attend the Art Center College of Design, majoring in industrial design with a focus on entertainment design. Since graduating, Gavriil has worked on a wide variety of projects for such studios as Activision, Adhesive Games, Blizzard Entertainment, Blur, Ignition Creative, Kojima Productions, MPC, NVIDIA, Paramount Pictures, Pixar Animation Studios, Prologue, Rhythm & Hues Studios, and Treyarch. He is currently traveling the world while freelancing on film and game projects.

www.gavriilklimov.com

Bastiaan Koch

Filmmaker and designer Bastiaan Koch is a member of Marauder Film and works for Industrial Light & Magic. He is noted for his work on powered exoskeletons, robotics, and his CG mecha design for the *Transformers*, *Pacific Rim*, and *Avengers* movies.

www.facebook.com/IsThisHeavenmovie
www.facebook.com/followthecamera

John Liew

John Liew is a concept artist and digital illustrator who works in the film and games industries. He studied industrial and entertainment design at FZD School of Design in Singapore. Shortly after finishing school he began working for CD Projekt RED in Warsaw, Poland.

www.johnliewconcept.blogspot.com
johnliewdesign@gmail.com

Vaughan Ling

Vaughan Ling is an instructor at Concept Design Academy in Pasadena, California, who has worked in video game, film, product, automotive, naval, and theme park design.

His past clients include Disney (*Tron: Uprising*), Marvel, Warner Animation, Insomniac Games (*Sunset Overdrive*), Mattel (Hot Wheels), Psyops, Little Tikes, Honda, Curiosity Shoppe, K Motion Pictures, and Melrae pictures (*Space Junk 3D*).

www.heavypoly.com
www.facebook.com/vaughan.ling

Miguel Lopez

After teaching for a few years following his studies at the University of Texas at El Paso, El Paso native and artist Miguel Lopez chose industrial design at Arizona State University as his path to a more design-focused career. He now designs Hot Wheels and Matchbox toy vehicles at Mattel in El Segundo, California. A brief stint at freelance work in entertainment doing key art, storyboarding, and video game concepts allowed him to experiment artistically within Mattel. He has created graphic arts, package art, and currently 3D modeling in Maya and Zbrush while still attending workshops in the area to keep up with today's competition. Since working at Mattel, he has quickly become the favorite uncle to his niece and nephew, Lucy and Lucas, since they now know Miguel gets free toys at work. If you ever see an Infiniti G35 loaded with toys in the back traveling east, yup, that'd be him.

www.devilminercom.blogspot.com
mlopezart@yahoo.com

Benjamin Louis

Benjamin Louis is a French creative designer at Faurecia, a worldwide automotive interior supplier. He lives in Detroit, Michigan, and is responsible for the General Motors design account, working on production car interiors as well as internal research and innovation projects, forecasting two to five years ahead. His daily job consists of challenging ergonomics, kinematics, costs, quality, and manufacturability constraints while infusing a proper brand styling into the design.

Benjamin was awarded with a First Class special distinction in 2007 for his Transportation Design and Management master's degree at the Institute School of Design, France, not only for his car designs, but also a 30-foot-long yacht (in production since 2007 and sold worldwide), as well as motorcycles, quads, and many other projects.

During his free time, being a highly curious and constant self-improver, Benjamin likes to step aside from today's reality and unleash his growing creativity on personal projects such as spaceships, cars, concept arts, and obviously, last but not the least, mechs.

asphaaalt.blogspot.com
design.benjamin@gmail.com

Ben Mauro

Ben Mauro is an American concept designer who studied industrial design and entertainment design at Art Center College of Design in Pasadena, California. After college he relocated to Wellington, New Zealand, where he worked at Weta Workshop from 2009 to 2013, contributing to a vast array of film, television, and video game projects such as *The Hobbit* trilogy and *Elysium*, among many others. He is currently working as an independent freelance concept designer, continuing to offer his design services to clients around the world, including Boston Dynamics, Treyarch, Sledgehammer Games, MPC, Legendary Pictures, Lucasfilm, Rhythm & Hues Studio, Activision, EuropaCorp, Universal Pictures, Sony Pictures Animation, Insomniac Games, Design Studio Press, and Vishwa Robotics.

www.artofben.com

John McInnis

John McInnis graduated from the University of North Texas, where he studied graphic design and computer animation. After working on commercials for five years, the Texas native headed west to Los Angeles to pursue a career in film. Since 2000 he has worked on more than 20 feature films, commercials, and game cinematics as a storyteller, concept designer, sculptor, animator, and previsualization artist. John currently works at DreamWorks Animation.

www.johnwmcinnis.blogspot.com

Elijah McNeal

Elijah McNeal is a concept artist working in the entertainment industry. He's lent his skills to studios such as Black Tusk, Epic Games, WB Montreal, Cloud Imperium Games, and Troublemaker Studios. He spends his days designing characters and hard surfaces and his nights studying classical art and painting.

mcneal@emcnealdesign.com
el1j4h.artstation.com

Ian McQue

Formerly assistant art director on the *Grand Theft Auto* series at Rockstar North, Ian McQue is now a freelance concept artist and illustrator.

www.ianmcque.bigcartel.com
www.twitter.com/ianmcque
www.facebook.com/ianmcque

Patrick O'Keefe

Born in Toronto, Canada, Patrick O'Keefe is a Bay Area-based illustrator working in the entertainment industry. Patrick studied illustration at Sheridan College and film design at the Emily Carr University of Art and Design, and he is currently a senior concept artist at Visceral Games.

www.theOKartist.com

Long Ouyang

Long Ouyang is currently a freelance concept artist working in film and games. He is a sucker for anything sci-fi, and his other interests include fashion.

www.cargocollective.com/long0800

James Paick

James Paick is the founder and creative director at Scribble Pad Studios. With more than 15 years of design experience, James is also cofounder of Brainstorm School in Glendale, California, an entertainment art and design school.

Scribble Pad Studios, under the direction of James, has been responsible for creating some of the most memorable designs and moments in entertainment design. He has developed many projects within the gaming, film, theme park, illustration, entertainment space, and advertising fields. His clients include Riot Games, Naughty Dog, Electronic Arts, Sony, Respawn Entertainment, Epic Games, Activision, NCSOFT, Crystal Dynamics, Wizards of the Coast, and many more.

Heavily involved in education, James has been instructing future artists of the entertainment industry for almost eight years. He has taught at many design institutions such as Brainstorm School, Art Center College of Design, Otis, Fashion Institute of Design & Merchandising, Concept Design Academy, FZD School of Design, and CG Master Academy, and conducted workshops worldwide.

James is currently working with his team of designers at Scribble Pad Studios on many unannounced projects, including new next-gen games, MMOs, books, films, and more!

www.scribblepadstudios.com
james@scribblepadstudios.com

Sunil Pant

Sunil Pant is an entertainment designer engaged in concept design and 3D visual development on feature films, games, and commercials.

Having acquired a bachelor's degree from the Academy of Art University, San Francisco, he has worked on several Hollywood blockbusters, including *Megamind* for DreamWorks Animation, *Escape from Planet Earth* for Rainmaker Entertainment, and *Ironman 2* for George Hull Design, to name a few. Starting off as an intern at Electronic Arts on *The Simpsons* game, Sunil subsequently worked on feature film and commercial projects with the industry's leading designers and art directors, such as Hull (visual effects art director, *The Matrix* films) and acclaimed production designer Ged Clarke. In addition, his work is featured alongside some of the industry's leading art directors and designers in the previous *Nuthin' but Mech* volumes.

Sunil is currently the senior concept designer and illustrator on the highly anticipated film *Paani* ("water") by Shekhar Kapur, the acclaimed director who directed *Elizabeth* and *The Four Feathers*, among other films.

He continues his passion for film and entertainment design by offering his design and visual consulting services to clients worldwide.

www.sunilpant.com

Jake Parker

Jake Parker is an illustrator, concept artist, and comic creator. Since the turn of the century, he's worked in the publishing and entertainment industries on everything from commercials and animated films to graphic novels and picture books. His film credits include *Titan A.E., Horton Hears a Who!, Ice Age: Dawn of the Dinosaurs,* and *Rio.* He is also the creator of the all-ages *Missile Mouse* graphic novel series published by Scholastic. Jake lives in Utah with his wife and children.

www.mrjakeparker.com

Peter Popken

In a career that dates back to 1996, Peter Popken has worked on numerous movies in a variety of genres. Peter contributed designs and renderings to several projects of the Wachowski siblings and the Marvel franchises *Thor* and *The Avengers.* Among his credits are *V for Vendetta, The Bourne Supremacy, Prince of Persia: The Sands of Time, Mission: Impossible,* and Martin Scorsese's *Hugo.* Peter holds a diploma in visual arts and communication, and he conducts workshops at various events and film schools.

www.peterpopken.com
www.peterpopken.blogspot.com
mail@peterpopken.com

Chris Rosewarne

Chris Rosewarne is a British concept artist and illustrator working in the film and television industries. His fast cinematic renderings and industrial prop designs have led him to work on projects internationally, from Los Angeles to London and many studios across Europe. Born in 1978 to artist parents, Chris grew up in London and studied art at St. Martins College before graduating with a bachelor's degree (Hons) in model making for design and media in Bournemouth, England. In 2003, Artem Visual Effects employed him as a freelance model maker to work on the films *Reign of Fire* and Terry Gilliam's *The Brothers Grimm.* After four years as an industry prop maker, Chris turned his attention to the art department and began work on the sci-fi cult game adaptation of *Doom,* for which he applied his hands-on knowledge of machining, materials, and workshop processes to the design of props and set dressing.

He has since worked on a wide range of productions, from making high-tech designs and atmospheric key frames for George Lucas's *Star Wars* TV series, to intricately detailed matte paintings for the BBC's documentary series *Planet Dinosaur.* Chris's most recent projects include Tim Burton's *Dark Shadows,* the award-winning James Bond film *Skyfall,* and the Bruce Willis action epic *A Good Day to Die Hard,* for which he worked very closely with director John Moore to develop the detailed production illustrations that guided the shoot. In 2012, Chris received an Emmy nomination for his work with Jellyfish Pictures for Outstanding Special Visual Effects on the series *Inside the Human Body.*

www.chrisrosewarne.blogspot.co.uk

Emmanuel Shiu

Emmanuel Shiu currently specializes in concept design, illustration, and visual development for the film and video game industries. He has contributed to a variety of high-profile projects for film (*The Amazing Spider-Man 2, Cloud Atlas, Captain America: The First Avenger, Star Trek Into Darkness, Looper, Superman Returns, Harry Potter and the Goblet of Fire, Hellboy*) and video games (*Star Citizen, Lost Planet 3, Alien: Isolation*).

www.eshiu.com

Simon Stålenhag

Simon Stålenhag started painting as a child, learning the basics by doing watercolors of birds and landscapes. Having fallen in love with Sweden's natural landscape and its inhabitants, he was very much influenced by Swedish painters Lars Jonsson, Gunnar Brusewitz, and Bruno Liljefors. Later in life, and through the discovery of artists like Syd Mead, Ralph Mcquarrie, and John Conway, Simon took an interest in science fiction and natural history. He never felt satisfied splitting his interests up into different projects so he mashed them up together, creating a visual project incorporating his passion for the local Swedish landscape, natural history, and science fiction in one coherent universe, simultaneously telling something about himself and his generation of kids growing up in a post-welfare state in the last decades of the 20th century.

www.simonstalenhag.se

Chris Stoski

In his 15 years in the entertainment industry, Chris Stoski has worn many hats. As a concept designer, he has worked on more than 30 exciting Hollywood feature films, several riveting games, one super cool music video, and one Fruit of the Loom underwear commercial. Aside from grown men in tights dressed as giant fruit, he has designed shots for *Star Trek, Star Wars, Mass Effect 3, Looper*, visual effects Academy Award–winner *Hugo*, and his wife's yearly birthday cards. He has designed numerous shots and matte paintings for Matte World Digital and, during his years at Industrial Light & Magic, he supervised teams on *Iron Man, Pirates of the Caribbean: At World's End*, and *Star Trek* before moving to Disney and then Doug Chiang Studio. As an art director, Chris has worked on *Star Trek Into Darkness* and several other films before going to Electronic Arts to perform duties as lead concept artist on AAA titles. Nowadays Chris is a visual designer and concept artist at Google where he's working on some top-secret stuff!

Chris loves all genres of design and inventing robots, really wants a self-driving electric car, and prefers hot days to stay below 77 degrees Fahrenheit (that's 25 Celsius to the rest of the world). He currently lives in California where it's normally nice.

www.stoskidigital.com

Steve Talkowski

A 20-plus-year veteran of the computer-animation scene, Steve Talkowski has worked as an animation director, character animator, and designer on hundreds of national brands ranging from BMW, Pepsi, General Mills, Target, Reese's, and M&M's, to the groundbreaking feature films *Joe's Apartment, Ice Age, Alien: Resurrection*, and the 1988 Academy Award–winning short *Bunny*.

In 2008, Steve launched Sketchbot Studios and self-produced his first foray into the designer toy scene: the retro-styled, pencil-wielding creative robot Sketchbot. In 2010, the Sketchbot platform served as the basis for two highly successful DIY custom shows held in New York and Los Angeles, where he currently lives. Steve is presently bringing his robot creations to life as an animated series.

www.sketchbot.tv

Ash Thorp

Ash Thorp is a graphic designer, illustrator, artist, and creative director for a multitude of media, including feature films, commercial enterprises, and print. With an exceptional style of his own, he has quickly gained recognition in the industry, most notably for his role as lead graphic designer for *Ender's Game* and *Total Recall*. He has also contributed to the design direction and concepts for *Person of Interest, Prometheus, X-Men: First Class, The Amazing Spider-Man 2*, and many more titles. His work has been featured on *Motionographer, ImagineFX, Kotaku*, and *The Art of VFX*.

In addition to these feature projects, Ash is further fueled by his internal drive to develop his own signature imprint on the industry. He directed an international team of more than 30 members on the *Ghost in the Shell* tribute titled *Project 2501*. He wrote and directed the opening credits for the OFFF Barcelona 2014 film festival alongside acclaimed director Anthony Scott Burns. He has created feature film tribute prints for Mondo. He launched his own series of illustrations titled "Lost Boy," which is in development for additional media to be announced soon.

Compelled to give back to others, Ash has traveled the globe to speak at conferences and help share his journey and industry lessons with others. As creator and host of *The Collective* podcasts, he developed the series in an effort to connect artists. The topics of conversation are diverse, but they are filled with great advice, humor, industry lessons learned, and costly mistakes experienced or avoided; most importantly, the podcast aims to help motivate people to live out their passions.

www.ashthorp.com

Matt Tkocz

Matt Tkocz was born and raised in Poland and Germany respectively before moving to California to study entertainment design at Art Center College of Design in 2008. After graduating in 2012, he went on to become another Hollywood phony in the entertainment industry.

www.mattmatters.com

Colie Wertz

Colie Wertz is a freelance concept artist, illustrator, and CG generalist who lives and works out of the San Francisco Bay Area. He's worked on a number of films in art, visual development, and production pipeline roles. Follow him on Instagram @coliewertz for regular sketch and design updates.

www.coliewertz.com

Jan Urschel

Jan Urschel is a freelance art director, concept designer, and illustrator working in the entertainment industry, designing for feature films and video games. His clients include Warner Brothers, Lucasfilm, Marvel, Electronic Arts, Sony, Ubisoft, LucasArts, Cloud Imperium Games, and Psyop.

www.hendrix-design.com

Lorin Wood

Lorin Wood is a conceptual designer with nearly two decades of professional experience. His work has been seen on television and in films, video games, publications, and various other entertainment venues. Concurrently with these projects, he also continues to dabble in product design for non-entertainment clientele to keep his design chops sharp. He is also an appreciator of a cool glass of fine, Welsh mineral water. It really hits the spot!

In 2012, Lorin lost a bet to Scott Robertson, which cost him a finger, a substantial portion of hair, and three teeth. He must also organize and manage the artists who create the content for the *Nuthin' But Mech* book series.

Only part of the above statement is true . . .

www.lorinwood.com

Josh Viers

Josh Viers has had a varied career as an artist and designer that began more than 20 years ago. In the beginning, he designed shoes for Adidas, toys for Hasbro, and phones for Samsung, but he found his passion in concept art when he first worked as an art assistant in the Industrial Light & Magic art department. Since then, Josh has gone on to work as an artist on films for Steven Spielberg, Robert Zemeckis, and J.J. Abrams.

www.ConceptByJosh.com

Andrée Wallin

Concept artist and art director Andrée Wallin works mainly on commercials and films—with expertise in concept/previsualization art—as well as high-end promo art for movie posters, magazine covers, and billboards. His clients include Universal, Warner Bros., Disney, Digital Domain, MPC, Blur Studio, Legendary Pictures, and Lucasfilm.

www.andreewallin.com

Nuthin' But Mech

The *Nuthin' But Mech* blog is the brainchild of Lorin Wood of Gearbox Software. He wanted a place to harbor his passion for robots so he put together a blog and corralled some of his friends and professional acquaintances to populate this nook of cyberspace. The book series is a collaborative effort that showcases various styles of mecha design the contributing artists create when they are not working on blockbuster movies, TV shows, and video games.

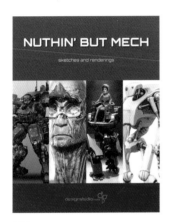

128 pages
Paperback
ISBN-13: 978-1-933492-67-4

Nuthin' But Mech features the works of:

Carlo Arellano, Aaron Beck, Søren Bendt, Greg Broadmore, Sam Brown, Steve Burg, Peggy Chung, Jeremy Cook, Alex J. Cunningham, Fon Davis / MORAV, TyRuben Ellingson, Marc Gabbana, Eduardo Gonzalez, Alex Jaeger, Eliott Lilly, Miguel Lopez, Ben Mauro, Ian McQue, Michael A. Nash, Sunil Pant, Jake Parker, Christian Pearce, Peter Popken, Kemp Remillard, Neil Campbell Ross, Oliver Scholl, Robert Simons, Thom Tenery, Imery Watson, Lorin Wood, Feng Zhu

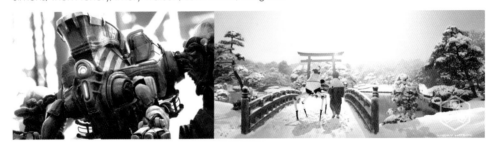

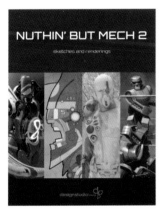

128 pages
Paperback
ISBN-13: 978-162465010-9

Nuthin' But Mech 2 features the works of:

Darren Bartley, Aaron Beck, Sam Brown, Dylan Cole, Kevin Conran, Jeremy Cook, Fausto De Martini, Eddie Del Rio, TyRuben Ellingson, Landis Fields, Danny Gardner, James Gurney, Brian Hagan, David Hobbins, Alex Jaeger, Eric Joyner, Kurt Kaufman, Ara Kermanikian, Gavriil Klimov, Bastiaan Koch, Eliott Lilly, Vaughan Ling, Miguel Lopez, Ian McQue, Josh Nizzi, James Paick, Sunil Pant, Jake Parker, Robh Ruppel, Phil Saunders, Emmanuel Shiu, Robert Simons, Chris Stoski, Ash Thorp, Matt Tkocz, Francis Tsai, Jan Urschel, Farzad Varahramyan, Calum Alexander Watt, Colie Wertz, Lorin Wood

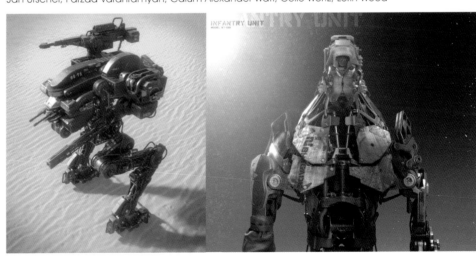

THE *NUTHIN' BUT MECH* BLOG

Check out the blog where the *Nuthin' But Mech* series got its start! See some of the world's leading artists create a wonderland populated by mechs and machines of all shapes and sizes!

www.nuthinbutmech.blogspot.com

To order additional copies of this book, and to view other books
we offer, please visit:
www.designstudiopress.com

For volume purchases and resale inquiries, please email:
info@designstudiopress.com

Or you can write to:
Design Studio Press
8577 Higuera Street
Culver City, CA 90232

tel 310.836.3116

To be notified of new releases, special discounts, and
events, please sign up for our mailing list on our website,
join our Facebook fan page and follow us on Twitter:

f facebook.com/designstudiopress

twitter.com/DStudioPress

designstudio | PRESS